SEE
HEAR
YOKO

SEE
HEAR
YOKO

BOB GRUEN AND JODY DENBERG
FOR YOKO ONO

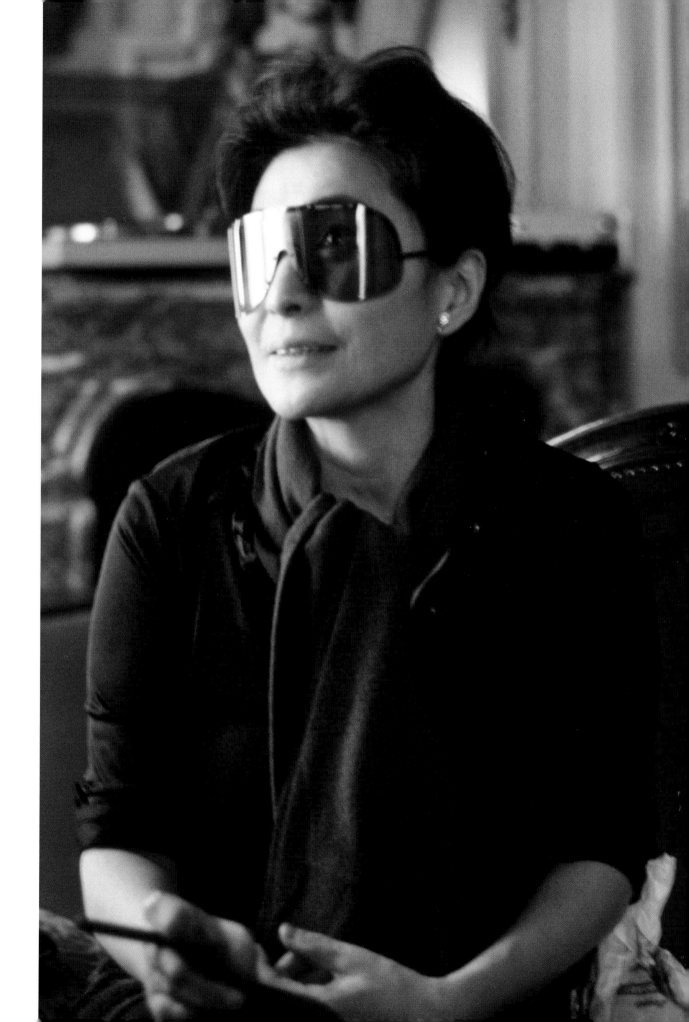

HARPER

An Imprint of HarperCollins*Publishers*

HarperCollins books may be purchased for educational, business, or sales promotional use. For information, please e-mail the Special Markets Department at SPsales@harpercollins.com.

All photographs by Bob Gruen

FIRST EDITION

Designed by Hanna Toresson

Text editing by Richelle DeLora

Library of Congress Cataloging-in-Publication Data has been applied for.

ISBN: 978-0-06-237070-9

15 16 17 18 19 OV/PRINTED IN ITALY 10 9 8 7 6 5 4 3 2 1

Thank you, guys!

What a great birthday present!

I never got anything like this
in my life.

Of course, I never lived
this long, either.

Stay around.

So we can have more laughs
together.

Love you! Yoko

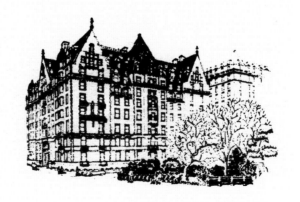

INTRODUCTIONS

Yoko Ono is the most interesting and inspiring person I know, and I've always felt very lucky to be a part of her life. We met in 1971 shortly after she came to New York with John Lennon, and we soon became friends. We shared many laughs in good times and were there for each other in hard times. I traveled to Japan and Europe with Yoko and saw her as an artist and performer. Over the years I've taken many photographs of her at public events and in private moments. When Sean was born they called me to take the first photos of him to send to their families, and in introductions Sean has referred to me as his "uncle." It makes me very happy to be considered part of the family.

For Yoko's eightieth birthday Jody Denberg suggested that we could gather my favorite photos and combine them with quotes from his interviews with her to make a special book just for Yoko. I thought it was a great idea.

This is the book we made. After we gave it to her, Yoko called and said she liked it so much that she wanted us to publish it.

I must thank Hanna Toresson for creating the design of this book and Richelle DeLora for her extensive work researching my files and Jody's interviews to select Yoko's quotes and the caption information.

BOB GRUEN, NEW YORK CITY, NOVEMBER 2014

I am a native New Yorker and turned thirteen shortly after Yoko Ono and John Lennon moved to the Big Apple together. They were a ubiquitous presence in the city during my teenage years, the first half of the 1970s—on TV, in the newspapers, and at political rallies and concerts. I never met either of them in those days but admired them from afar. I loved their albums. While John's records were globally revered, I felt like Yoko's music—as well as her art and writings—were personal communiqués. It was an illusion but a rewarding one.

After moving to Texas for college and becoming a broadcaster and a journalist, I was finally able to snag my first interview with Yoko, in 1984. Over the next quarter century we spoke more than a dozen times: for magazines and radio programs, on the phone and at the Dakota, in studios and in a hotel room. She always illuminated our conversations with candor and patience.

Any fan of Yoko Ono's is familiar with Bob Gruen's definitive images of her, and I was no exception. After he agreed to collaborate on this project as a gift for Yoko, he sent me files of countless photographs of her, and I matched quotes from my transcripts to some of his pictures. I hope the result you are holding ultimately brings two key Yoko concepts to the fore—that she always lives life as art, and that a dream you dream together is reality.

JODY DENBERG, AUSTIN, SEPTEMBER 2014

SEE
HEAR
YOKO

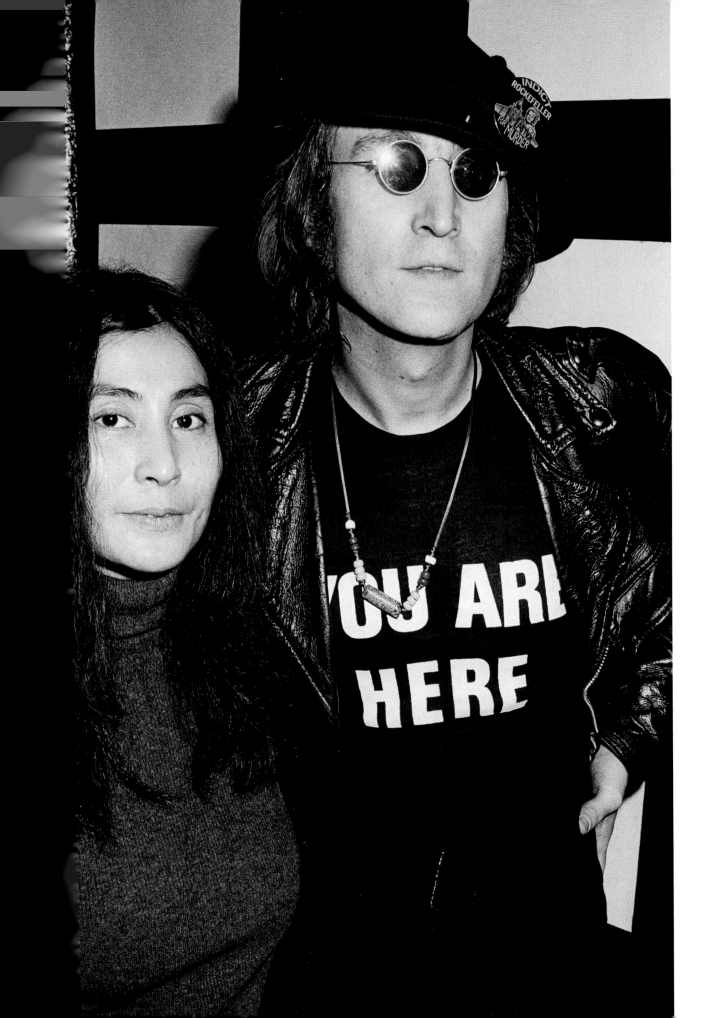

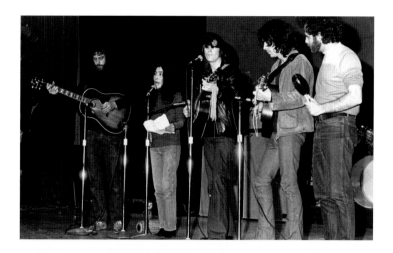

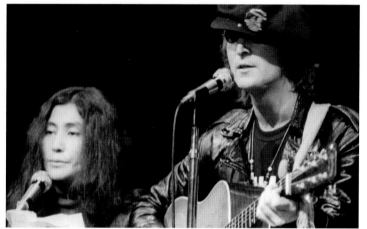

"The New York activists scene was going on. And John and I, when we came to New York, we jumped right into it. But before that, already in Ascot, we were watching a TV of Chicago Seven, that trial."

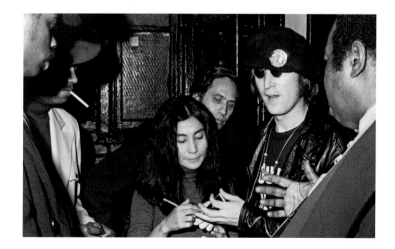

Yoko Ono, John Lennon, Jerry Rubin, and the Plastic Ono Band onstage during the Attica benefit at the Apollo Theater, New York City, December 17, 1971.

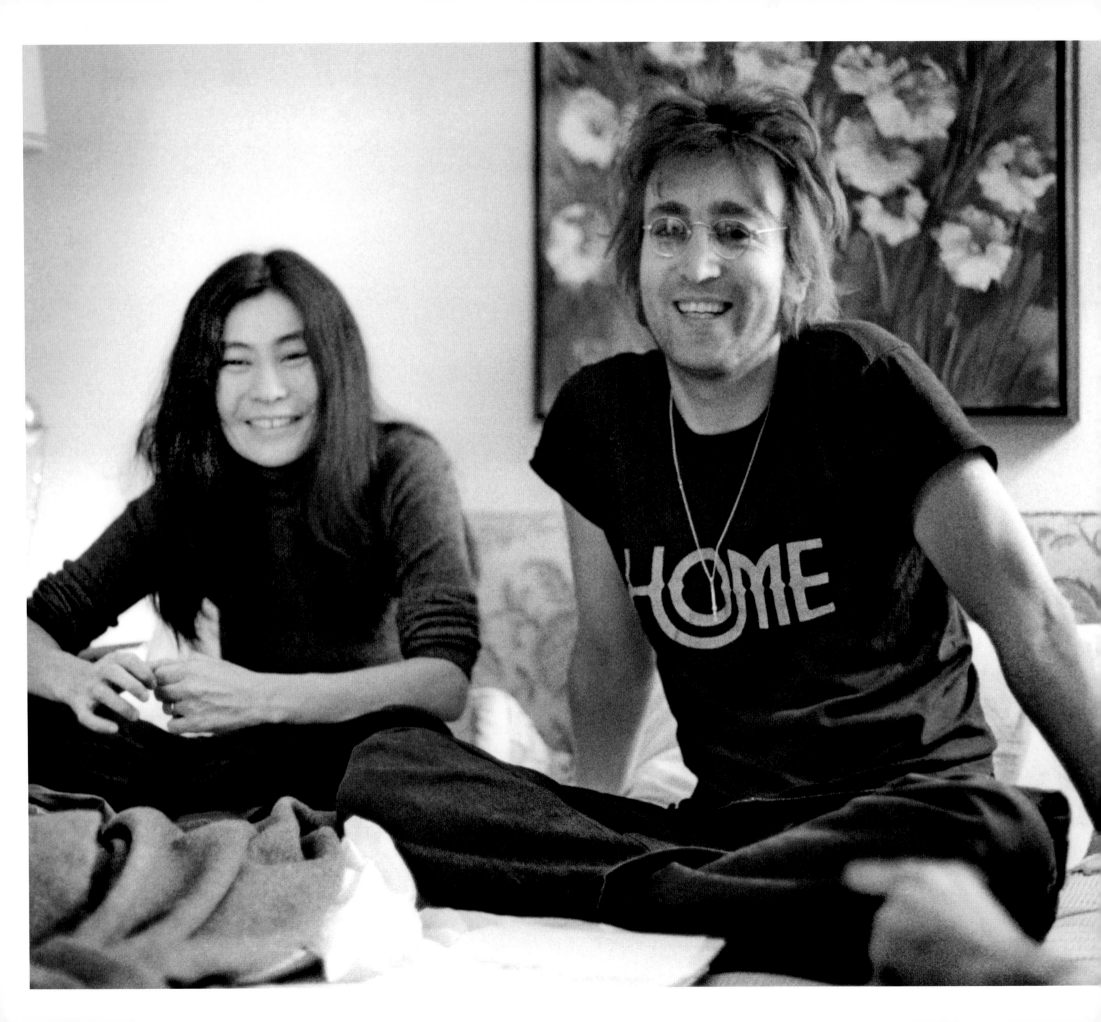

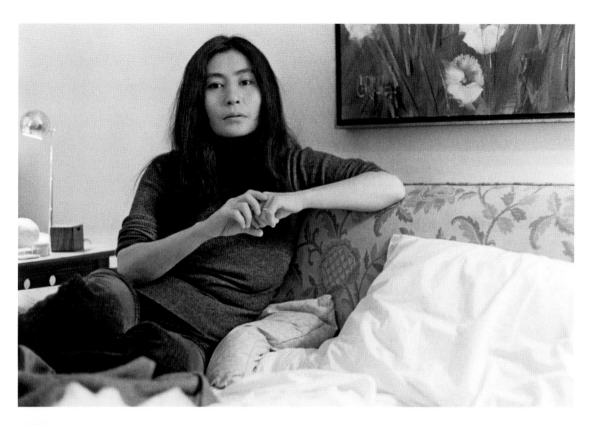

"There are very few things that you can write about John because he said it all, he wasn't hiding anything. I think he was very eager to show his vulnerability to the world."

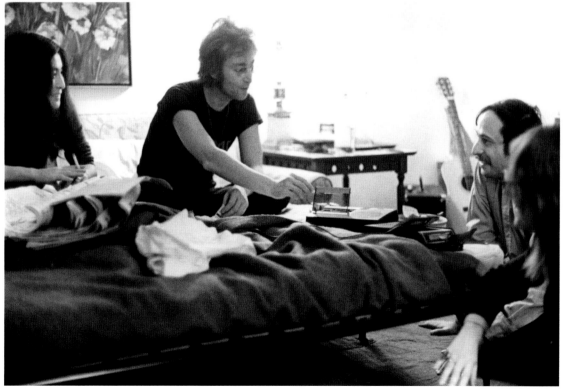

Yoko Ono and John Lennon being interviewed by Henry Edwards for *After Dark* magazine at the St. Moritz Hotel, New York City, 1972.

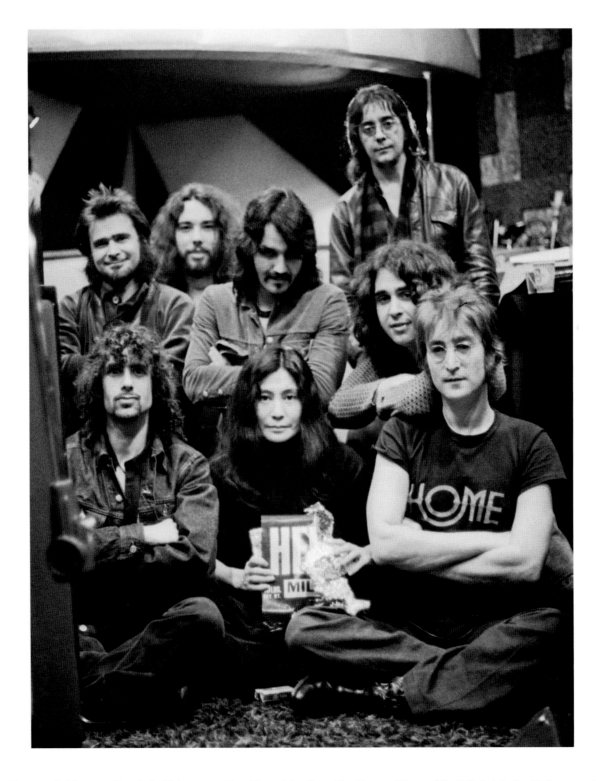

ABOVE Plastic Ono Elephant's Memory Band, (L–R) top row: Stan Bronstein, Gary Van Scyoc, Wayne "Tex" Gabriel, Jim Keltner, and Adam Ippolito. (L–R) bottom row: Rick Frank, Yoko Ono, and John Lennon during the recording of *Sometime in New York City* at the Record Plant, New York City, 1972.

RIGHT (L–R) Roy Cicala, John Lennon, and Yoko Ono during the recording of *Sometime in New York City* at the Record Plant, New York City, 1972.

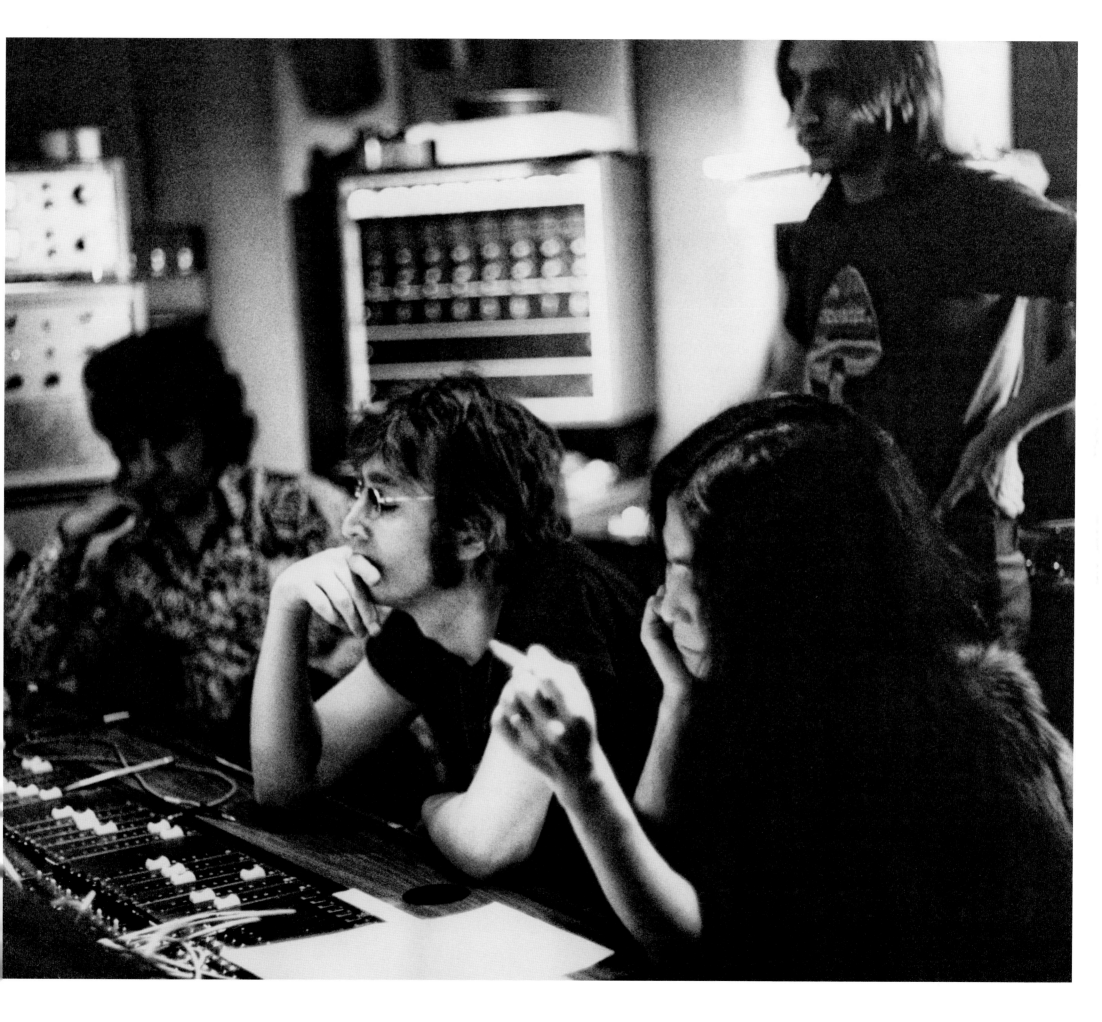

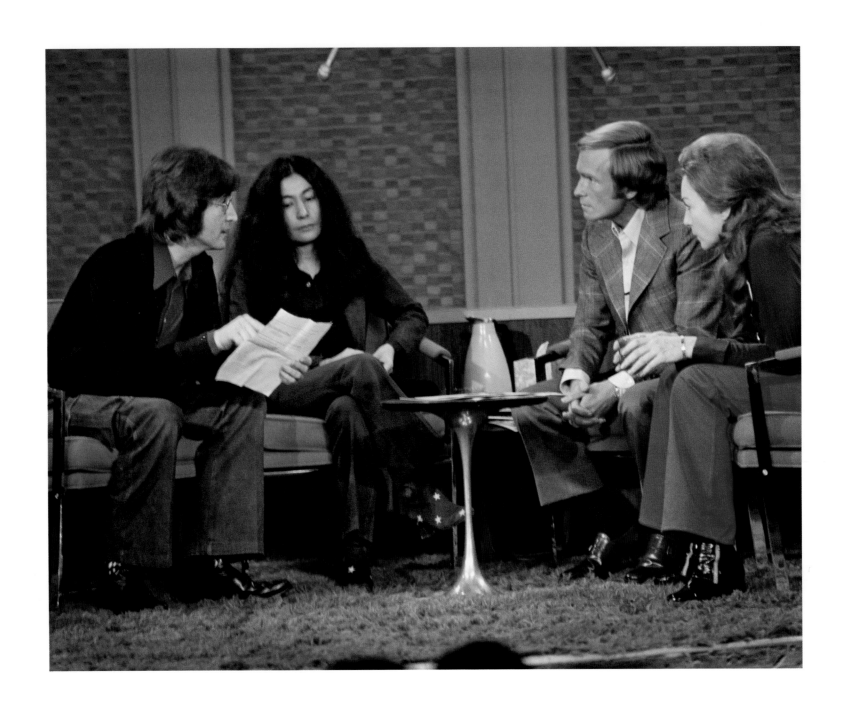

ABOVE (L–R) John Lennon, Yoko Ono, Dick Cavett, and Shirley MacLaine on *The Dick Cavett Show*, May 11, 1972.

RIGHT John Lennon, Yoko Ono, and Elephant's Memory onstage at *The Dick Cavett Show*, May 11, 1972.

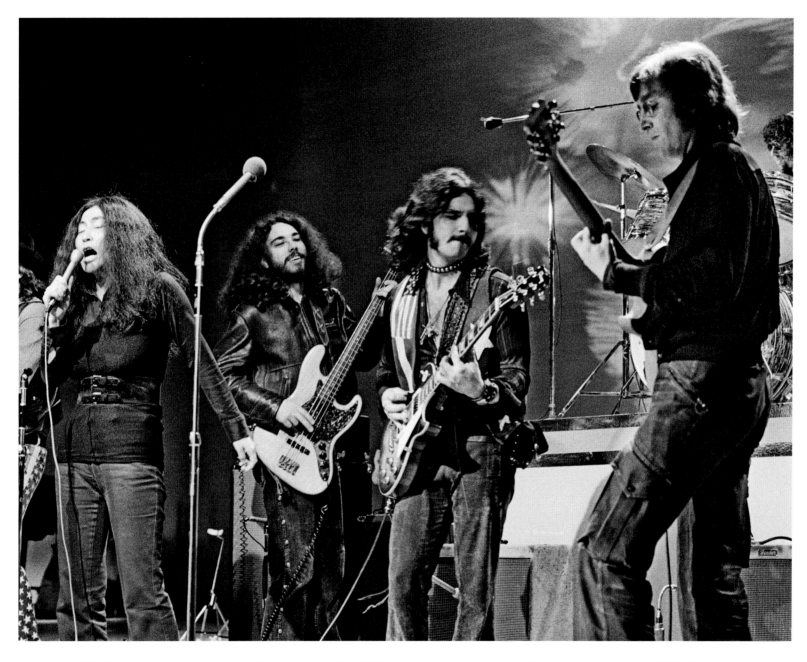

"John and I just met and sort of like two cars crashing, we just did it.
But of course I was doing that kind of stuff before, but doing it with John was
a different experience. Hear why and how he plays his guitar . . . his guitar and
my voice having a dialogue. That's something that I'd never done before."

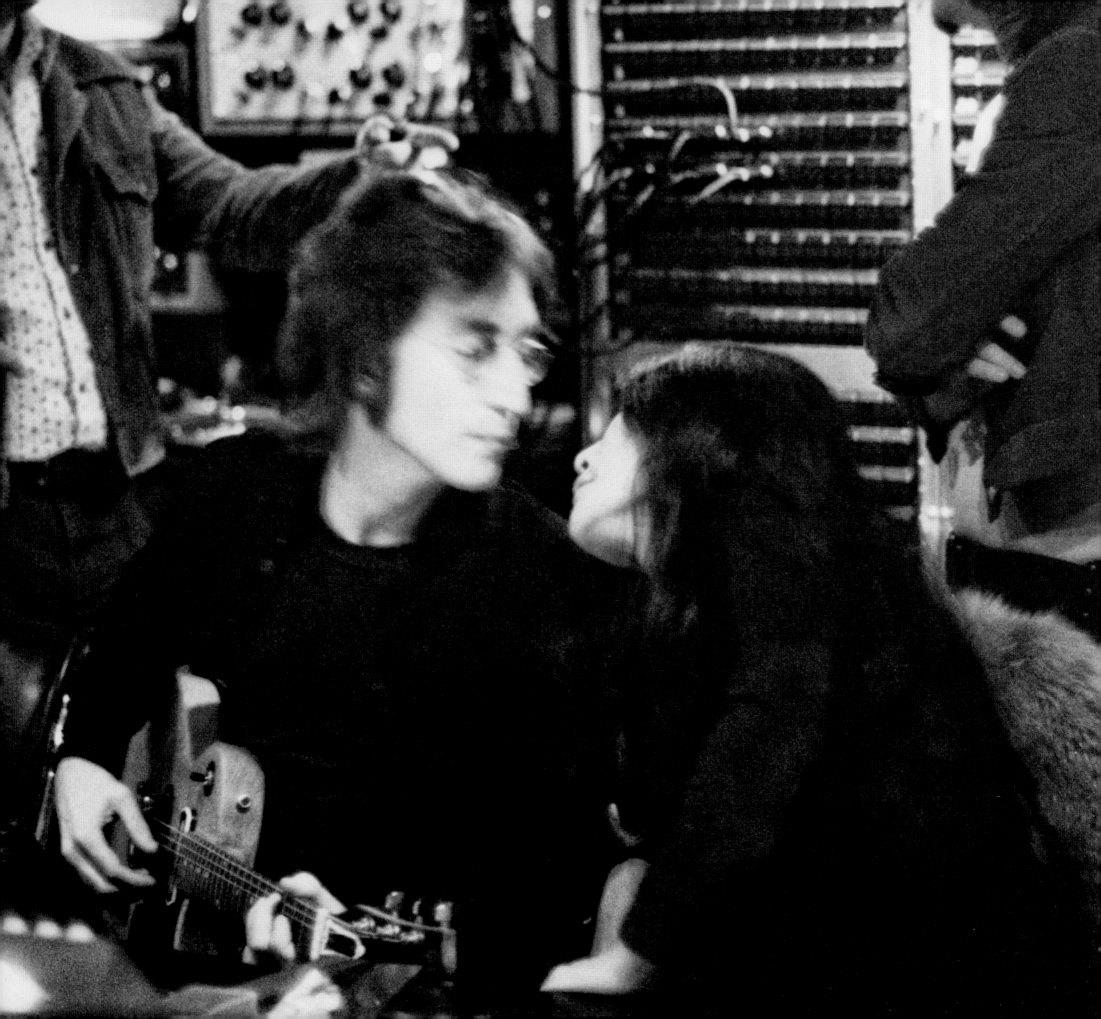

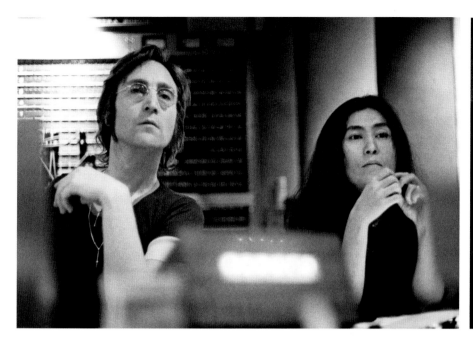
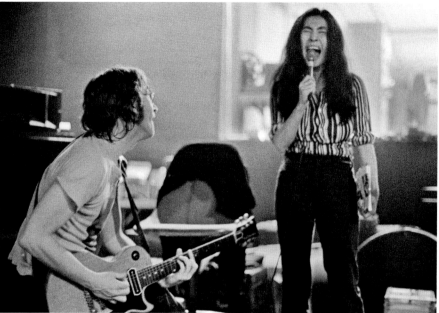
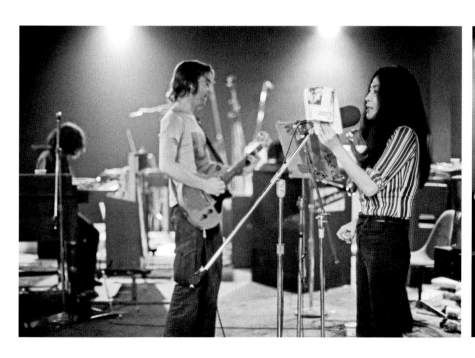
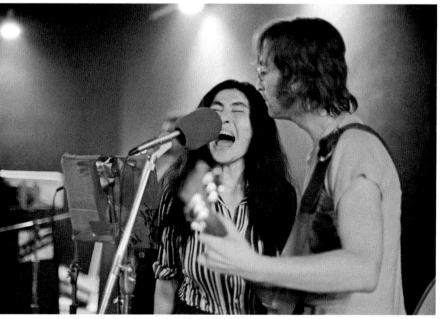

"John was very astute about anything in the record world. He used to say, 'If somebody covered your song, they're going to understand it. They're going to know that soul is going to communicate and they're going to know you're a writer.'"

John Lennon and Yoko Ono during the recording of *Sometime in New York City* at the Record Plant, and during rehearsals at Butterfly Studios for the "One to One" concert, New York City, April 1972.

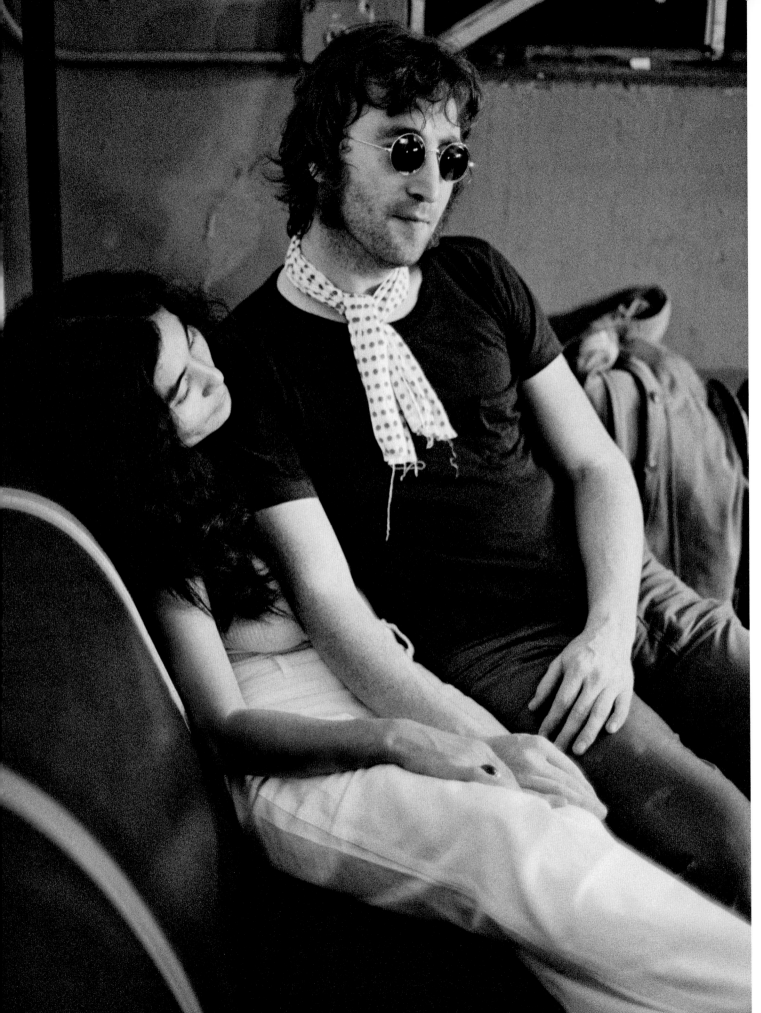

Yoko Ono and John Lennon during rehearsals at Fillmore East for the "One to One" concert, New York City, August 1972.

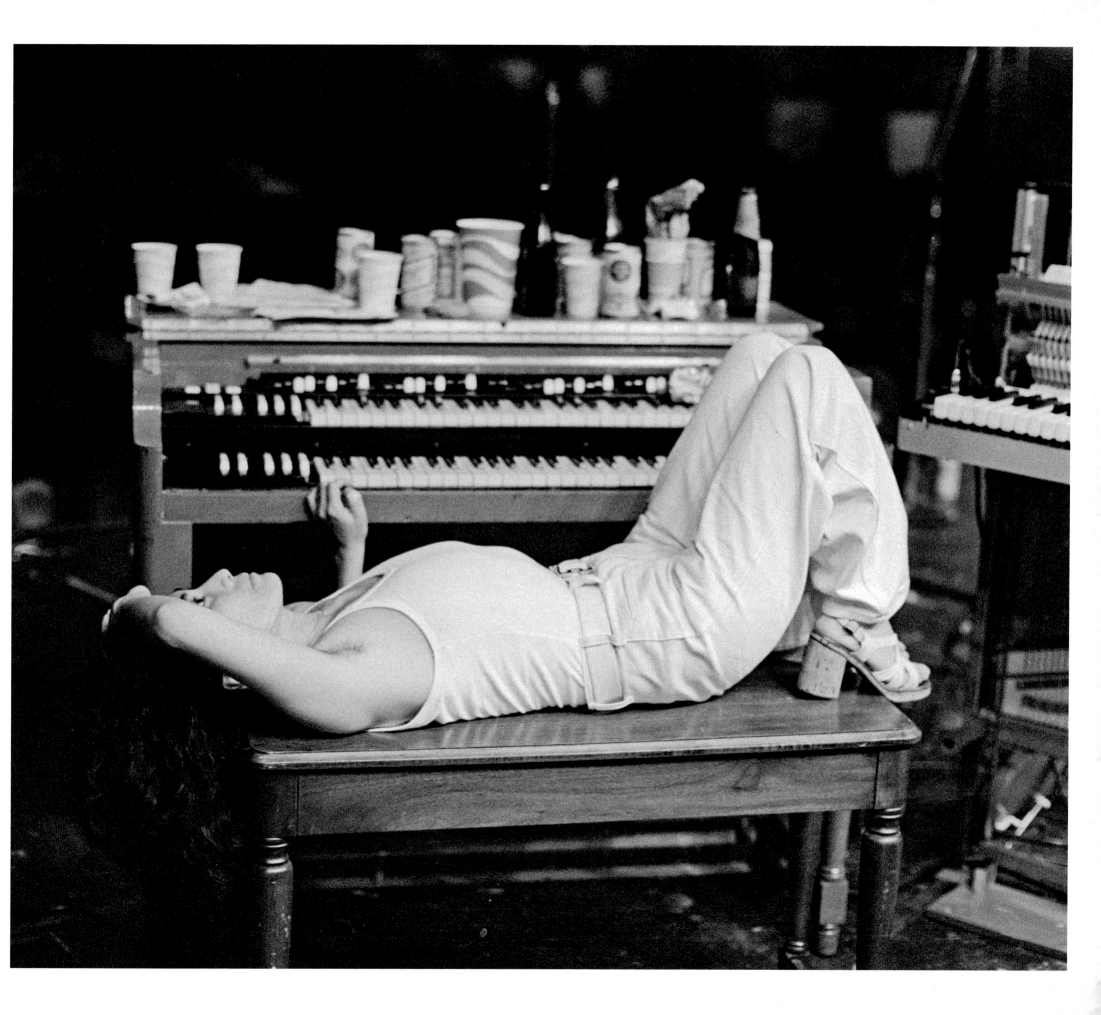

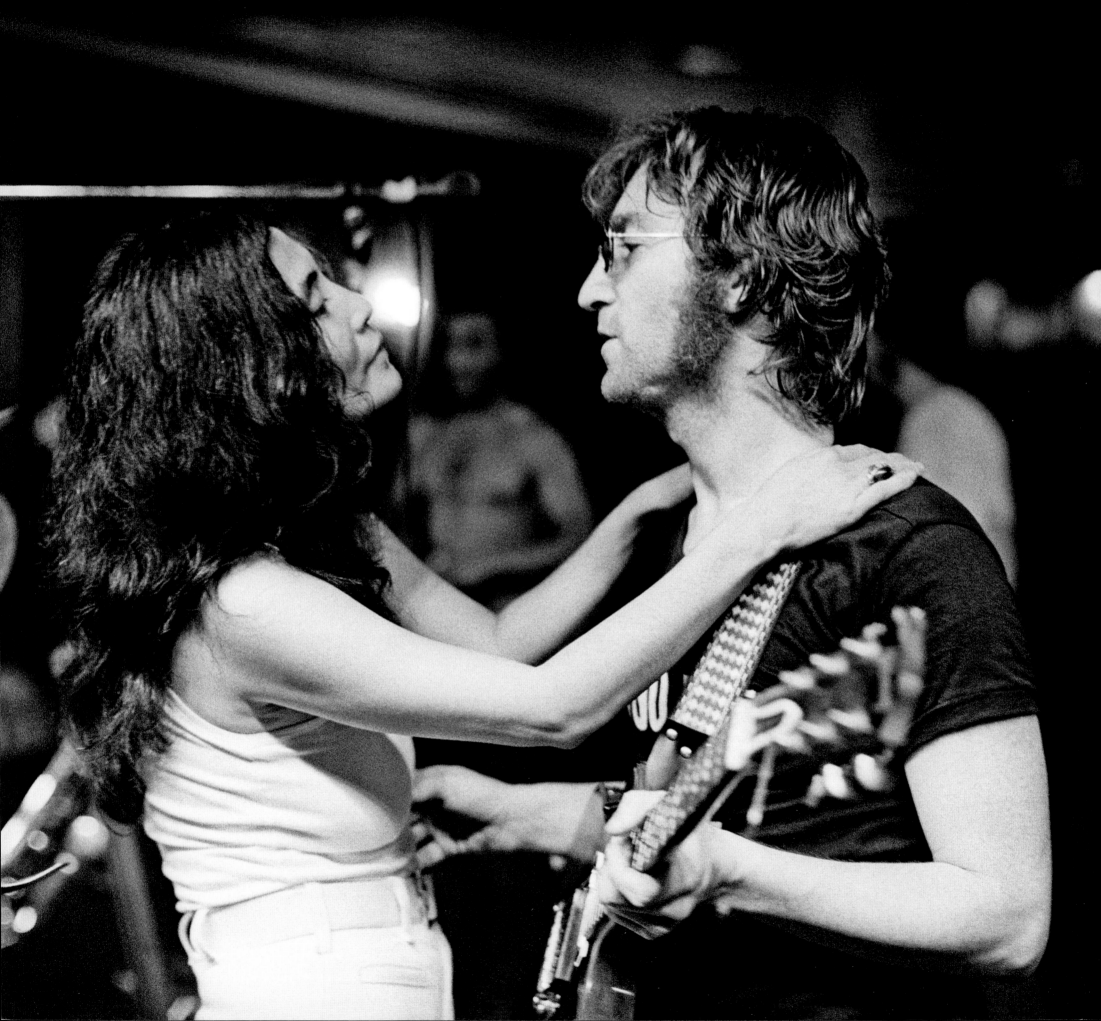

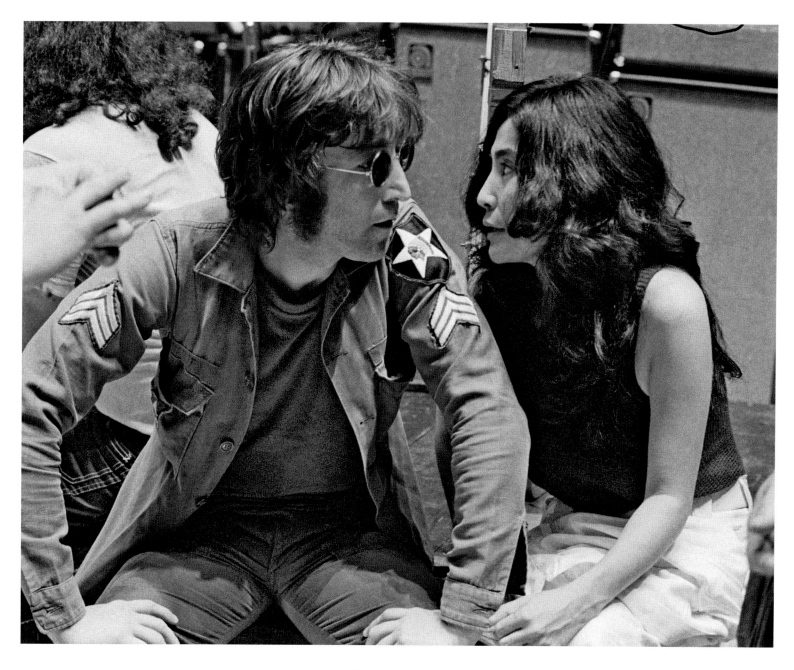

"[John's] a notch above every singer-songwriter in the world. Not just rockers: classic music, jazz, opera, you name it. And the way he was . . . you know, his diction is so incredible. I think that he's the Shakespeare of our age, in that sense."

LEFT Yoko Ono and John Lennon during rehearsals at Fillmore East for the "One to One" concert, New York City, August 1972.

ABOVE John Lennon and Yoko Ono during rehearsals for the "One to One" concert at Madison Square Garden, New York City, August 1972.

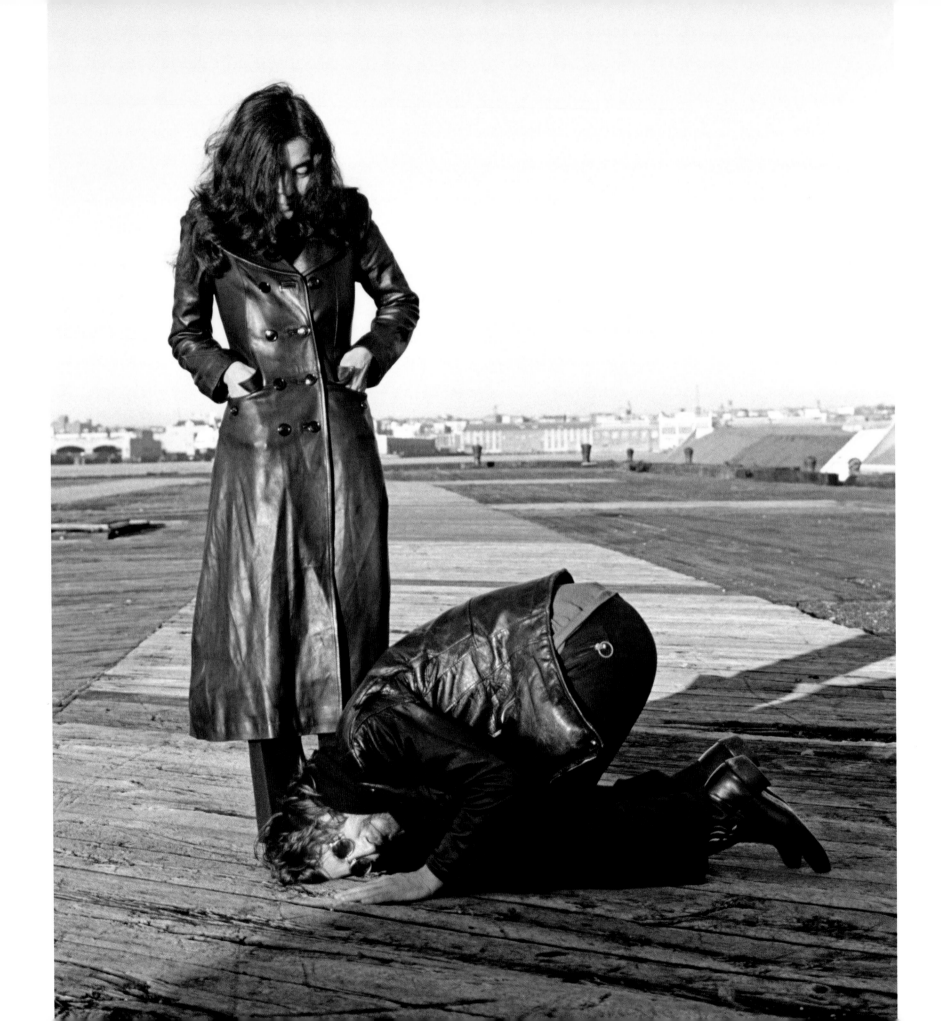

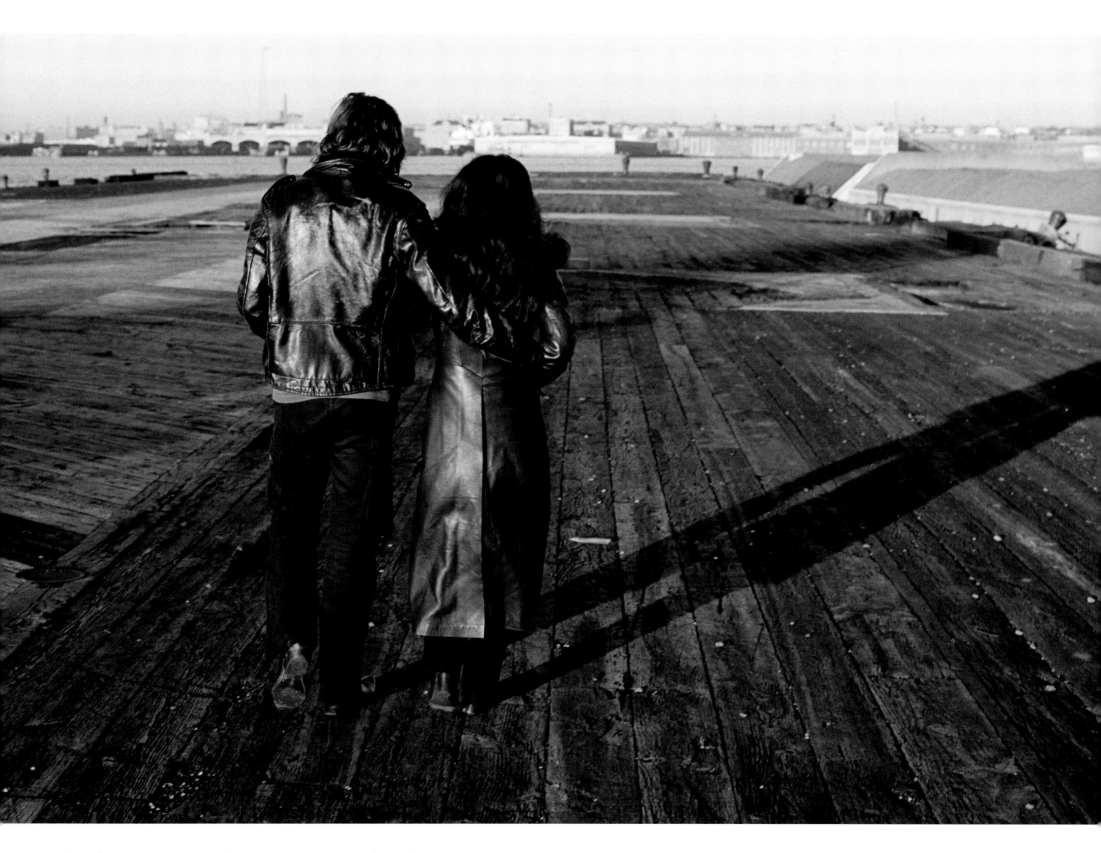

Yoko Ono and John Lennon taking a walk along the Bank Street Pier,
New York City, November 1972.

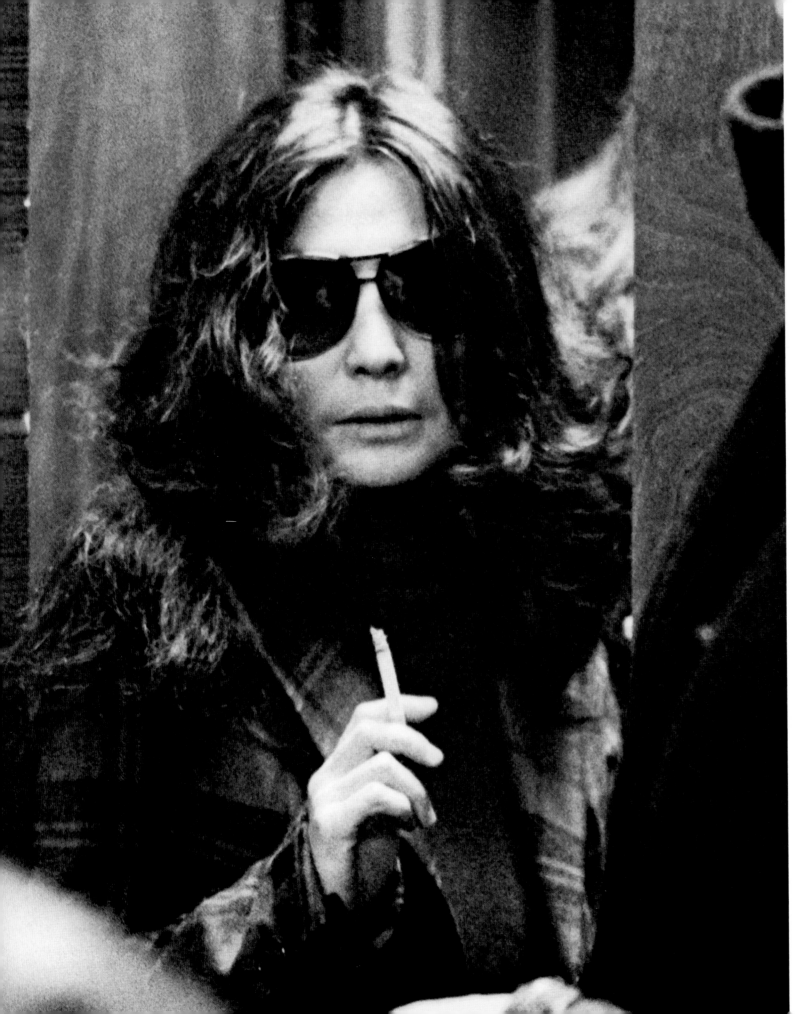

"I knew ["Imagine"] was a very important song, and we were both hoping that people would understand it and it would communicate widely. But we didn't believe it. I mean, part of us didn't believe that it's going to be a big song."

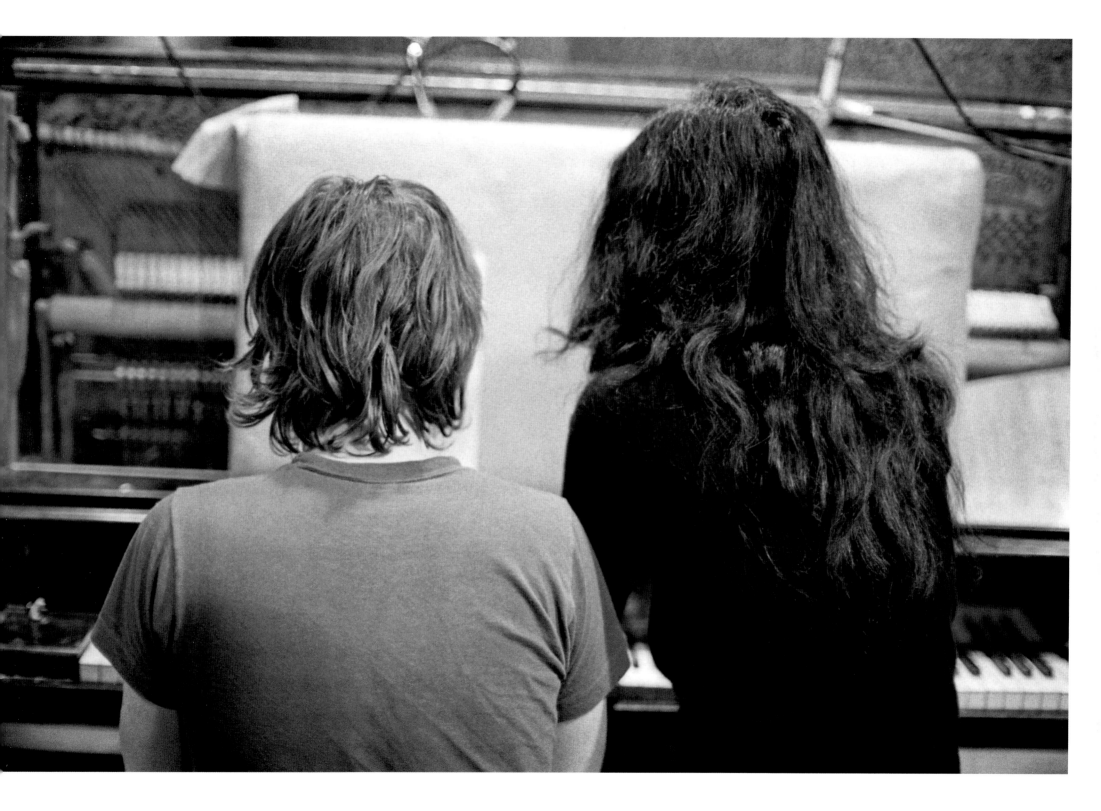

John Lennon and Yoko Ono during the recording of *Approximately Infinite Universe* at the Record Plant, New York City, 1972.

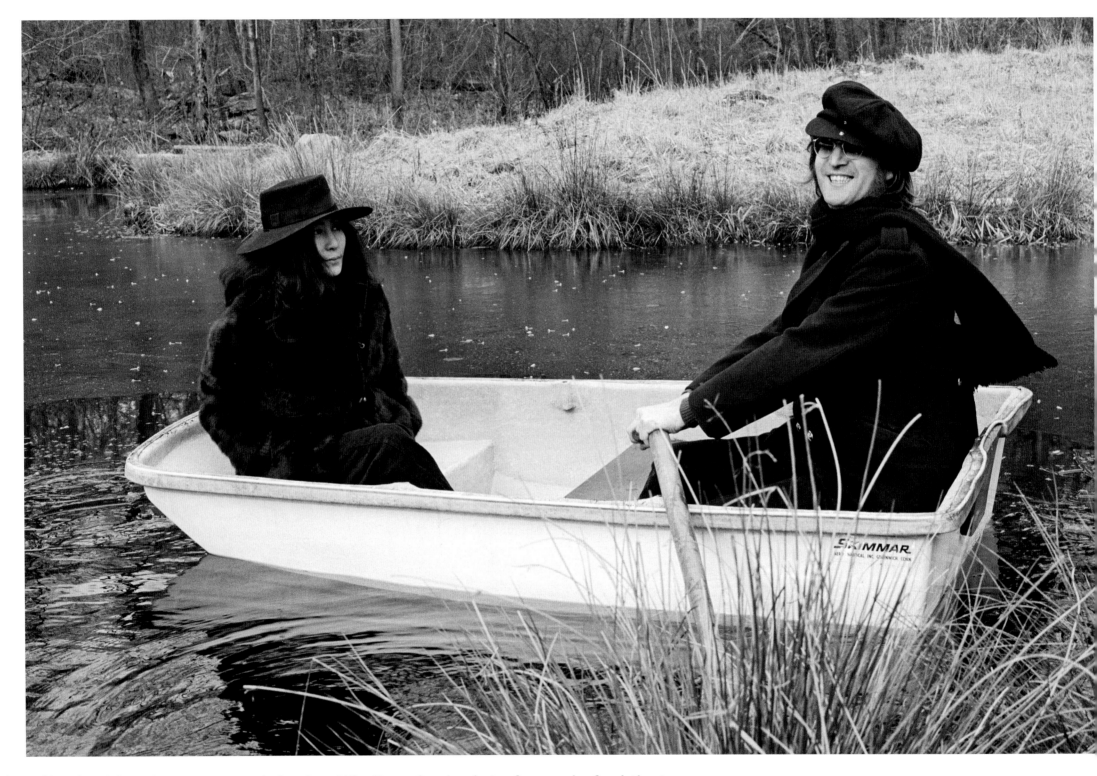

"In the big picture, yes, John is still alive. And a lot of people feel that way because his words and music and his artwork and all that is still here."

Yoko Ono and John Lennon house hunting in Greenwich, Connecticut, January 5, 1973.

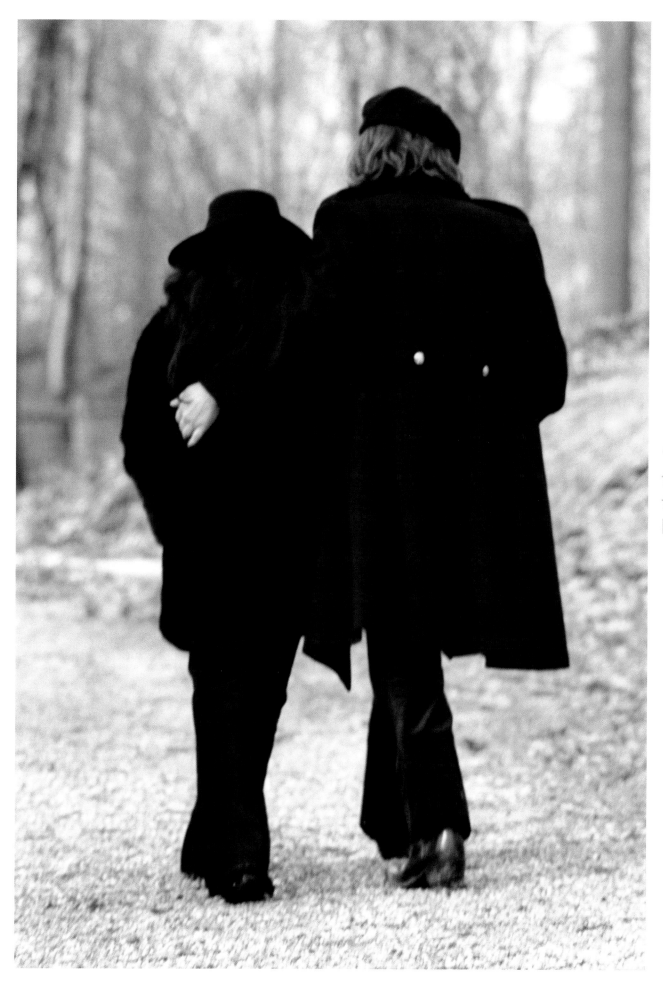

"You see, one of the things we felt was the feeling of peace between us."

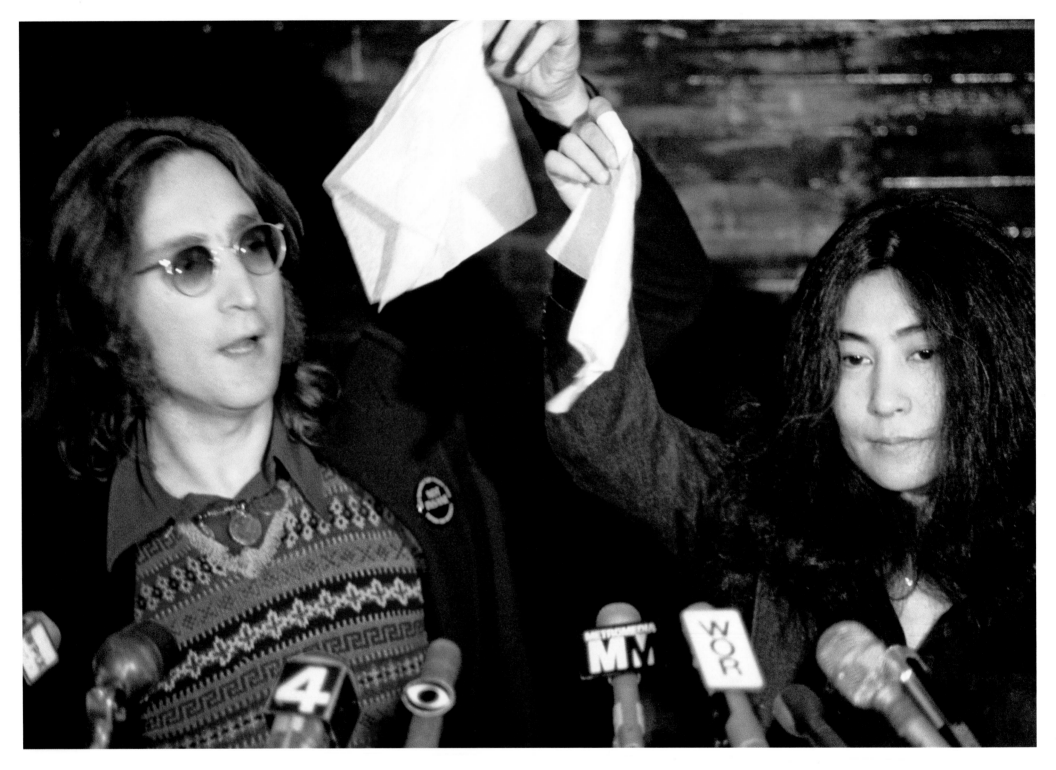

"Well I like to turn around things, and bring some positive quality to things that are actually negative. That's all we can do, really. If you just keep on having negative experiences in your life, that would get to you."

John Lennon, Yoko Ono, and their lawyer Leon Wildes during a press conference announcing the free country of Nutopia at the American Bar Association, New York City, April 1, 1973.

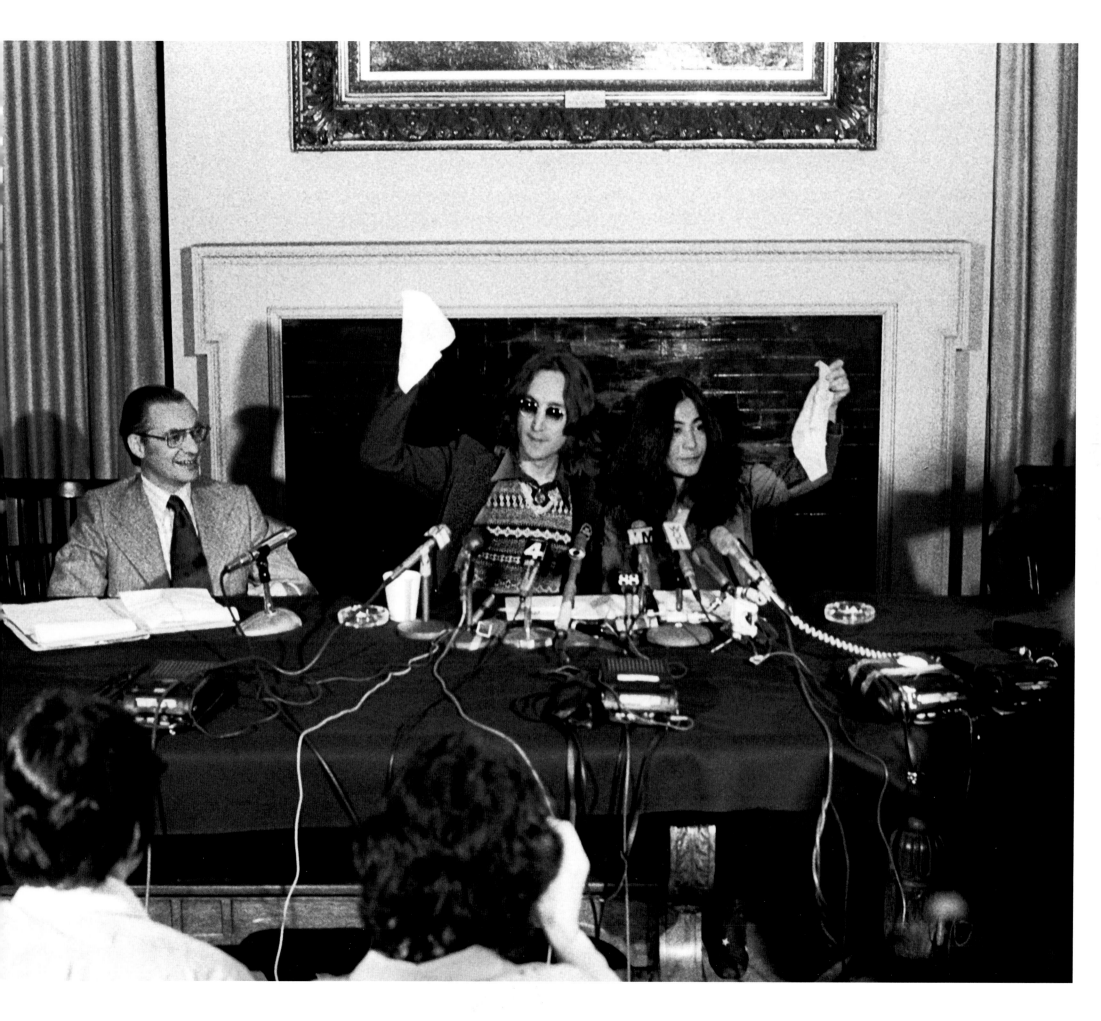

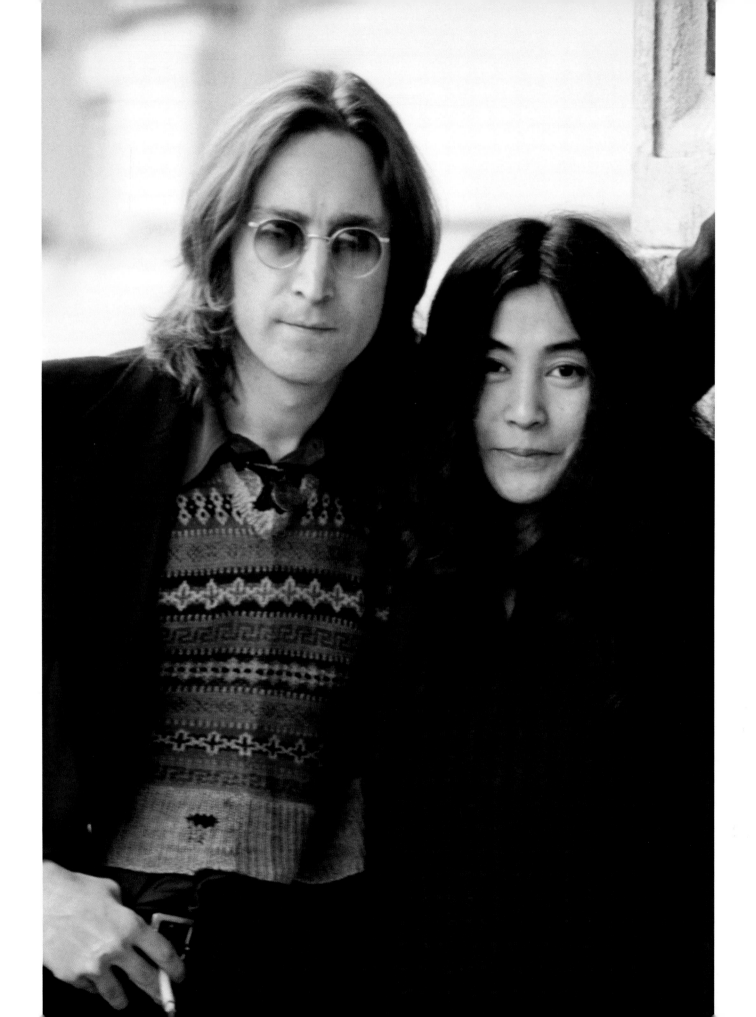

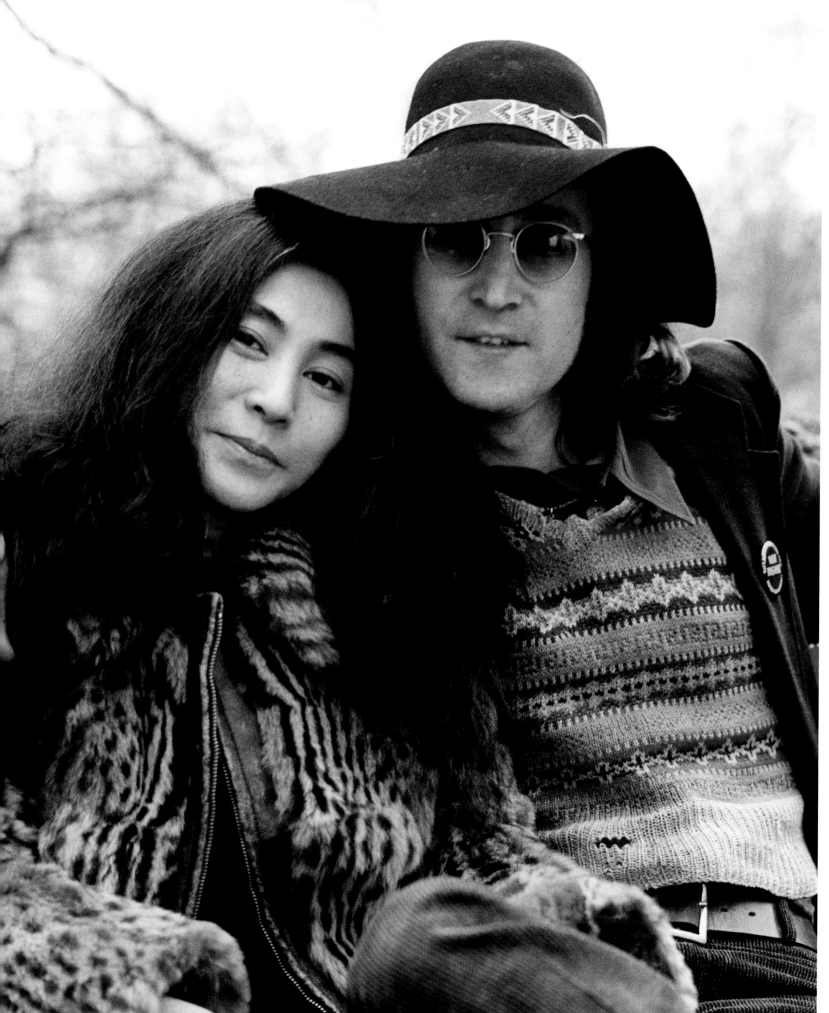

John Lennon and Yoko Ono
in Central Park, New York City,
April 2, 1973.

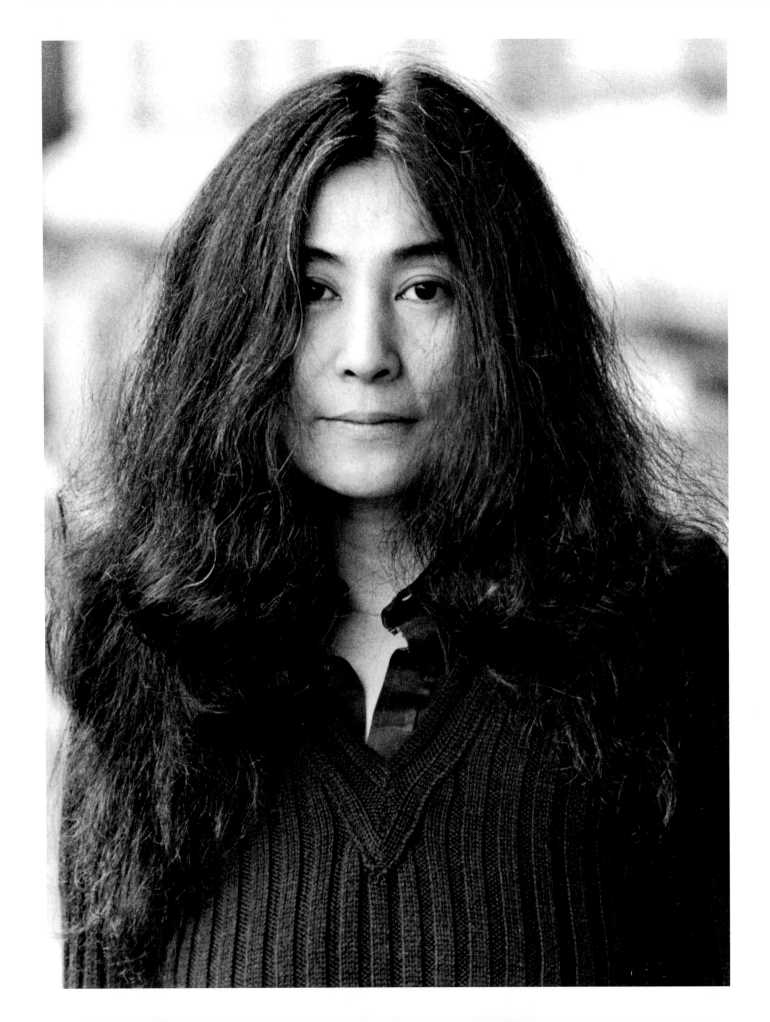

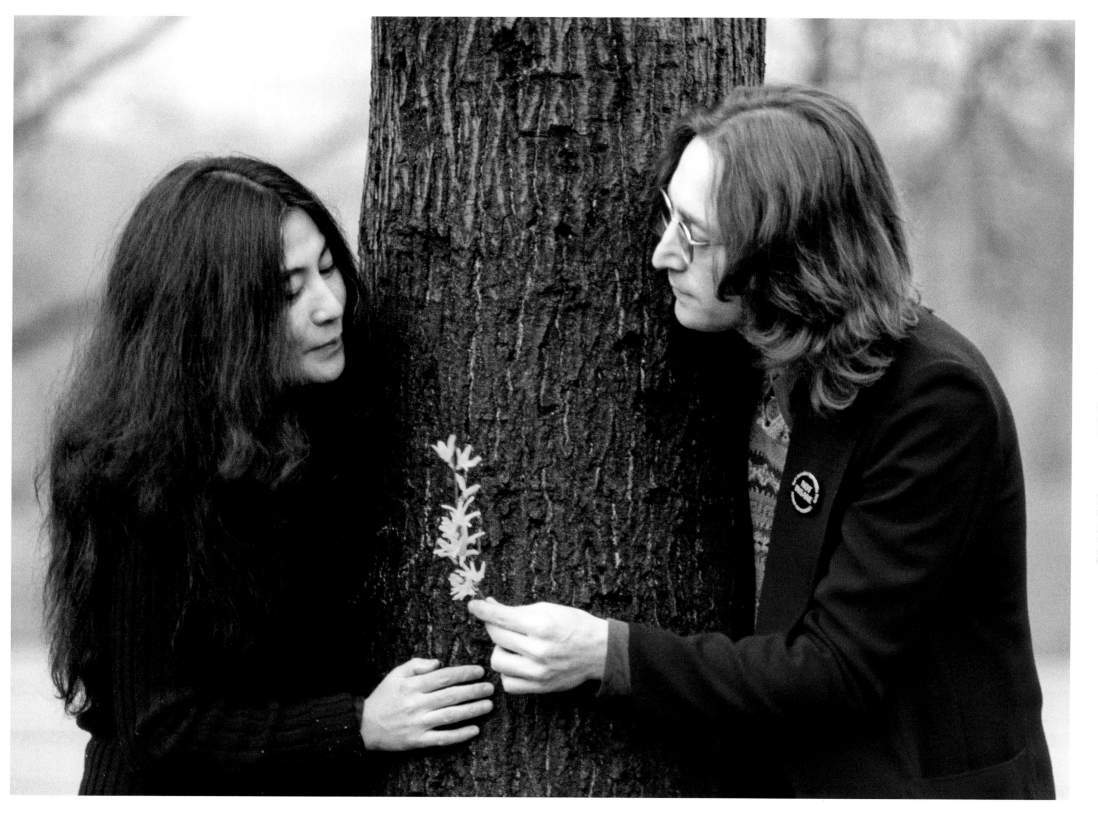

John Lennon and Yoko Ono in Central Park, New York City, April 2, 1973.

On the connection between the song "Imagine" and the book *Grapefruit*:

"Well, we were close together, and you know two artists living together, of course we're going to influence each other. Some of the things that I did rubbed off on him."

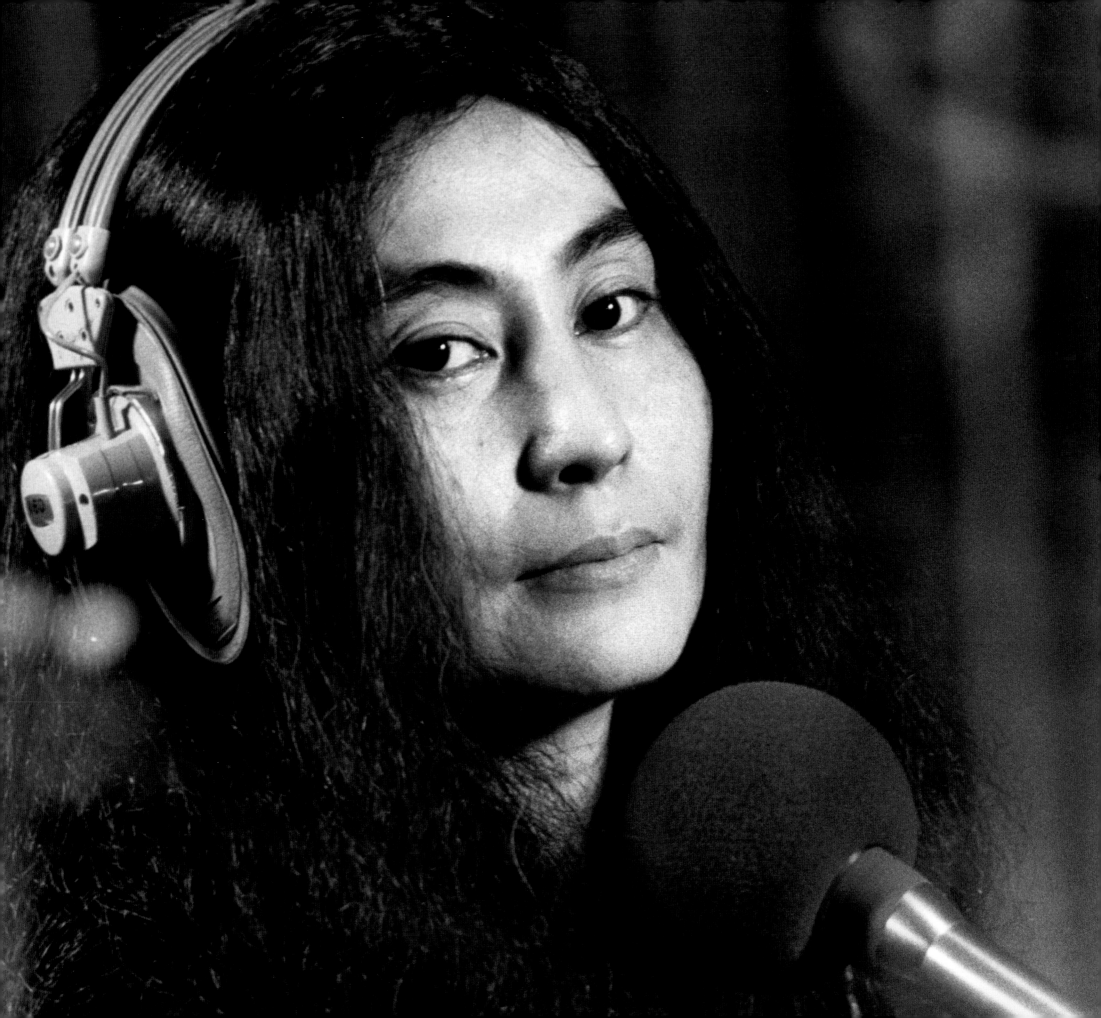

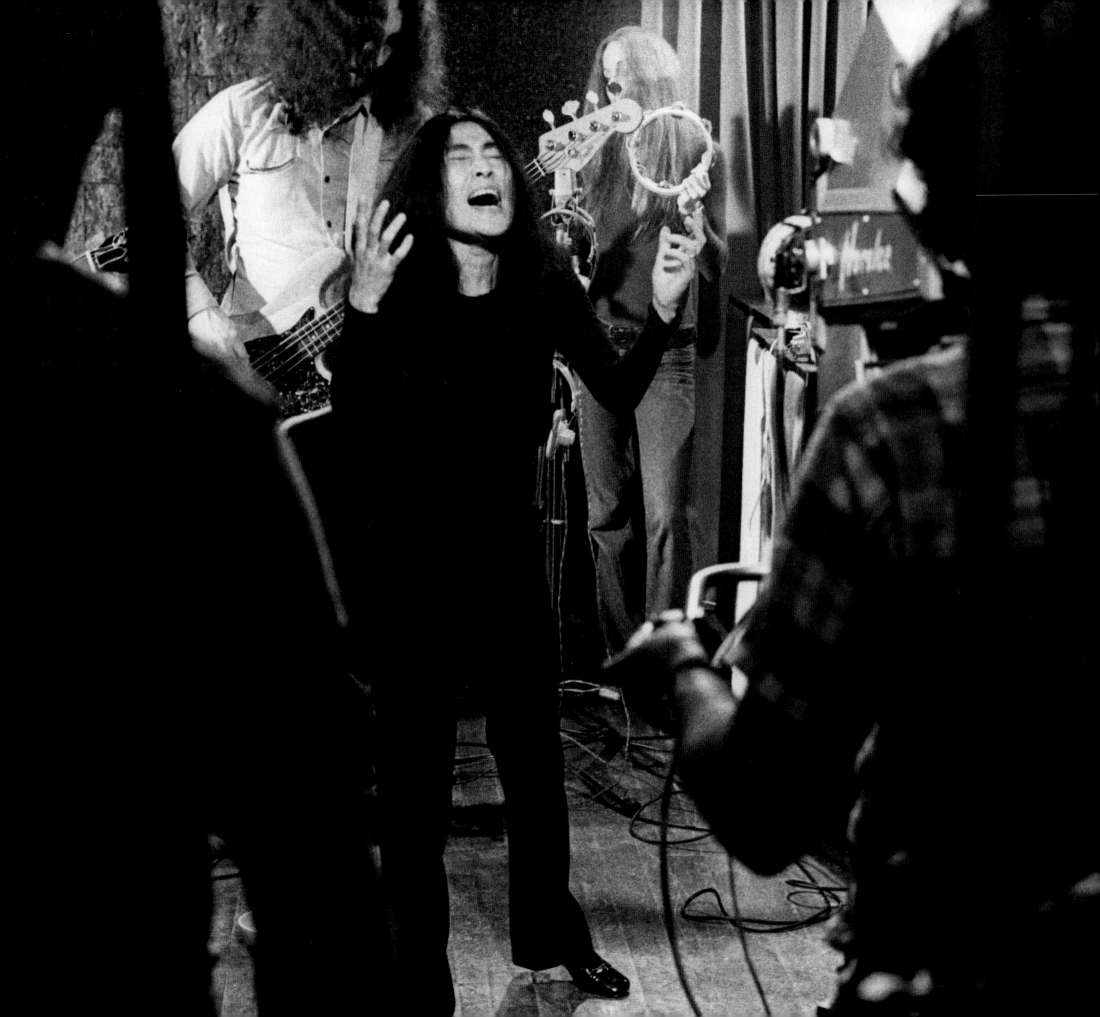

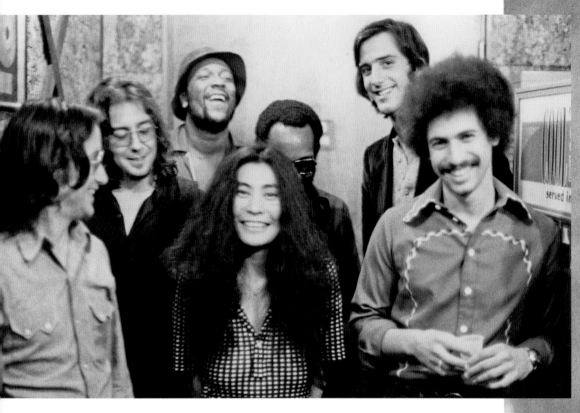

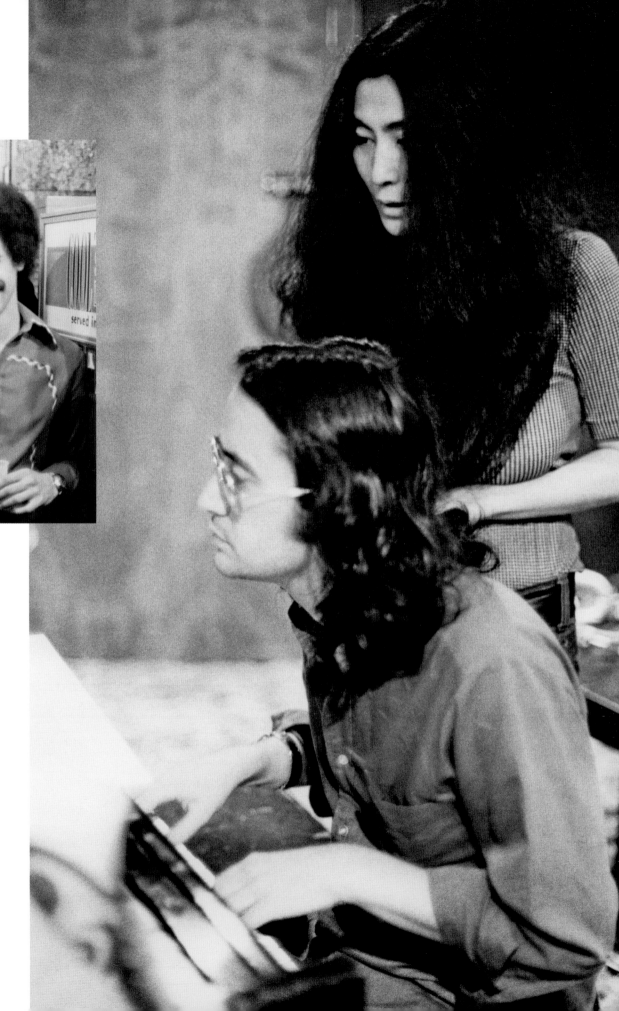

"Yeah, we separated and there was good reason for it. And I think that it was the best move that I/we made. The Lost Weekend ultimately strengthened our relationship, totally, but I wasn't sure whether we were going to stay together or not."

PREVIOUS SPREAD Yoko Ono and Elephant's Memory during the *Flipside* television show taping at the Record Plant, New York City, May 12, 1973.

ABOVE (L–R) Kenny Ascher, Jim Keltner, Gordon Edwards, Yoko Ono, Arthur Jenkins, Michael Brecker, and David Spinozza during the recording of *Feeling the Space* at the Record Plant, New York City, June 29, 1973.

RIGHT Yoko Ono and Kenny Ascher.

28

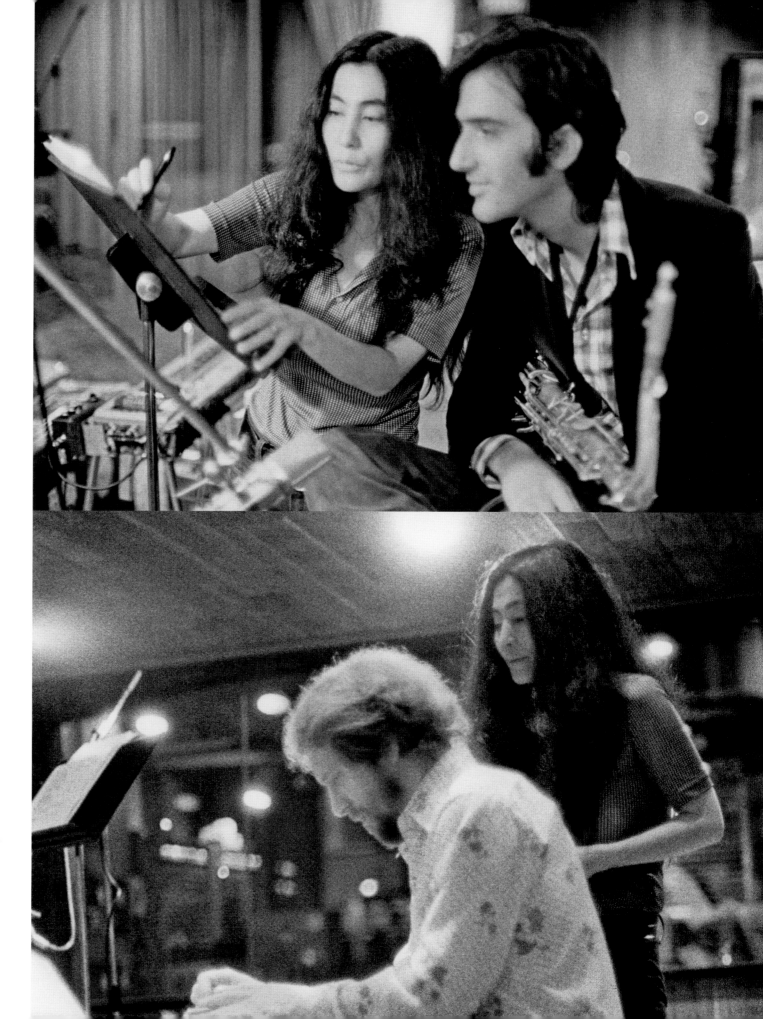

TOP Yoko Ono and Michael Brecker.

BOTTOM Yoko Ono and Sneaky Pete.

FOLLOWING SPREAD Yoko Ono in Central Park,
New York City, August 26, 1973.

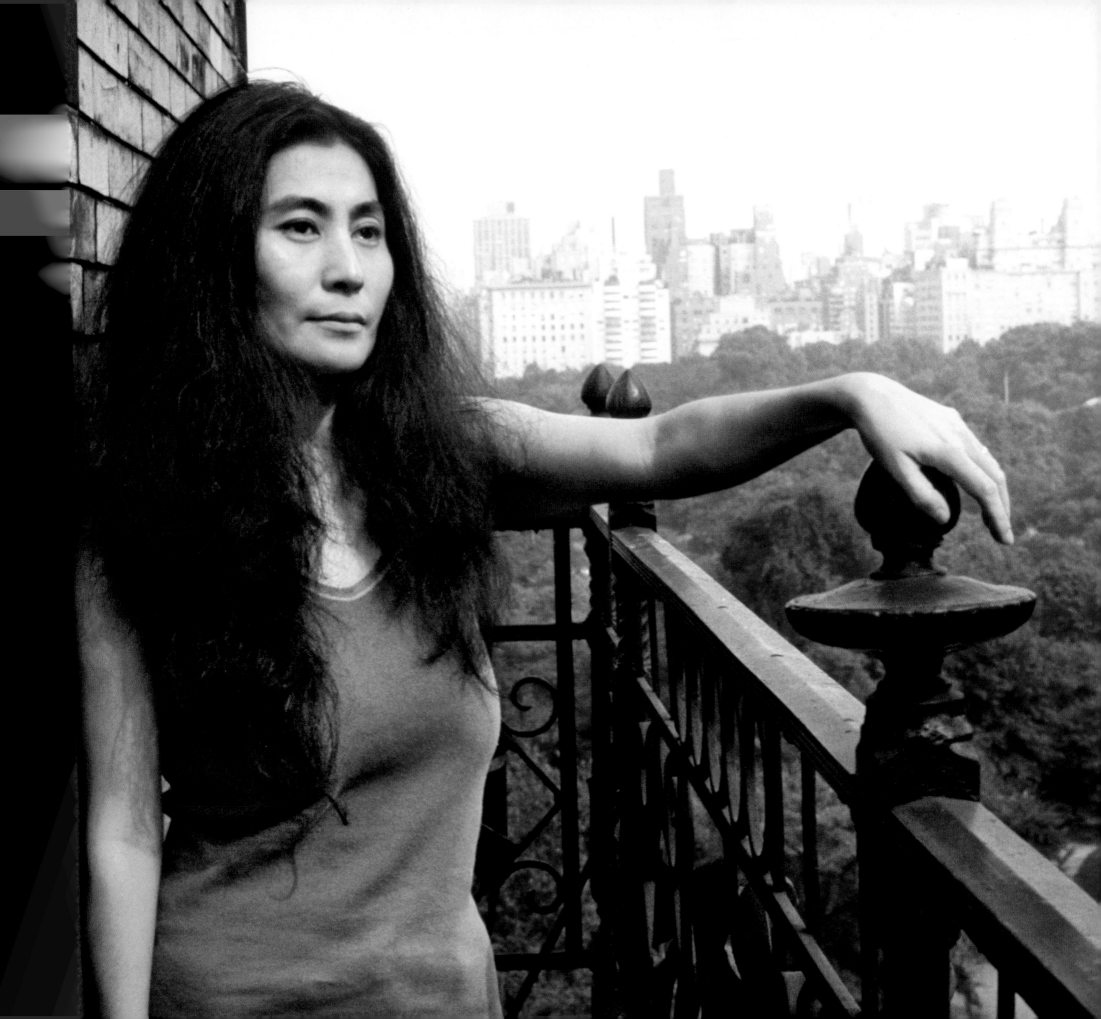

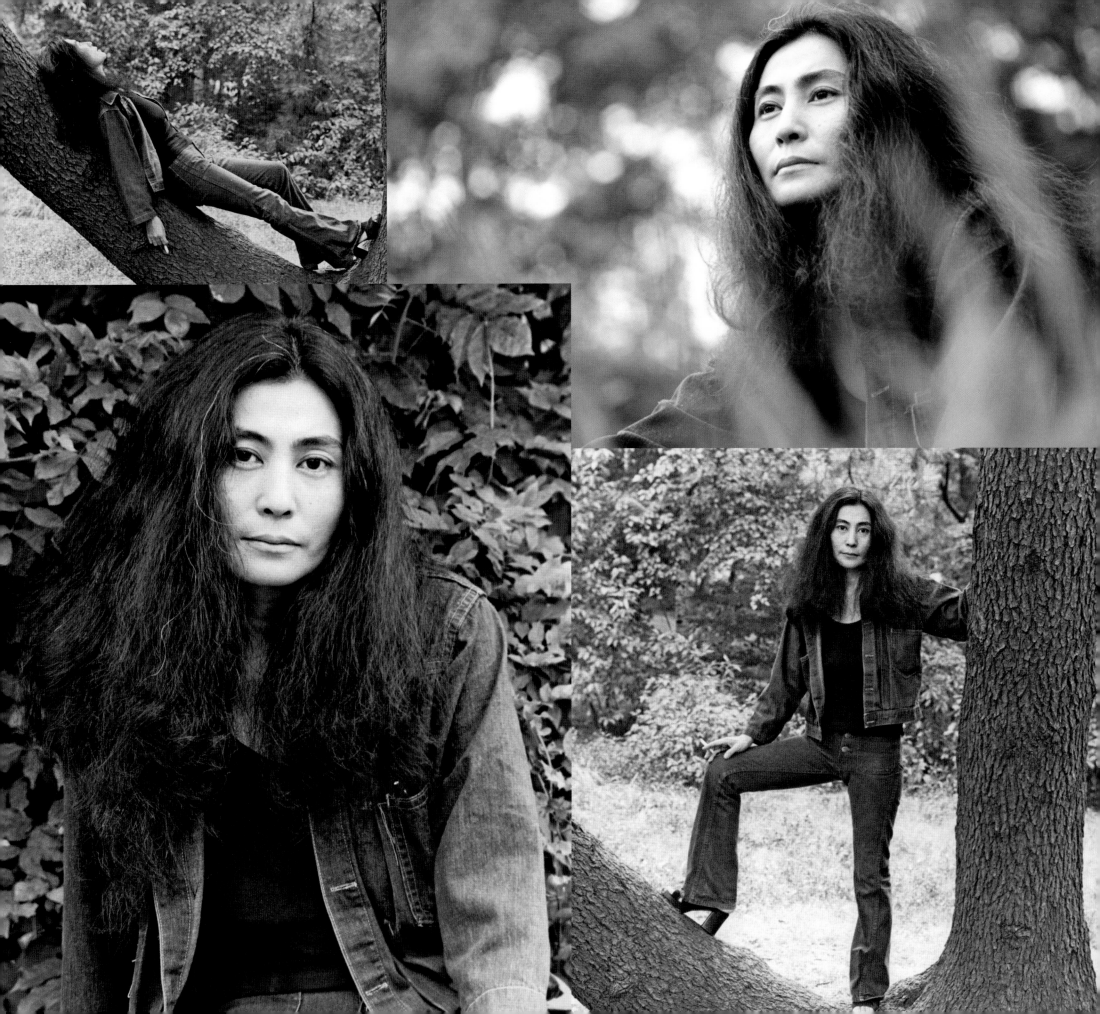

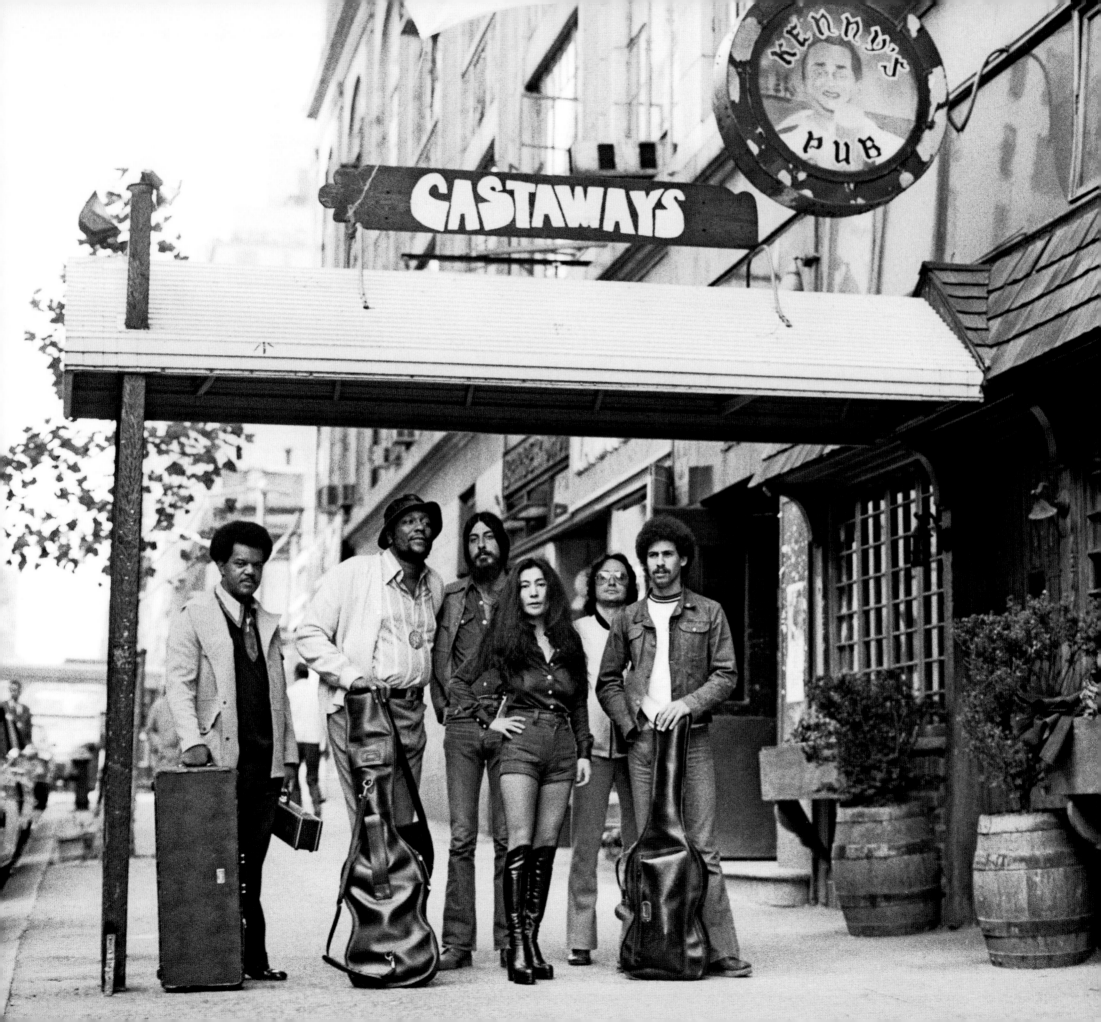

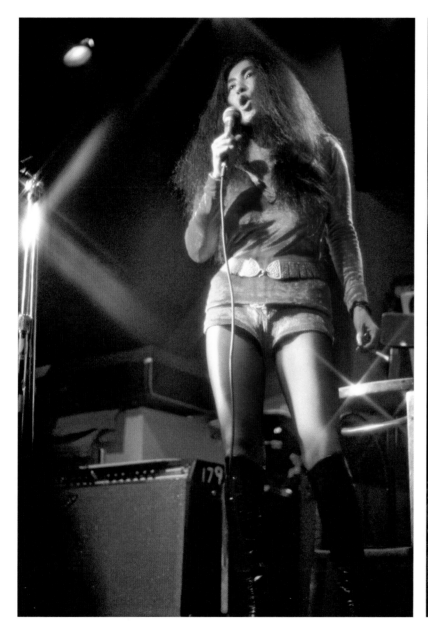

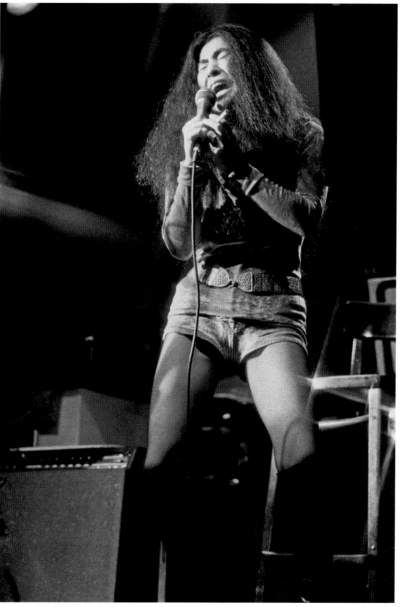

"I was not doing things that are experimental and new for the sake of being new. I was trying to express a certain emotion."

OPPOSITE (L-R) Warren Daniels, Gordon Edwards, Rick Marotta, Yoko Ono, Kenny Ascher, and David Spinozza during a series of shows at Kenny's Castaways, New York City, October 1973.

FOLLOWING SPREAD Yoko Ono arriving for her tour of Japan, August 1974.

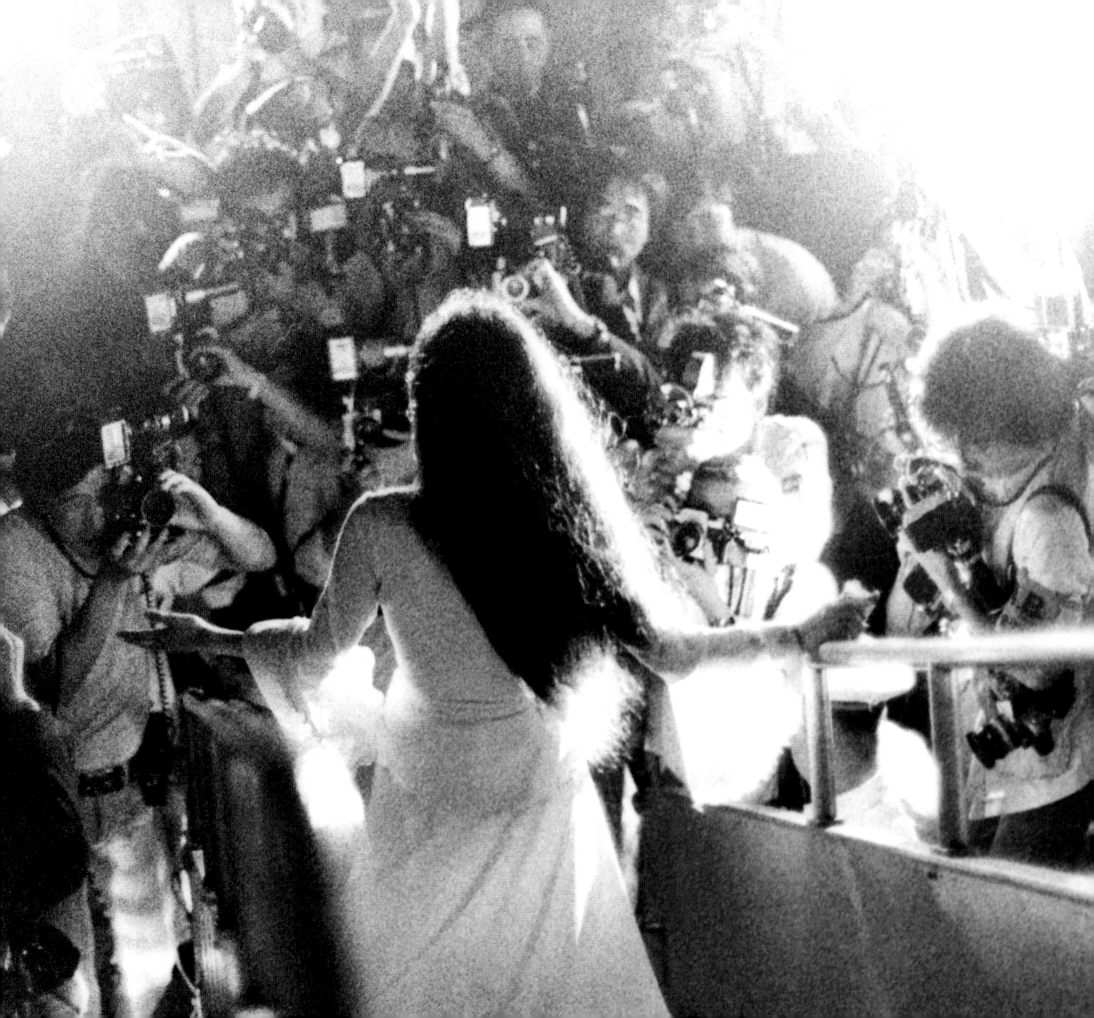

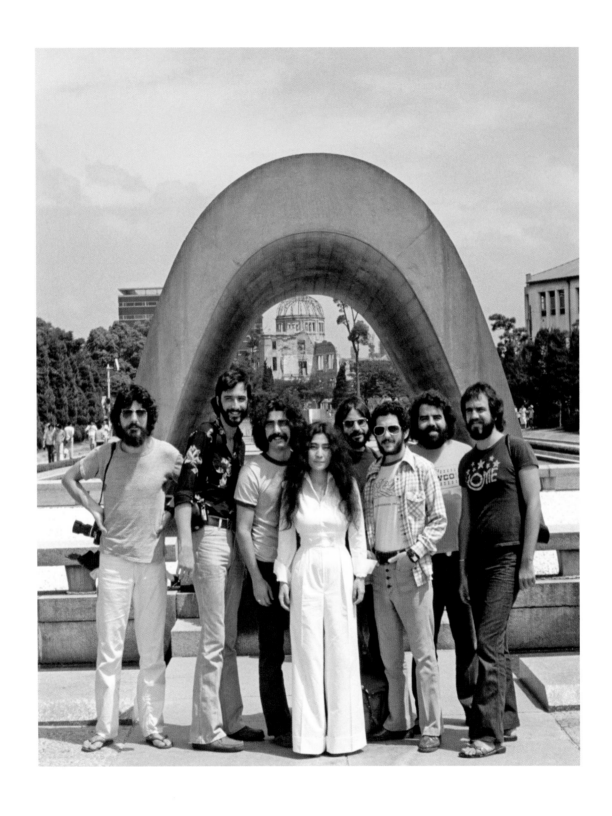

(L–R) Rick Marotta, Michael Brecker, Steve Kahn, Yoko Ono, Andy Muson,
Steve Gadd, Don Grolnick, and Randy Brecker in front of the Peace Arch in
Hiroshima, Japan, August 1974.

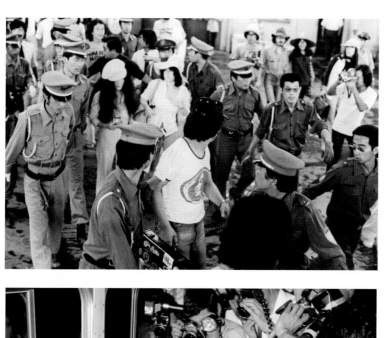

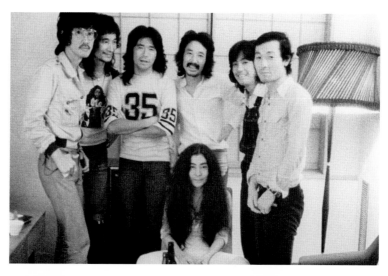

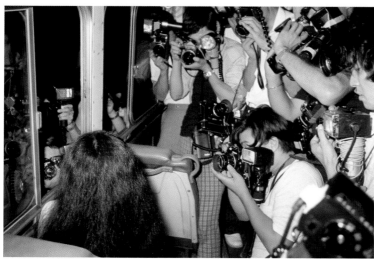

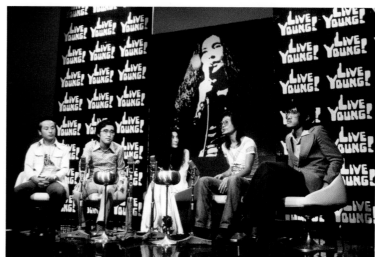

LEFT TOP AND BOTTOM Yoko Ono traveling in Japan, August 1974.

RIGHT TOP AND BOTTOM Yoko Ono, Yuya Uchinda, and Kei Ishizaka during the *Live Young* television show taping in Japan, August 1974.

FOLLOWING SPREAD Yoko Ono onstage in Japan, August 1974.

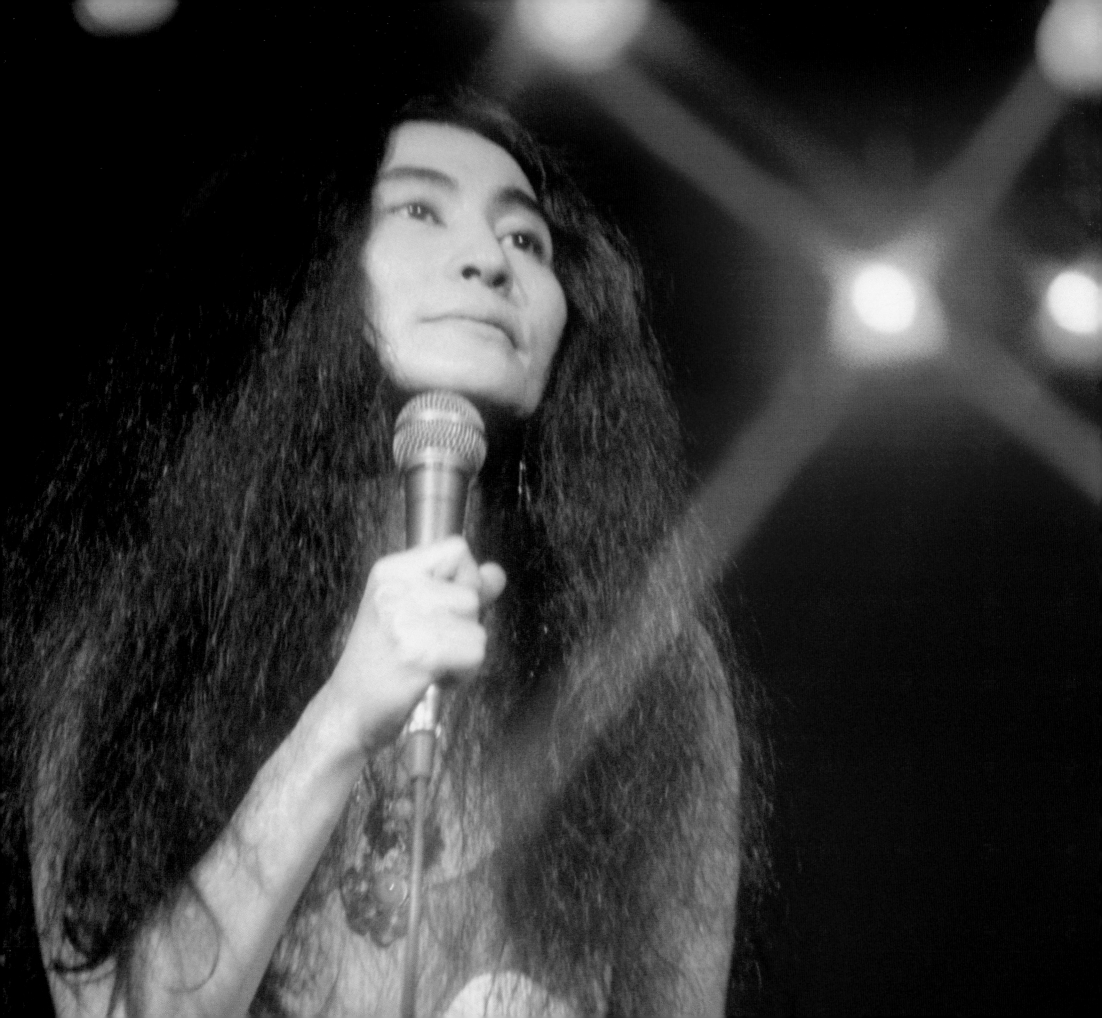

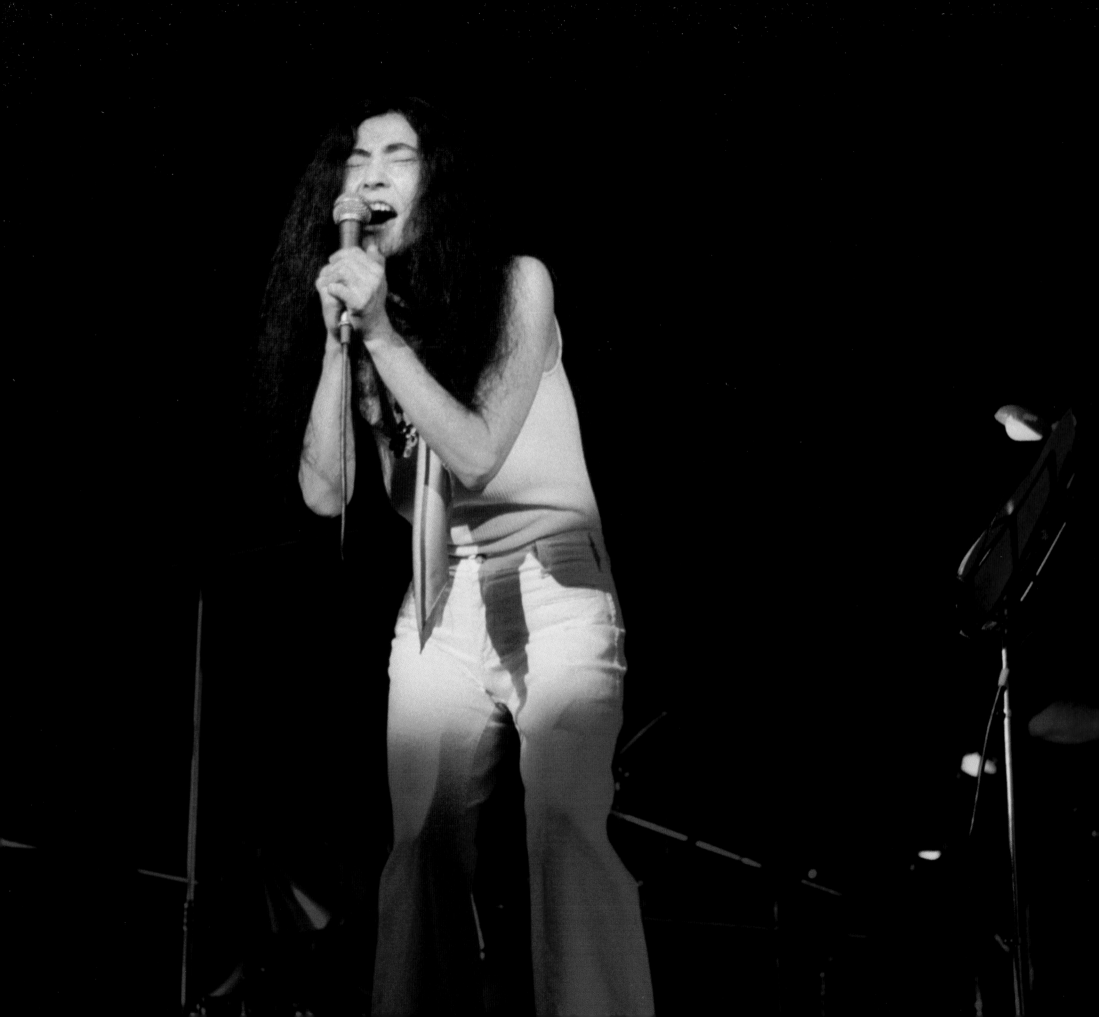

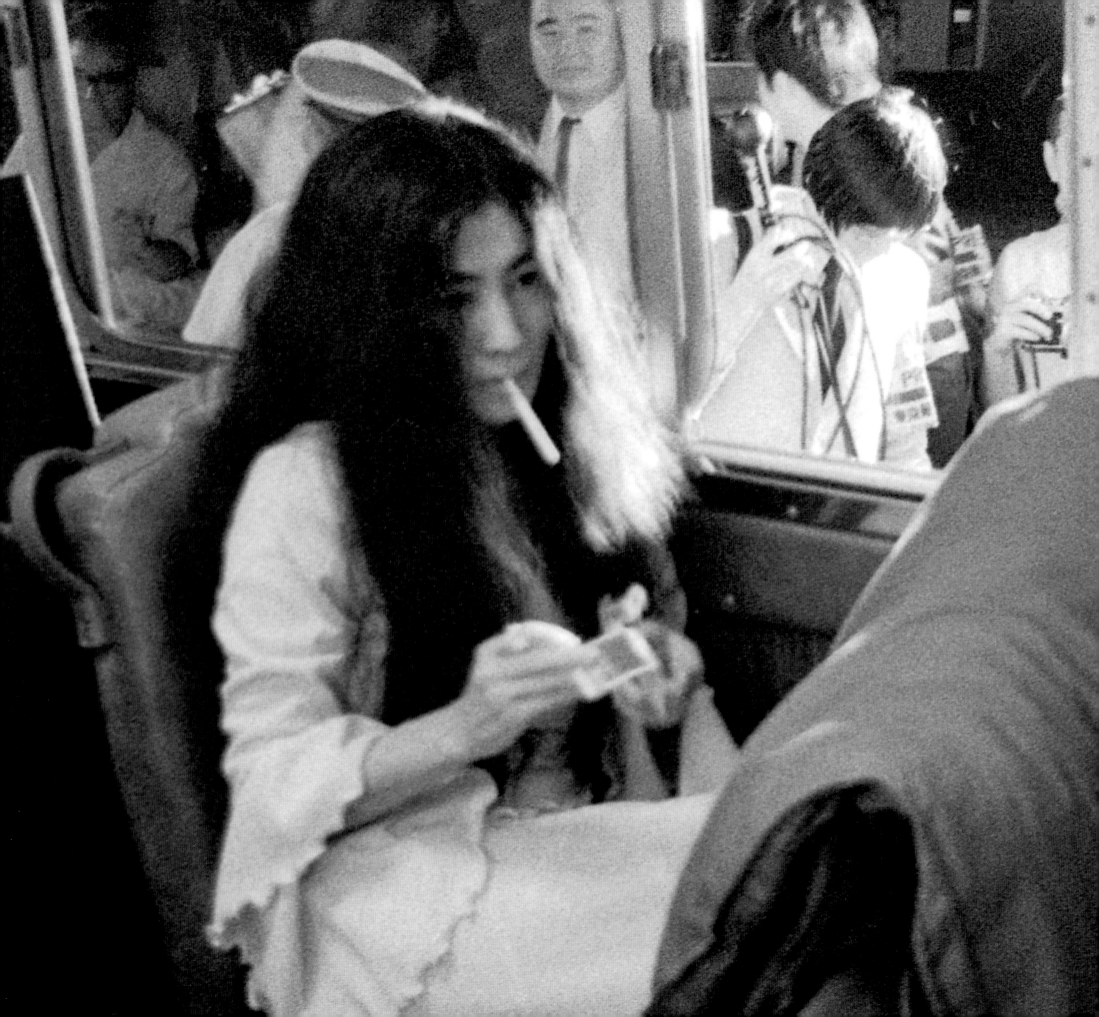

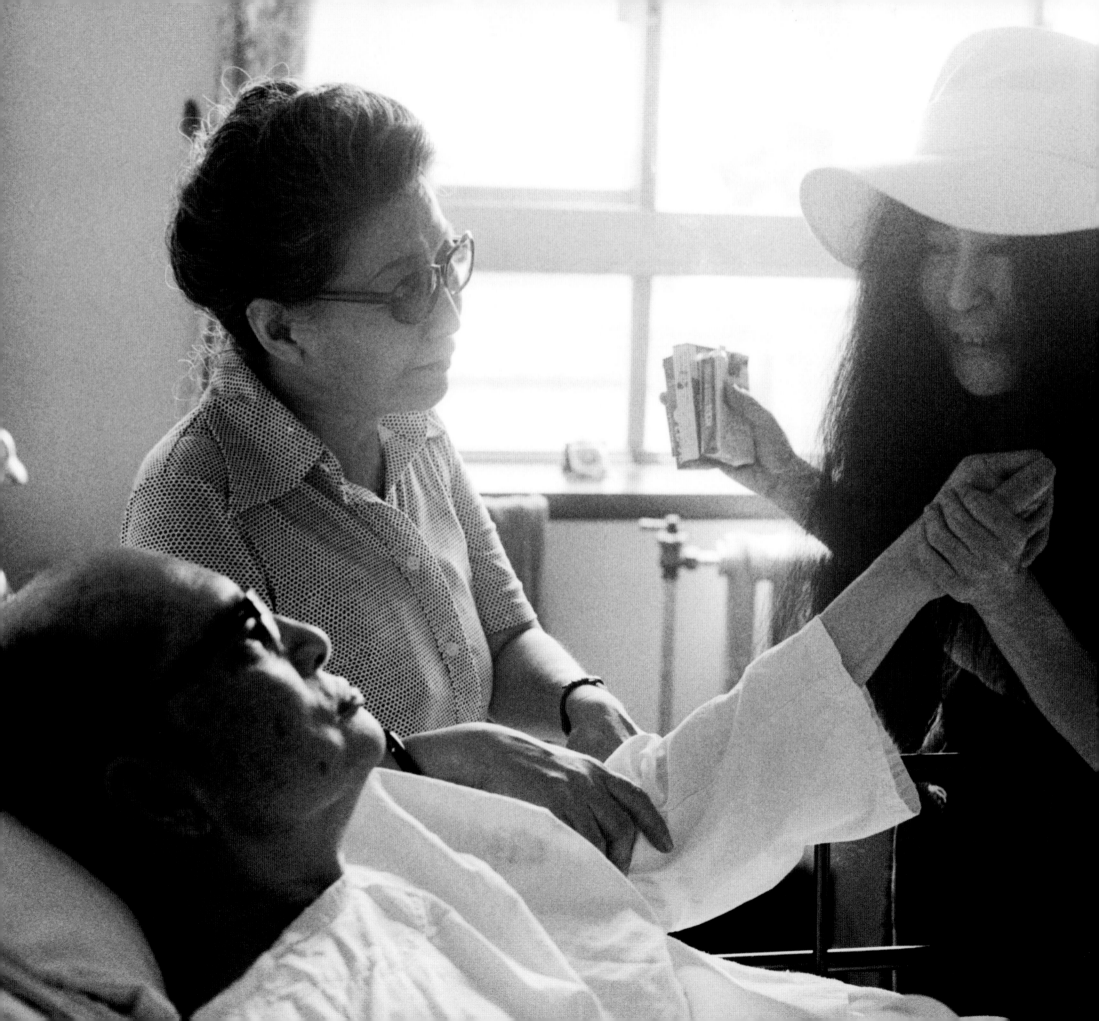

PREVIOUS SPREAD Yoko Ono on a train, Japan, August 1974.

LEFT Yoko Ono visiting with her parents at the hospital in Tokyo, Japan, August 1974.

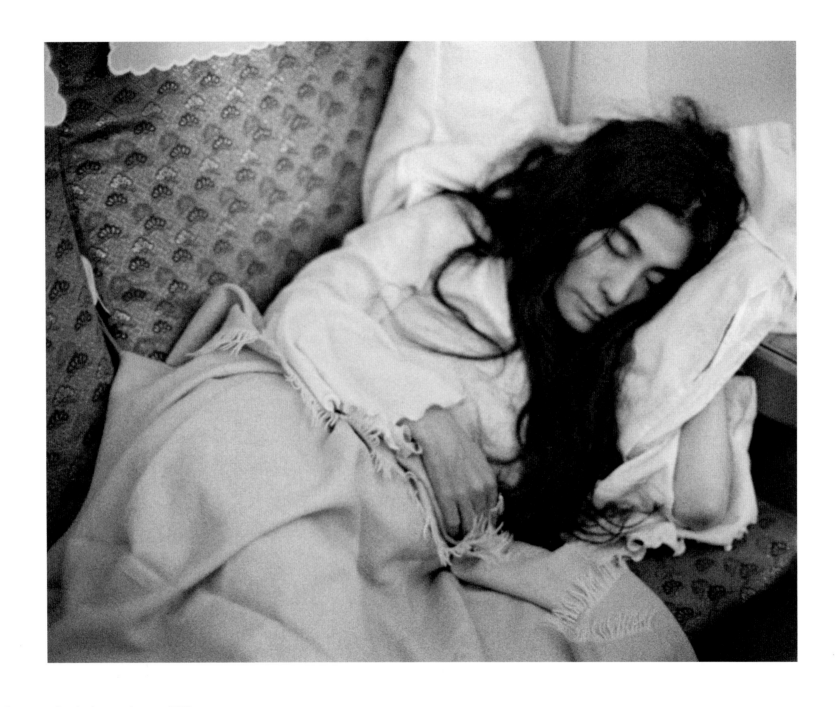

Yoko Ono traveling in Japan, August 1974.

FOLLOWING SPREAD Yoko Ono onstage in Japan, August 1974.

"I want to keep creating things
and that's who I am."

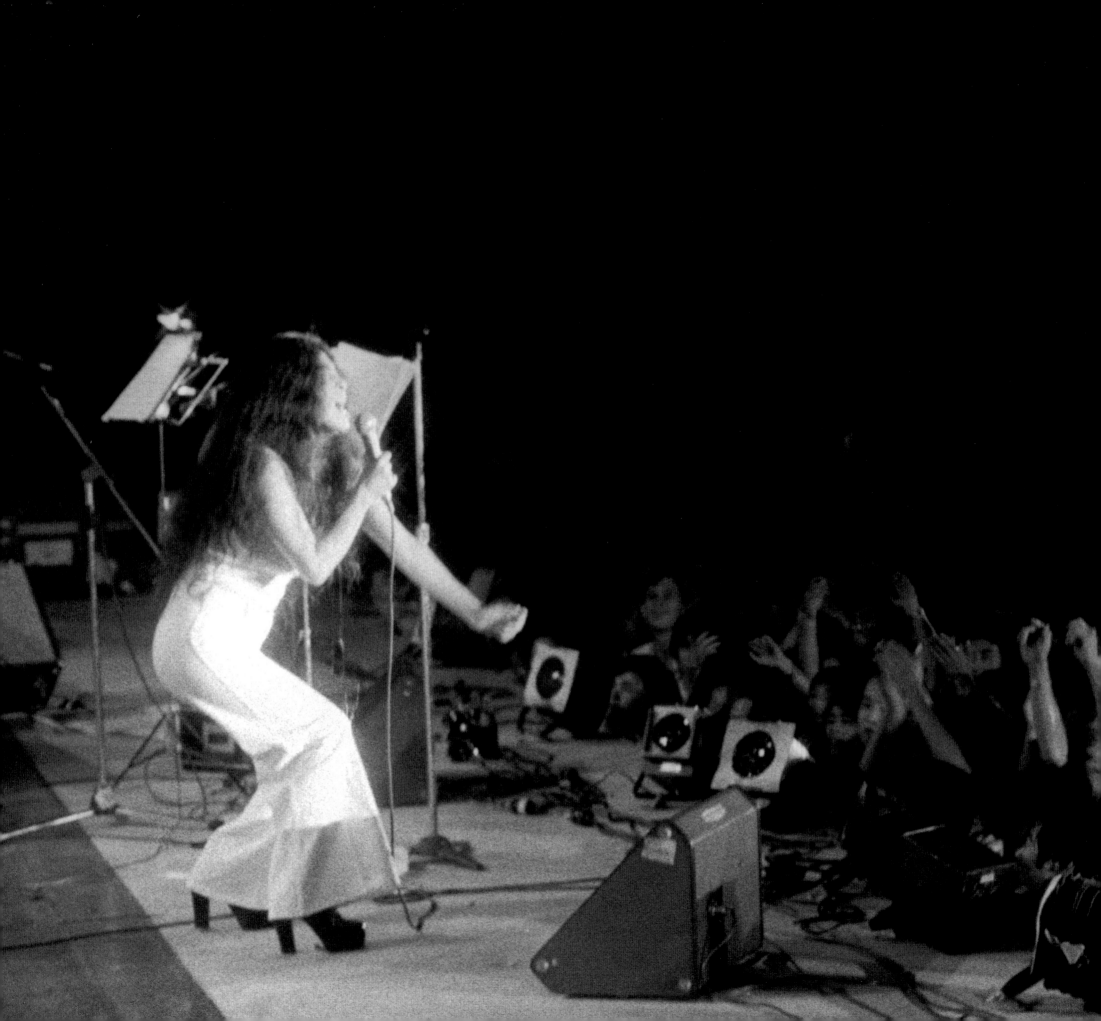

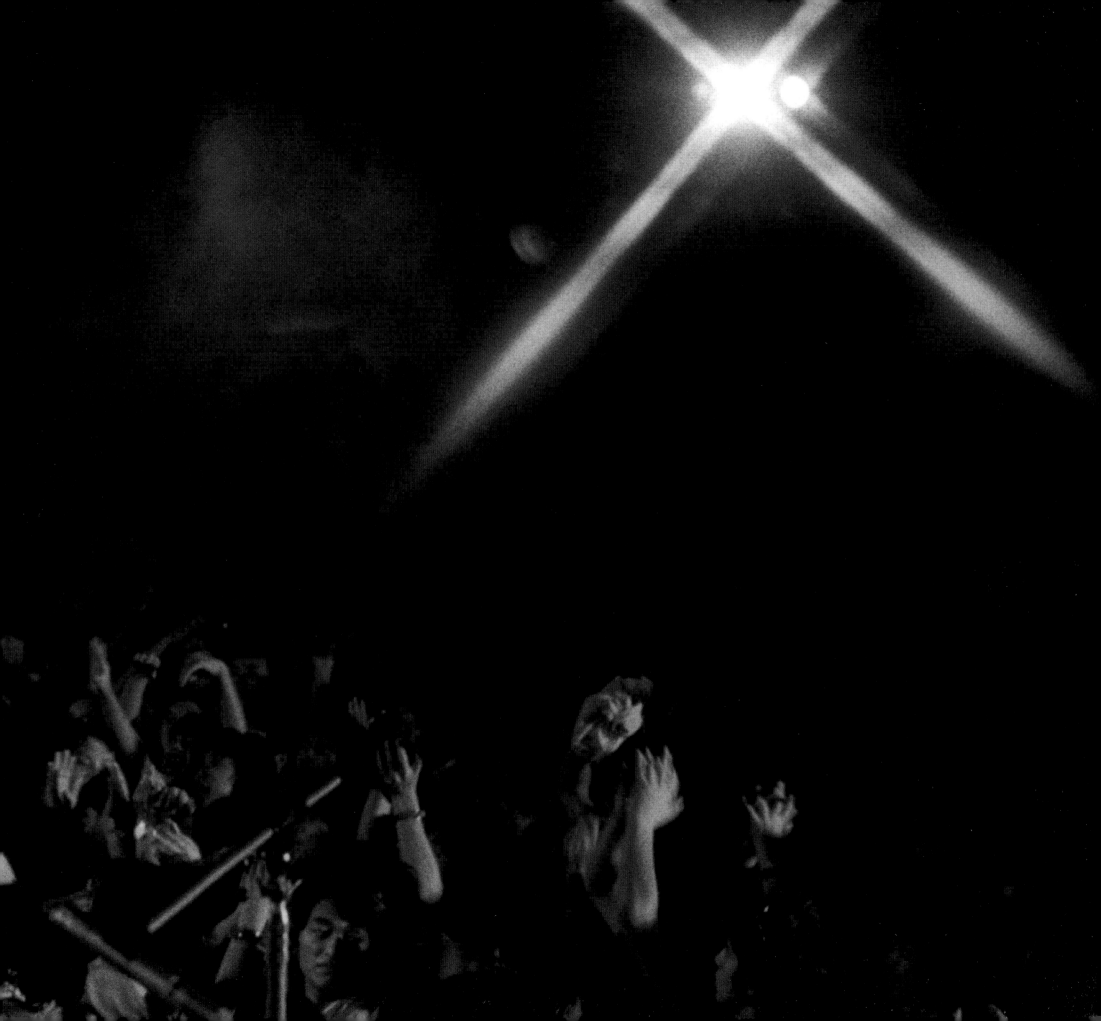

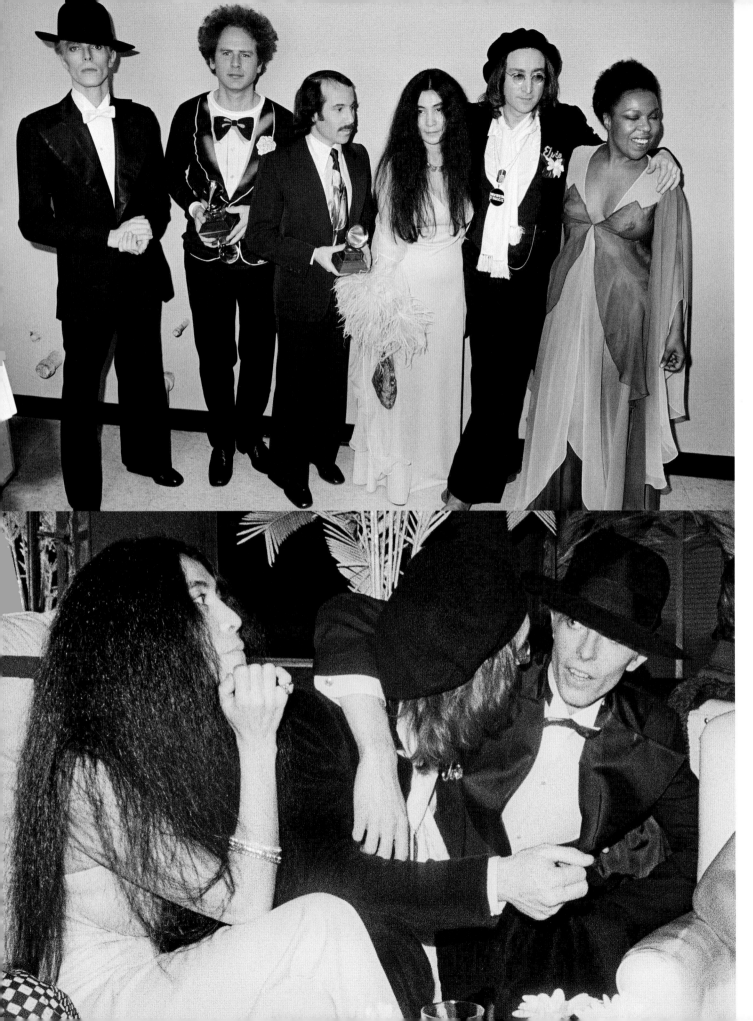

"A wife doesn't get too excited about her husband; you don't put him on a pedestal like he's God. Then you can't live. You can't breathe."

(L–R) David Bowie, Art Garfunkel, Paul Simon, Yoko Ono, John Lennon, and Roberta Flack after the Grammy Awards, New York City, March 1, 1975.

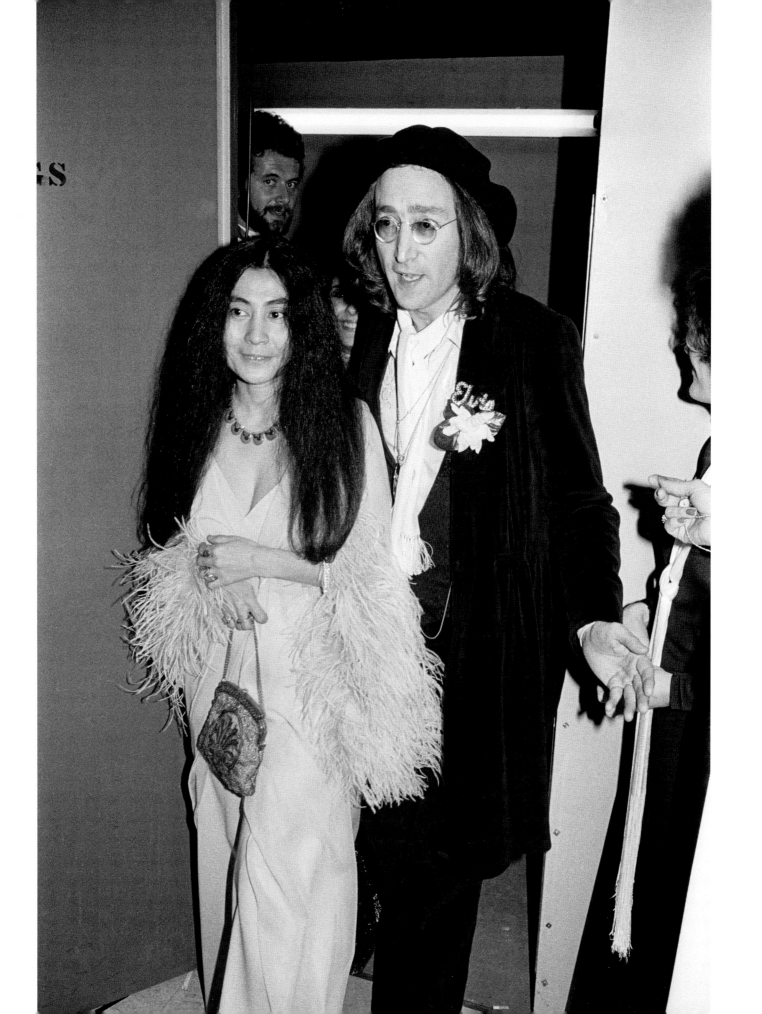

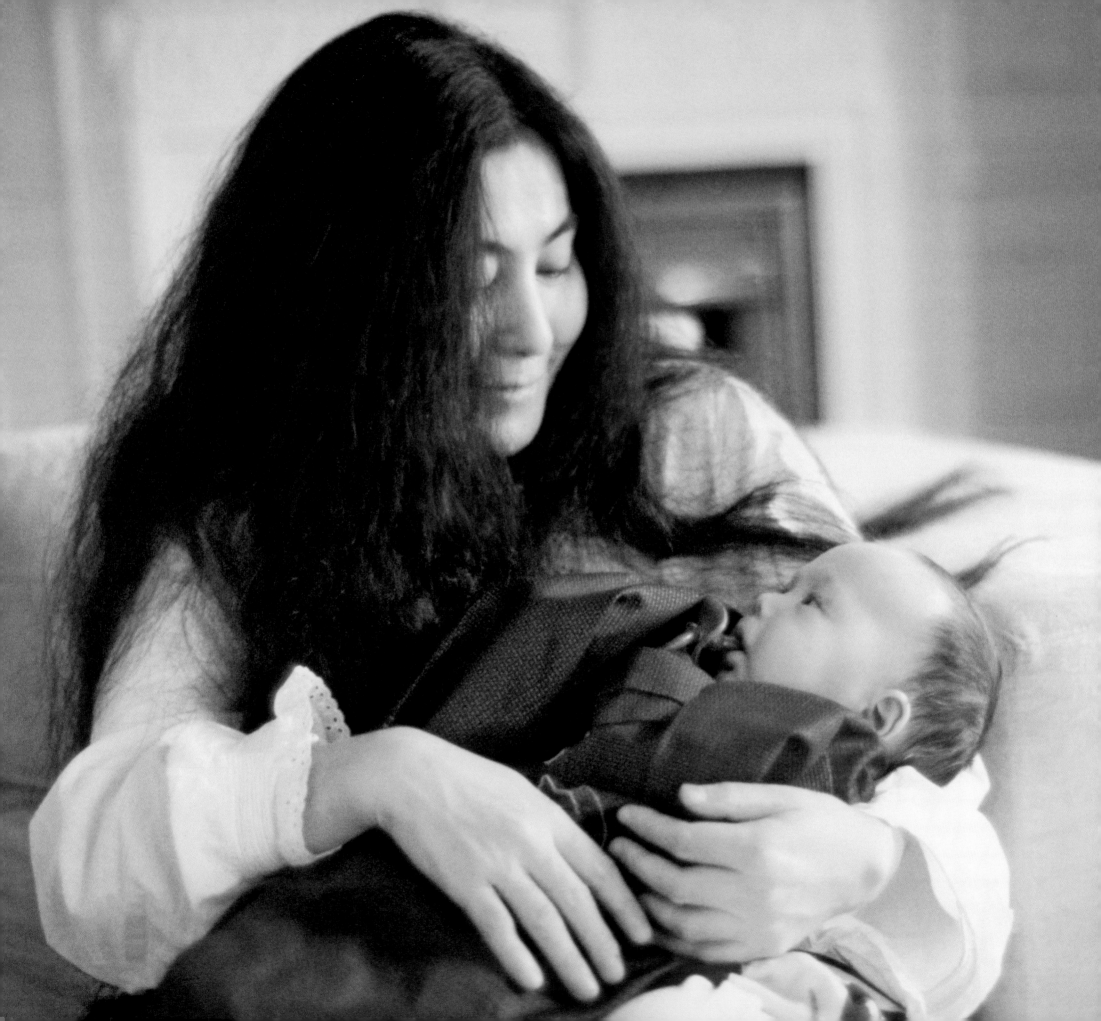

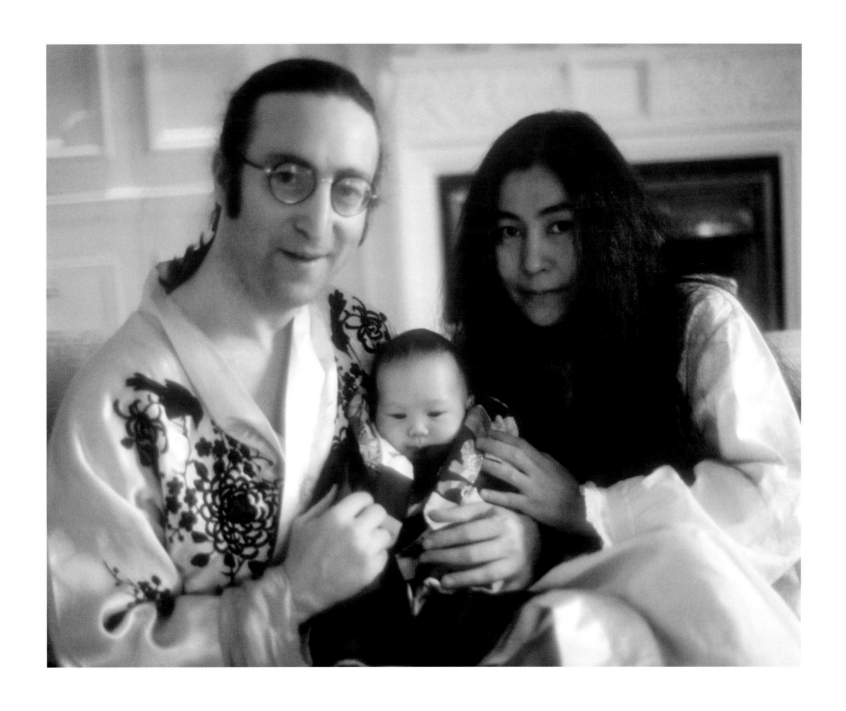

John Lennon, Sean Lennon, and Yoko Ono at the Dakota, New York City, December 12, 1975.

FOLLOWING SPREAD John Lennon, Sean Lennon, and Yoko Ono at the Dakota, New York City, December 12, 1975.

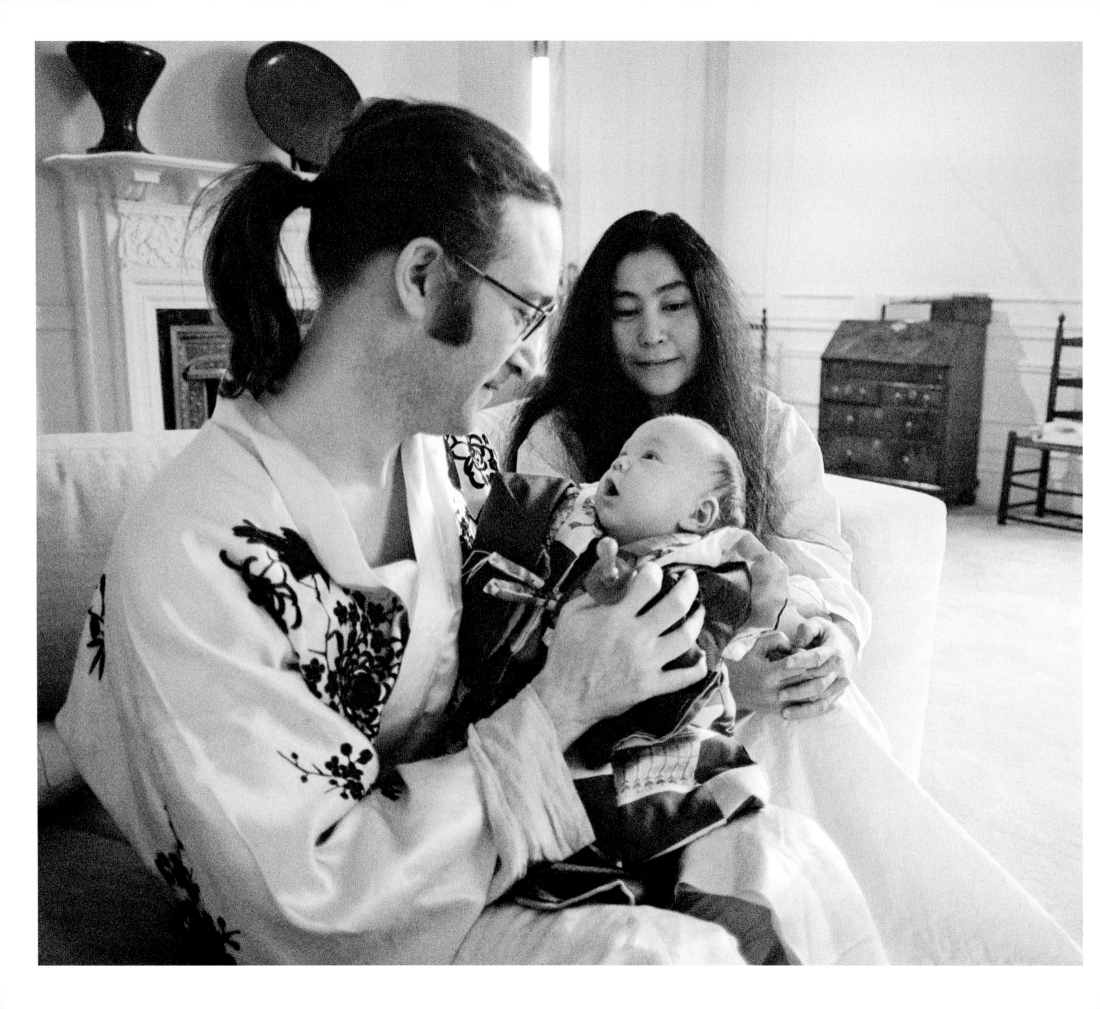

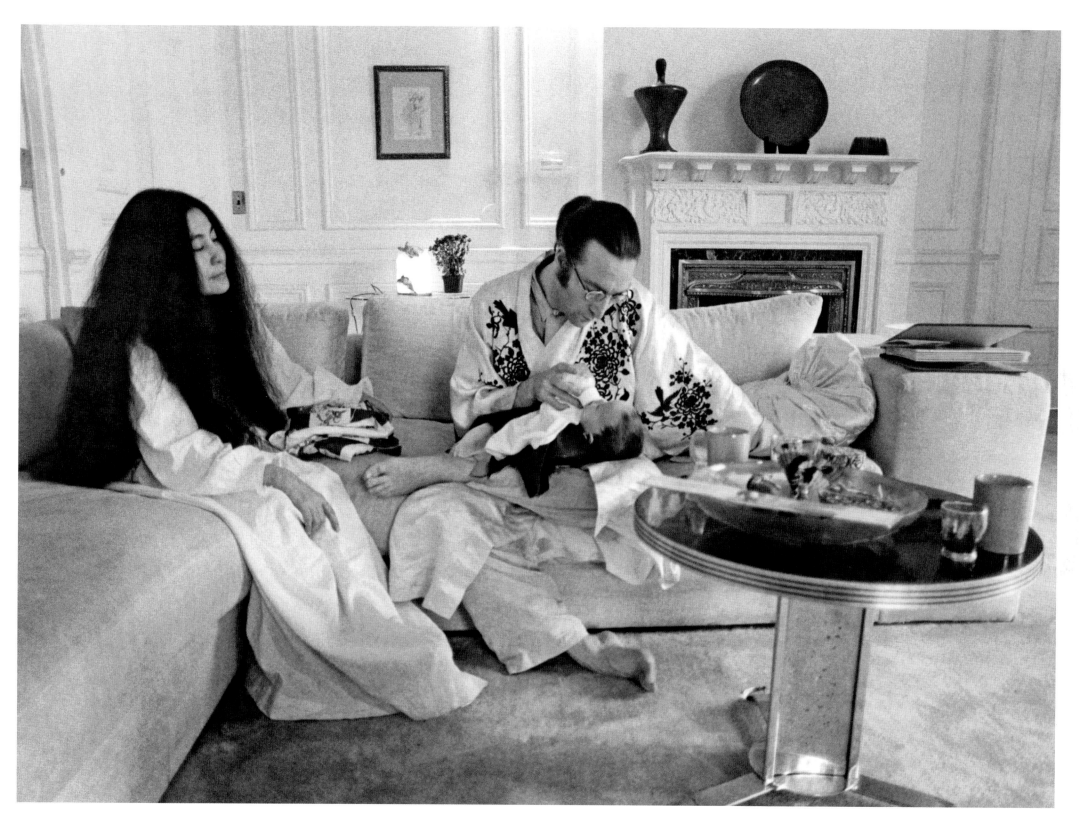

"You know, they talk about Dakota days as if it was like the lost days. But no, it wasn't. It's just that [John] wasn't going out in public and saying things or doing a concert or something like that. People just think about—in terms of what they saw. So they didn't see very much of us. So that's that."

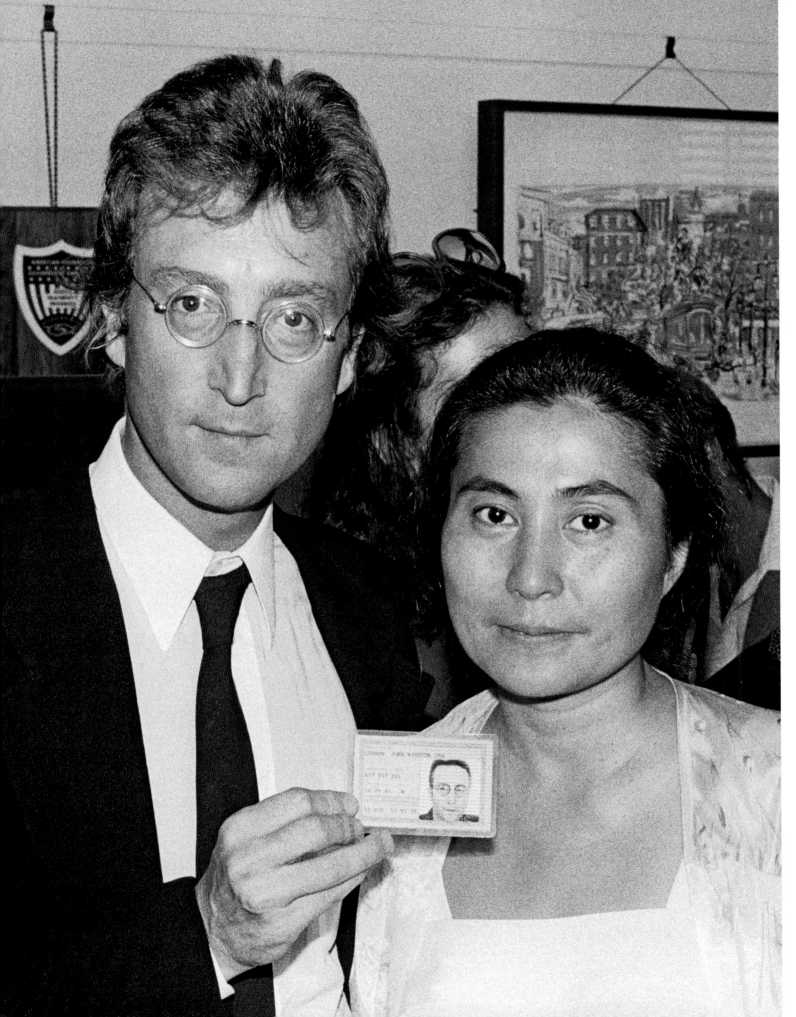

"When the United States government hit us with the immigration case, it was frightening. It was totally scary. But we felt that justice would prevail. And it took a long time, but it did. And we kept doing things while that was going on."

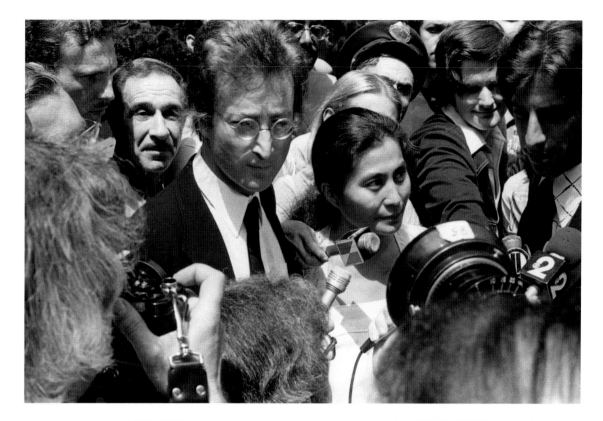

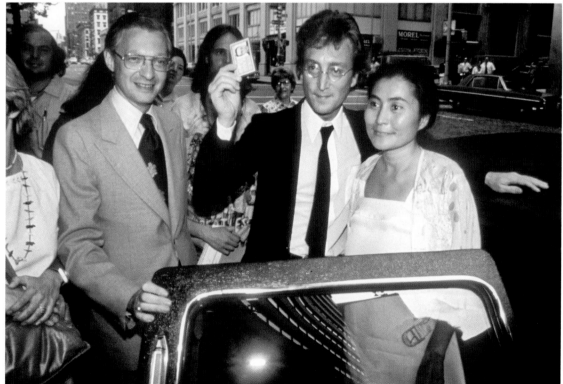

John Lennon, Yoko Ono, and their lawyer Leon Wildes after John won his immigration case to stay in the United States, New York City, July 28, 1976.

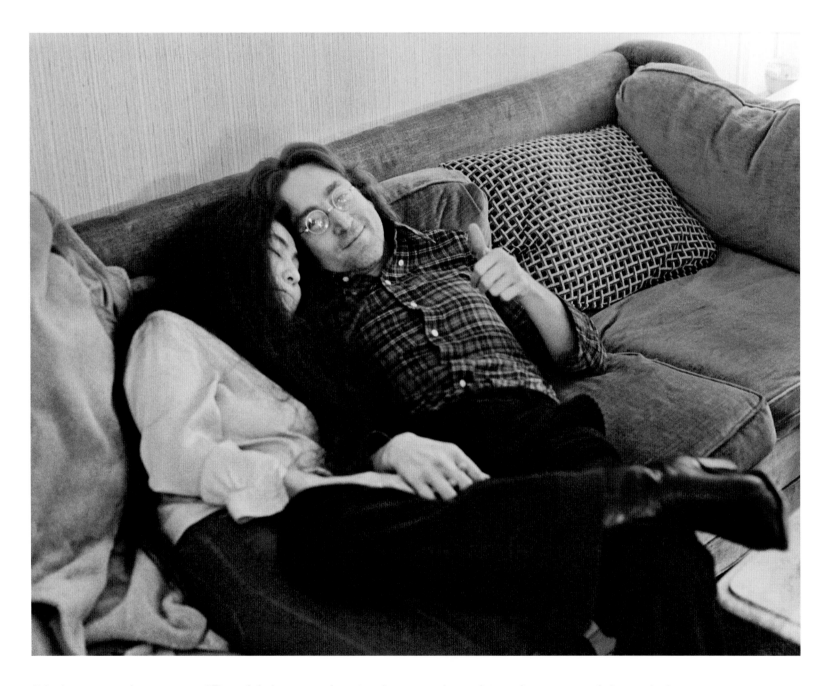

"John used to say, 'But Yoko, we're trying so hard to do everything right,
but y'know, out there there's those guys who are doing all sorts of things
and getting away with it!' Well, I didn't have the answer to that, but I was just
saying, 'Well look, until we understand why, we should keep our karma clean.'"

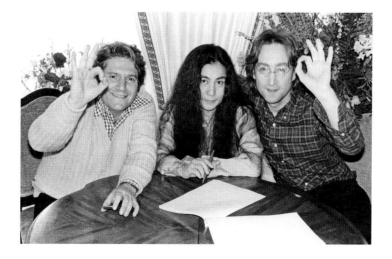

Allen Klein, John Lennon, Yoko Ono, and lawyers signing the agreement dissolving the management contract between Allen Klein and the Beatles at the Plaza Hotel, New York City, January 8, 1977.

FOLLOWING SPREAD John Lennon and Yoko Ono at the Plaza Hotel, New York City, January 8, 1977.

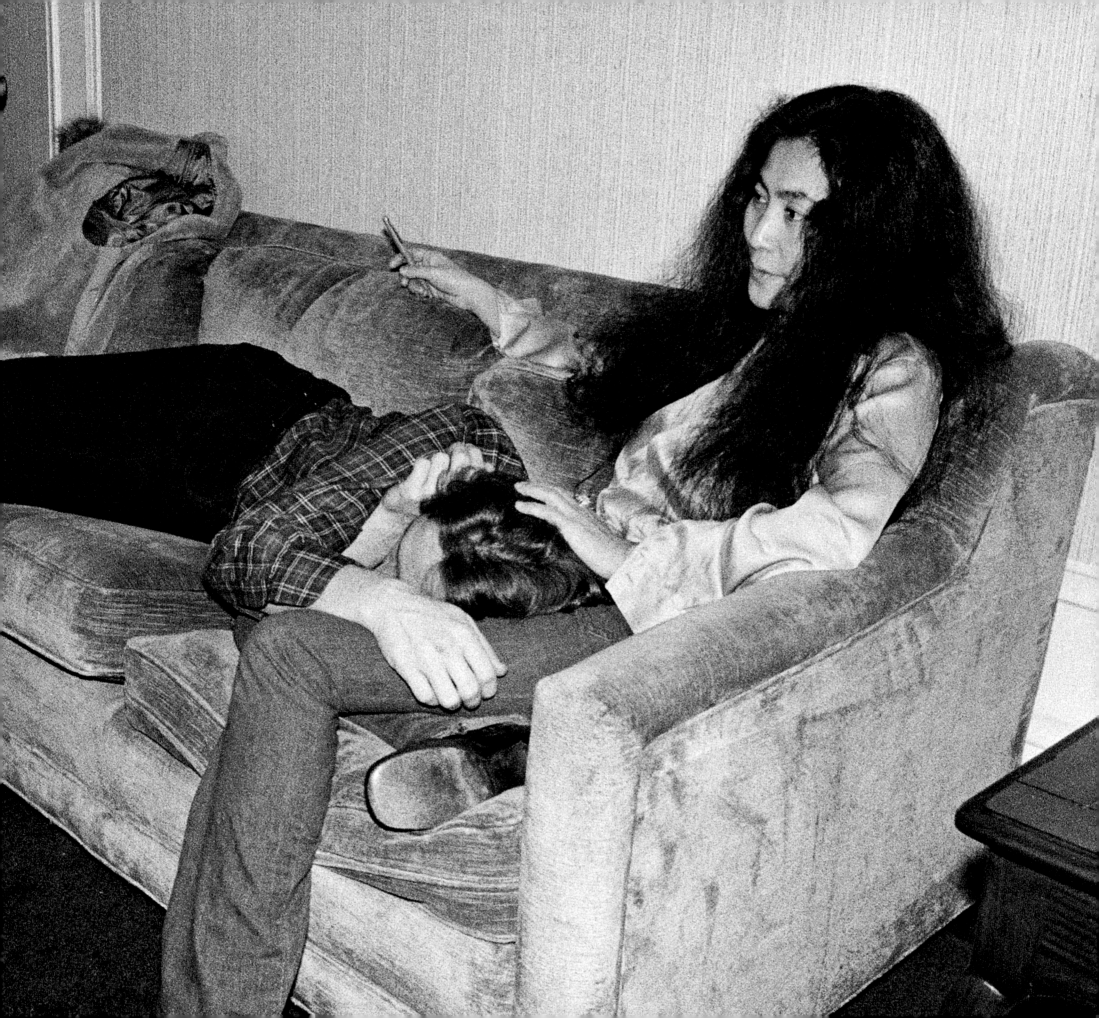

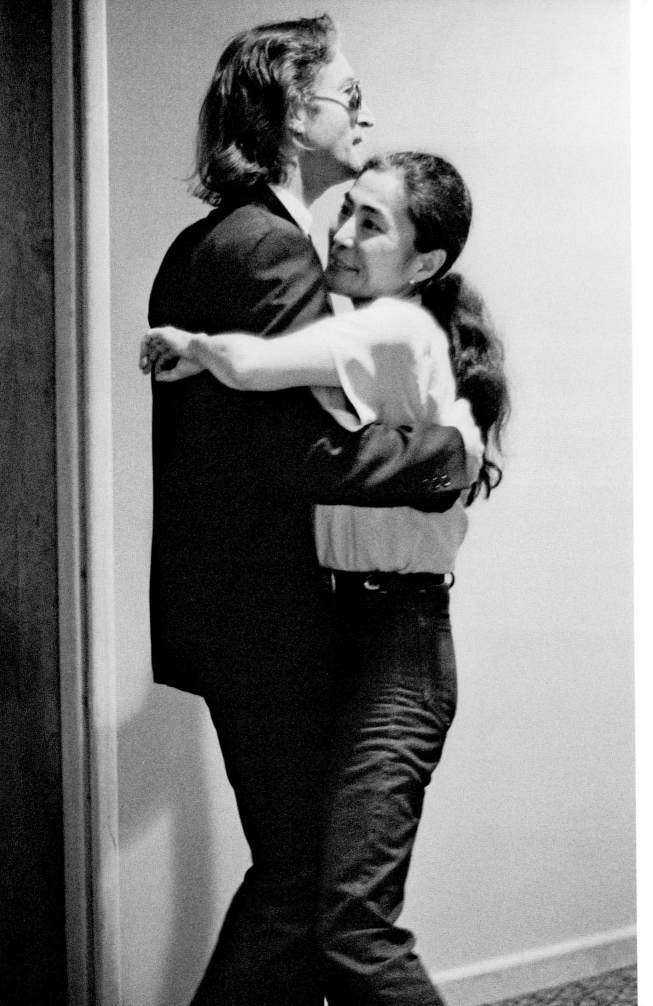

"It wasn't perfect, but whatever we did we tried to do our best. I think the reward of that was that we found within ourselves and between each other some beautiful moments. We were very happy. There were moments of incredible happiness."

John Lennon, Yoko Ono, and Sean Lennon during the recording of *Double Fantasy* at the Hit Factory, New York City, August 1980.

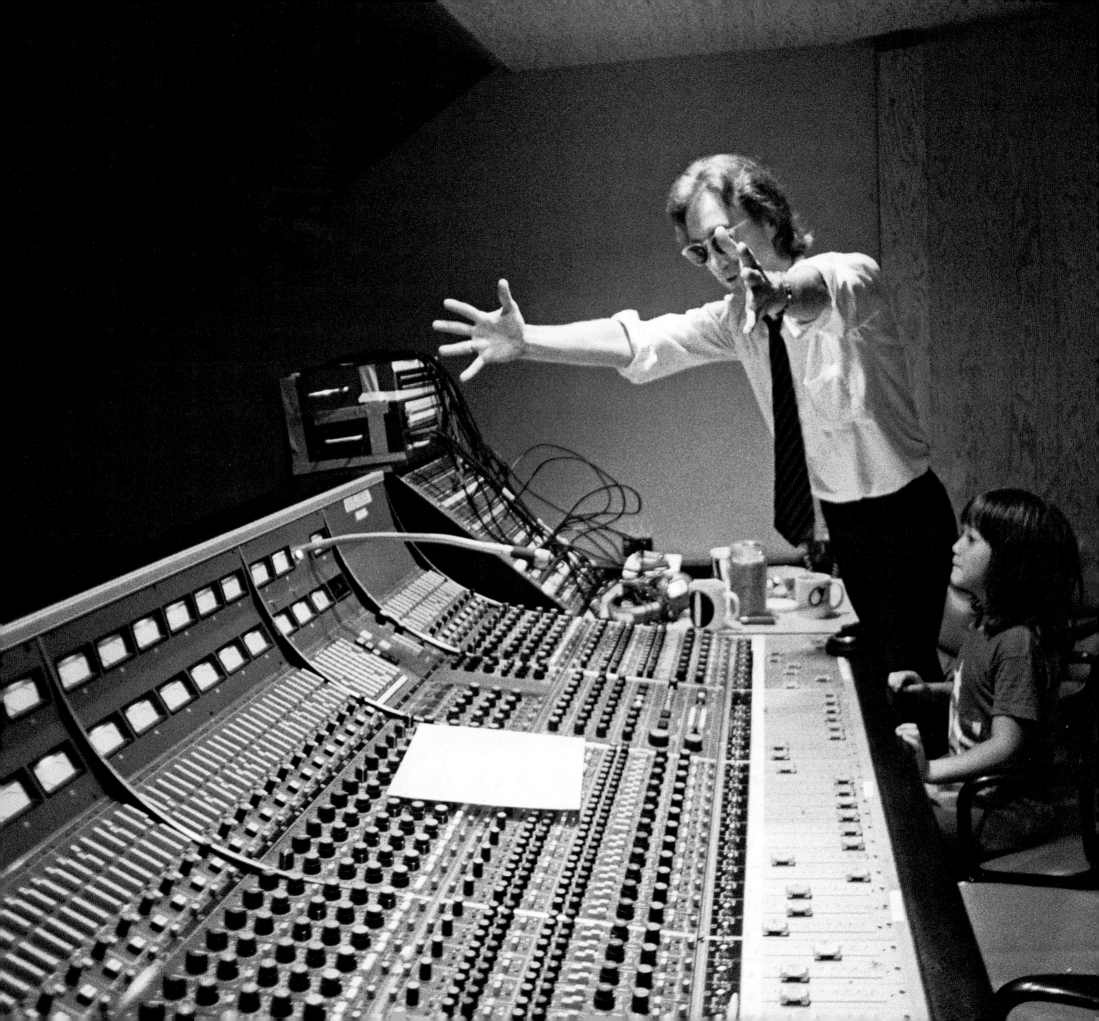

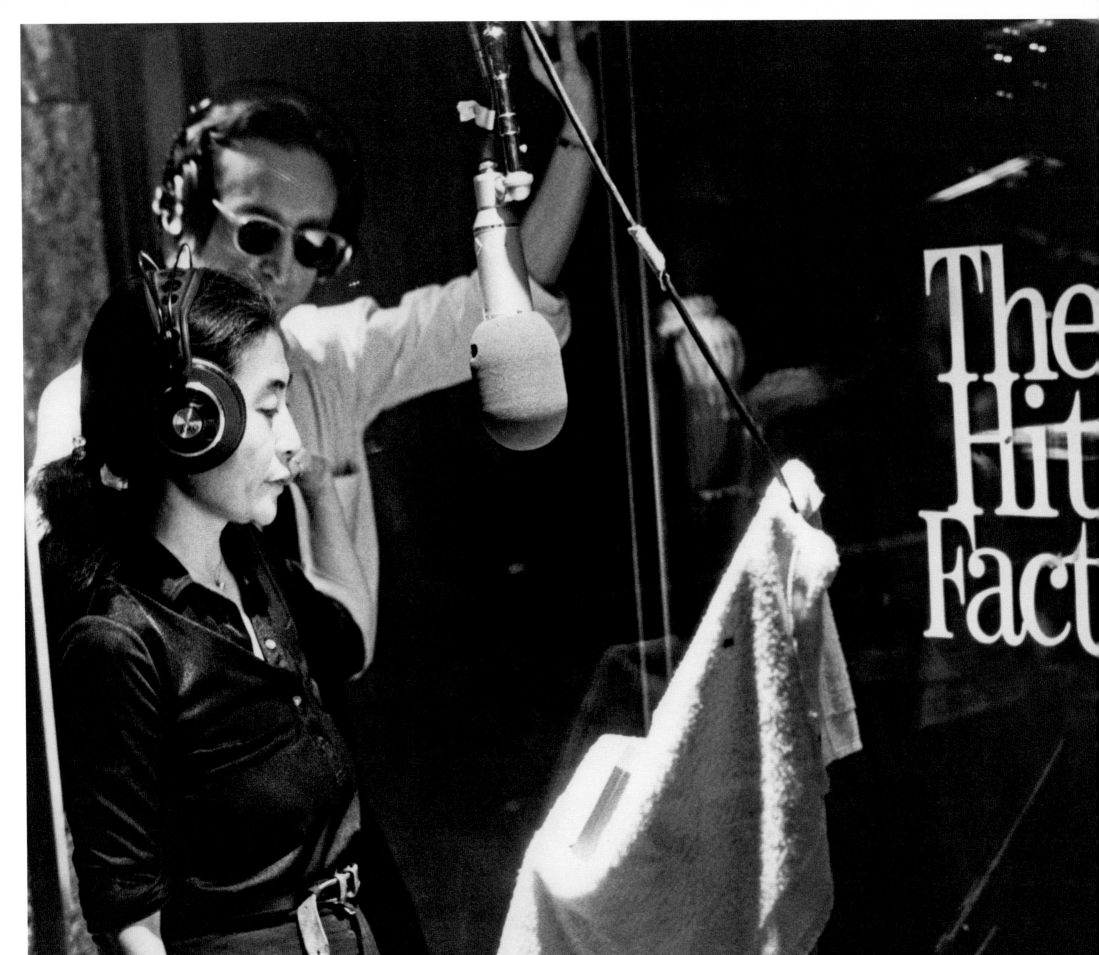

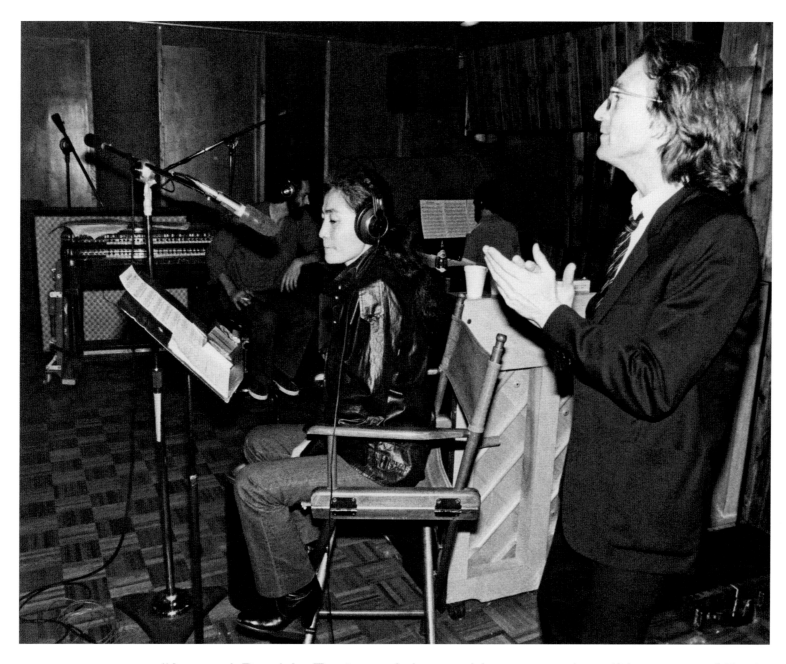

"Around *Double Fantasy*, John and I were saying, 'No more of that ten years too early stuff.' We want to communicate now. But I think *Double Fantasy* was a bit too early, maybe. I don't think people understood it so well. It took maybe six months or so."

Yoko Ono and John Lennon during the recording of *Double Fantasy* at the Hit Factory, New York City, August 1980.

FOLLOWING SPREAD Yoko Ono, John Lennon, Jack Douglas, and Toshihiro Hamaya during the recording of *Double Fantasy* at the Hit Factory, New York City, August 1980.

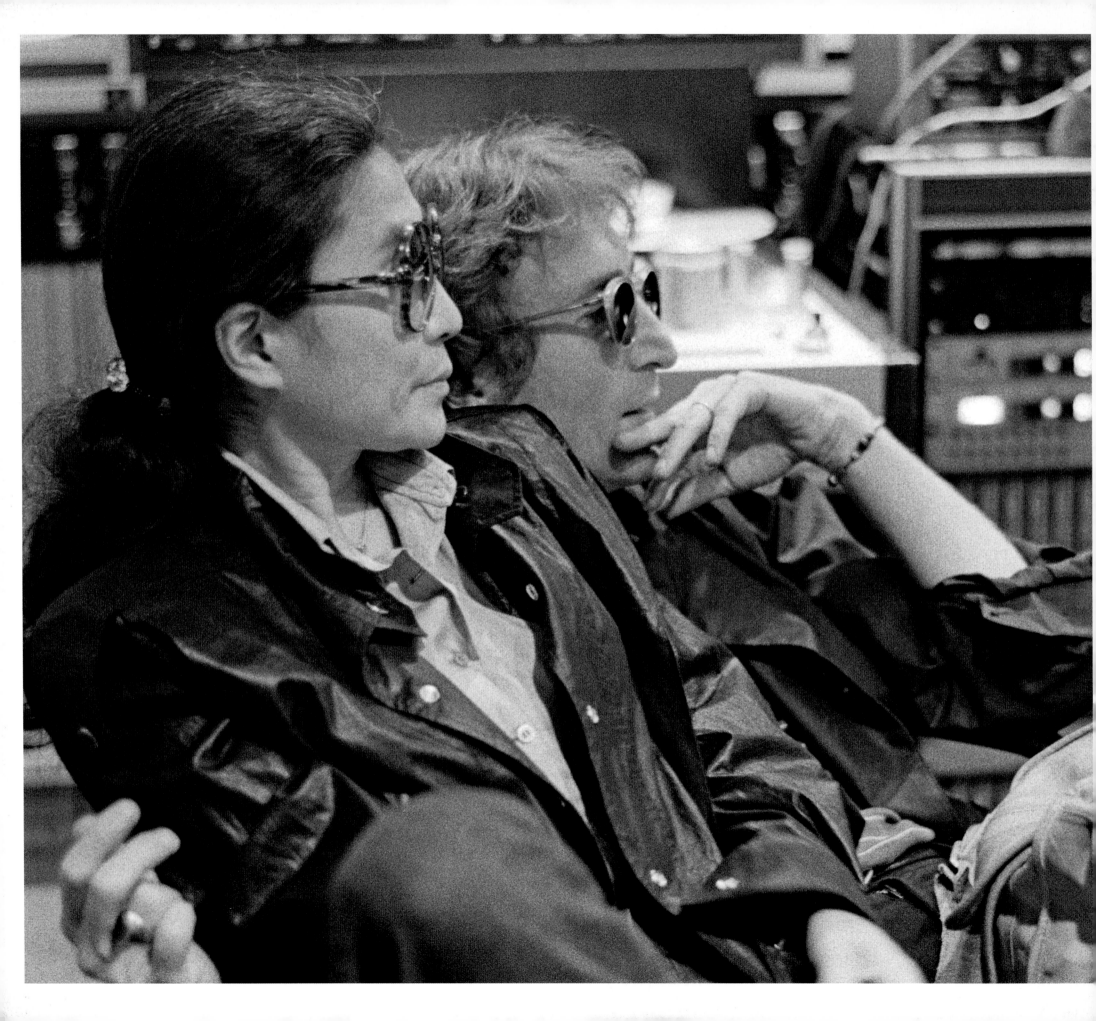

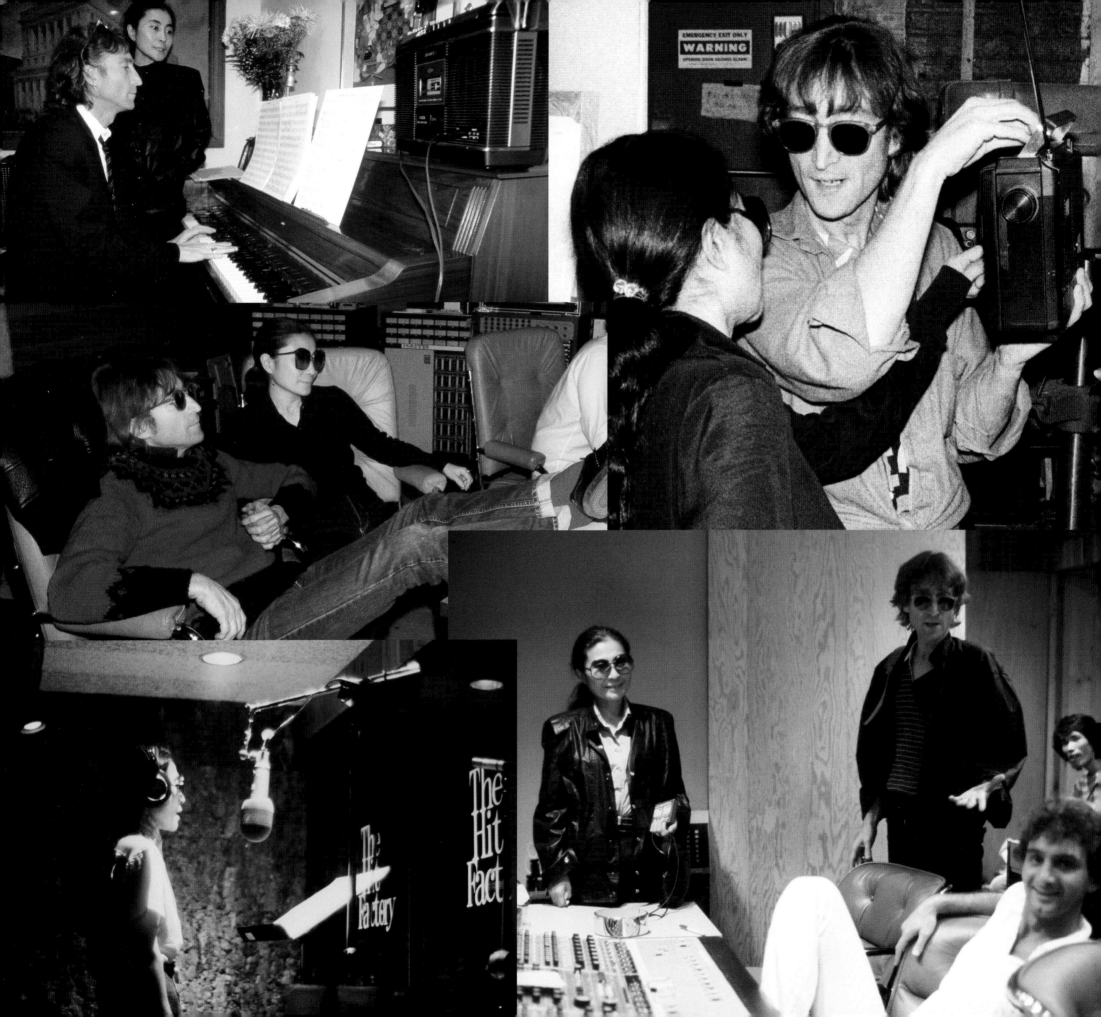

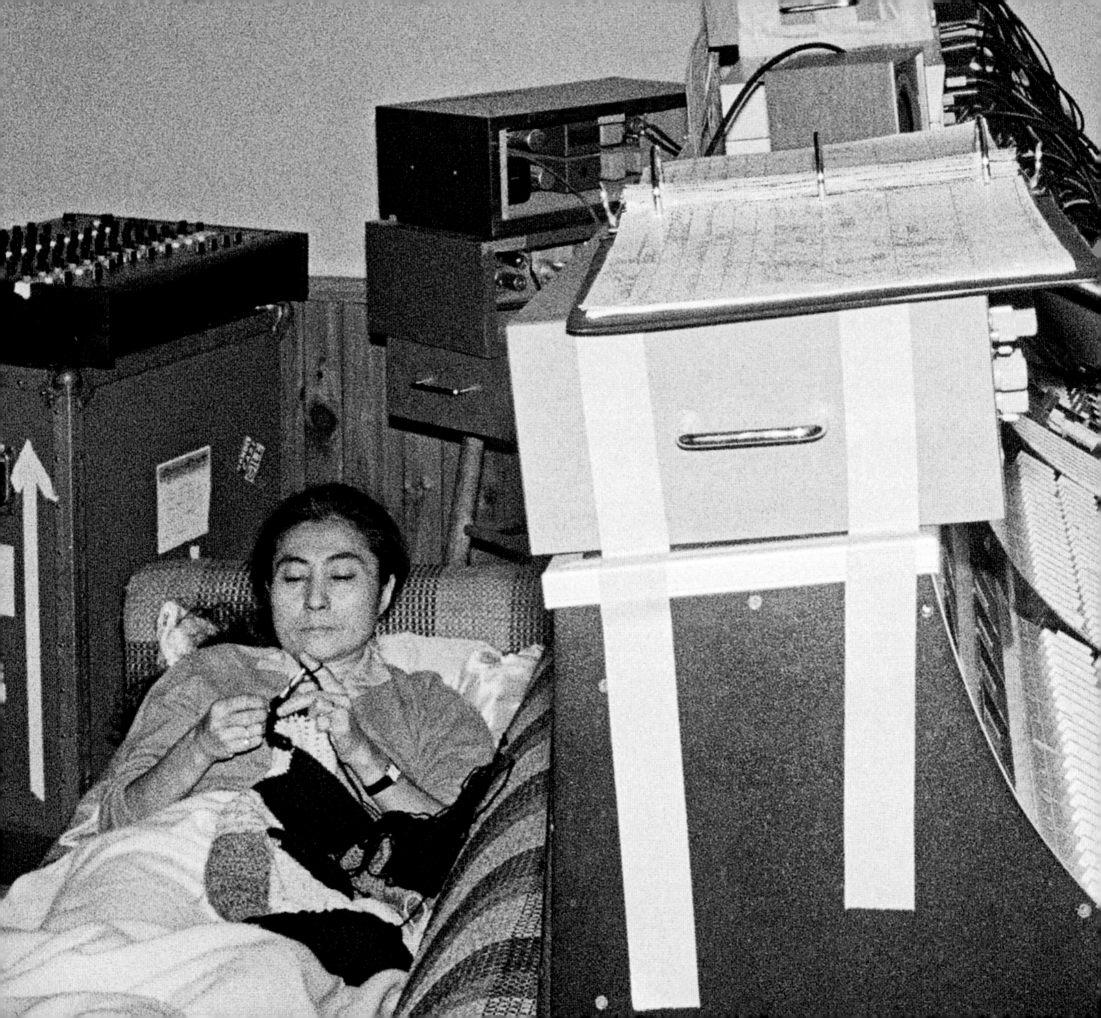

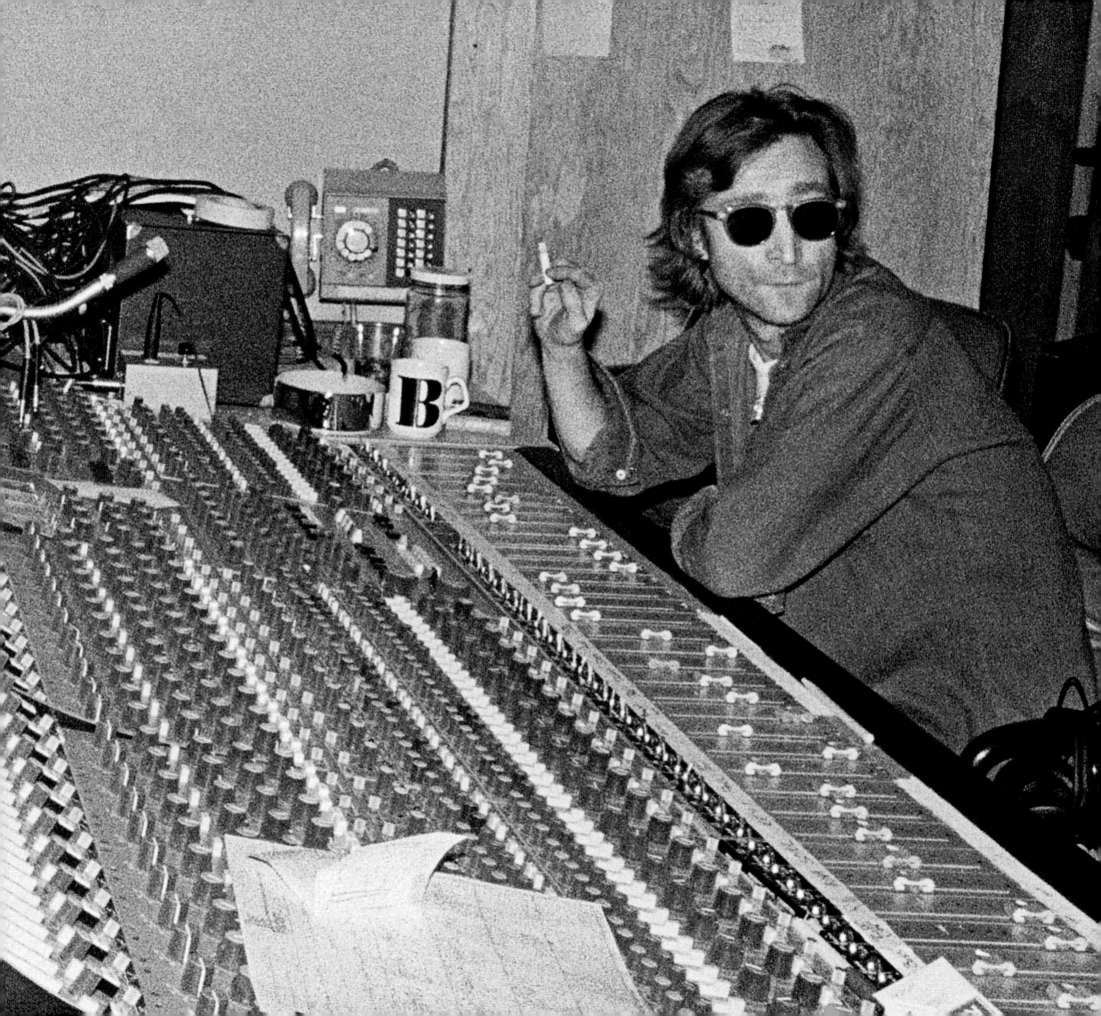

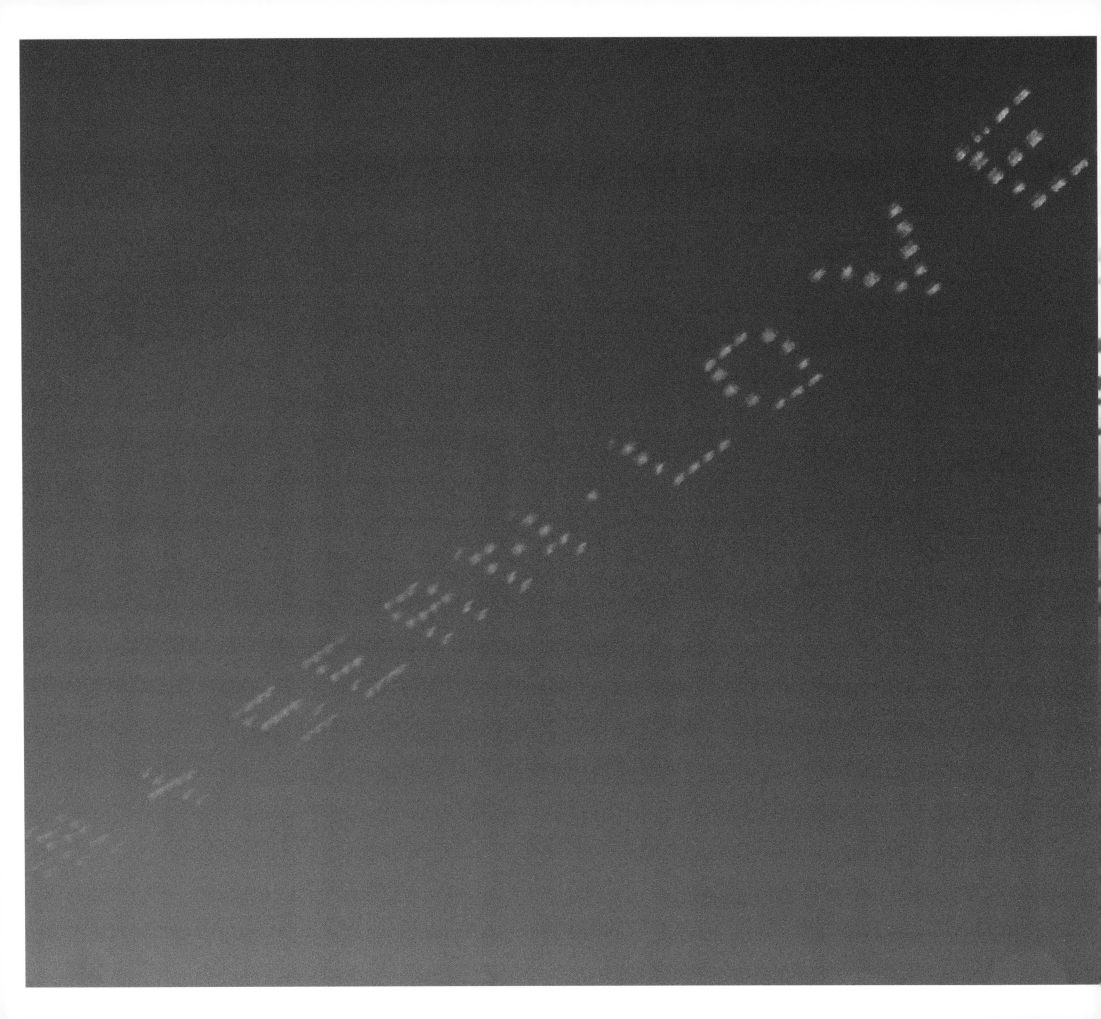

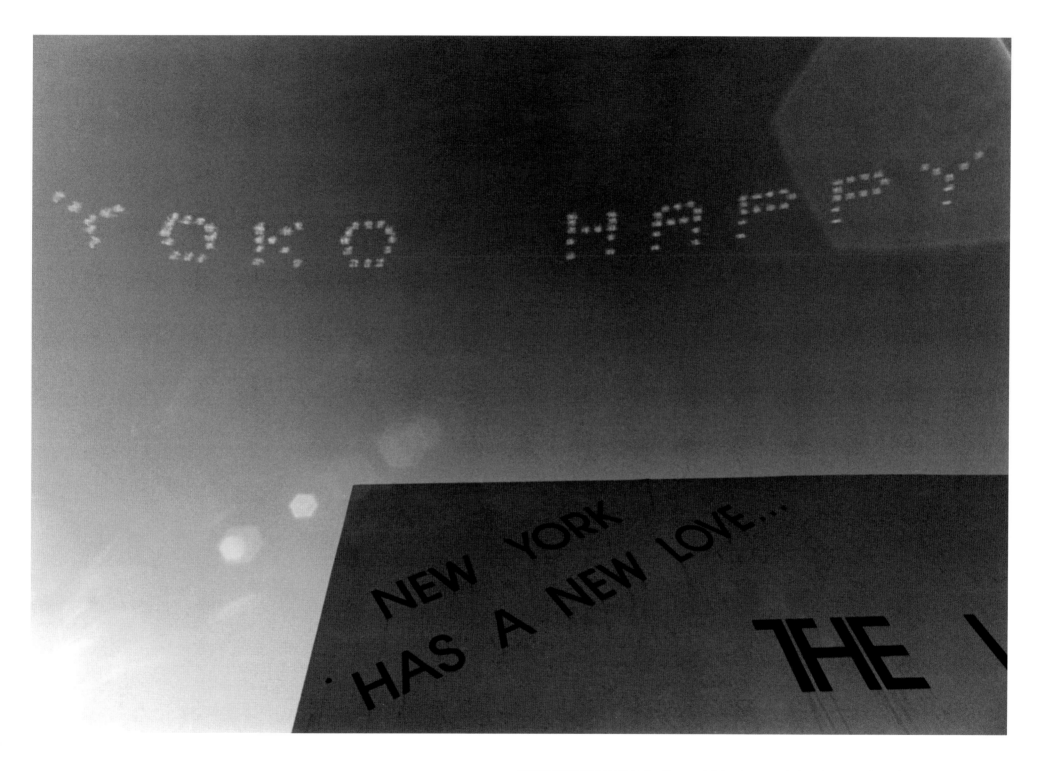

PREVIOUS SPREAD Yoko Ono and John Lennon during the recording of *Double Fantasy* at the Hit Factory, New York City, October 1980.

Skywriting for John's fortieth and Sean's fifth birthdays, arranged by Yoko Ono, New York City, October 9, 1980.

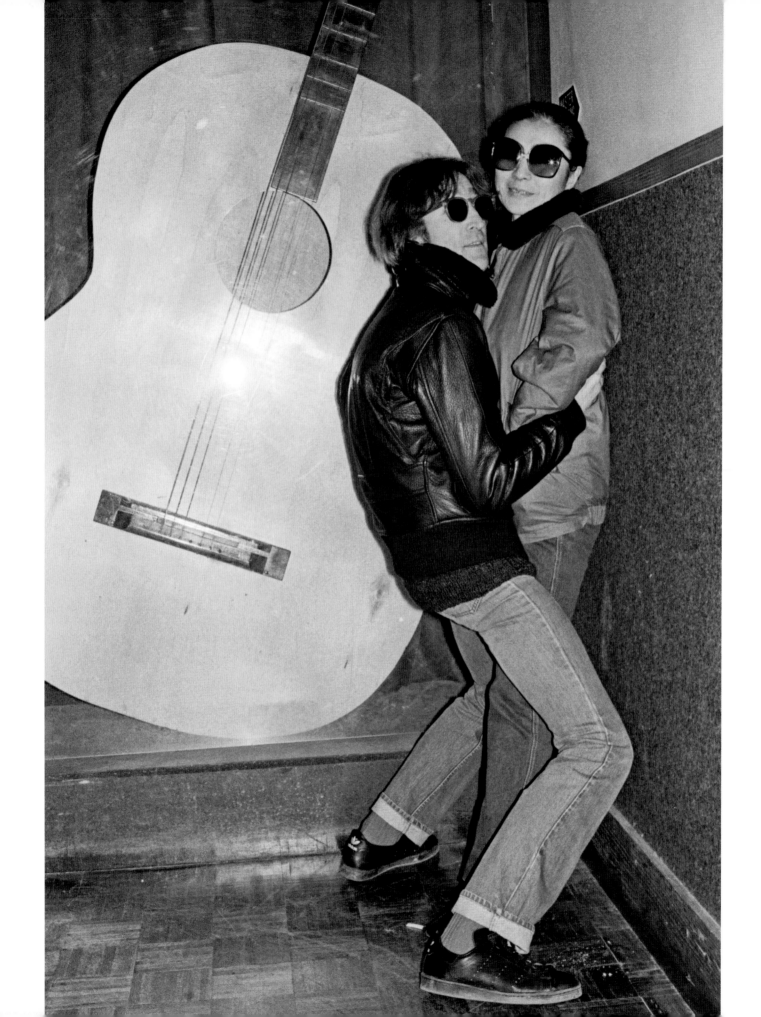

"That gigantic guitar was John's artwork. He created that. And when I did a show in Syracuse, Everton Museum, and it was my first museum show, actually, and I kind of dedicated it to John, because we did the opening on John's birthday, or something like that. And John put his work in there and said, 'Well, you know, I'm a guitarist and I'm going to do this.' And he did a huge, huge, guitar. And that was in the museum show, yeah. Exhibited."

John Lennon and Yoko Ono posing in front of John's guitar sculpture at the Record Plant, New York City, December 1980.

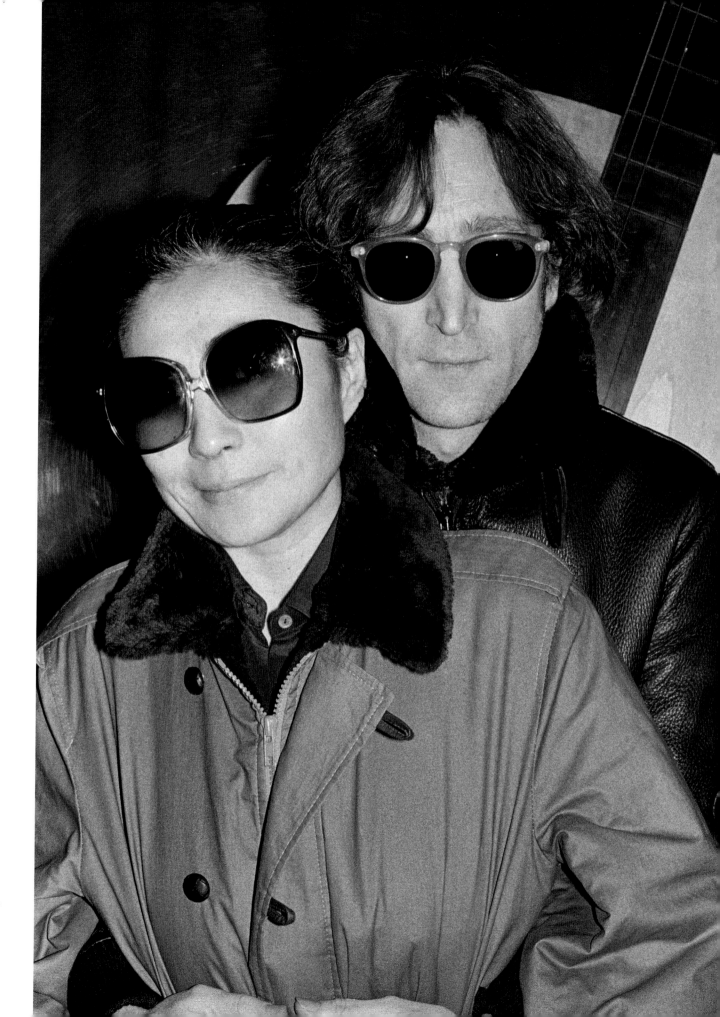

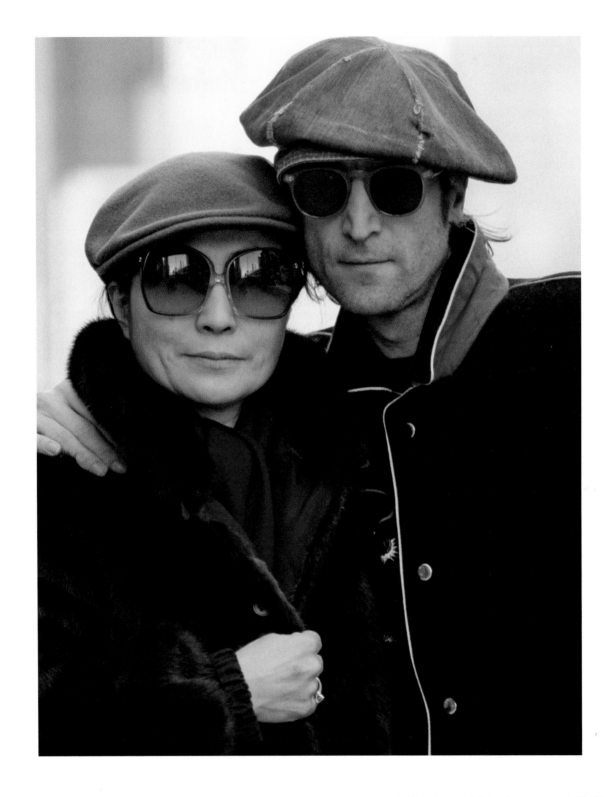

Yoko Ono and John Lennon on 44th Street after a night of recording at the Record Plant, New York City, December 1980.

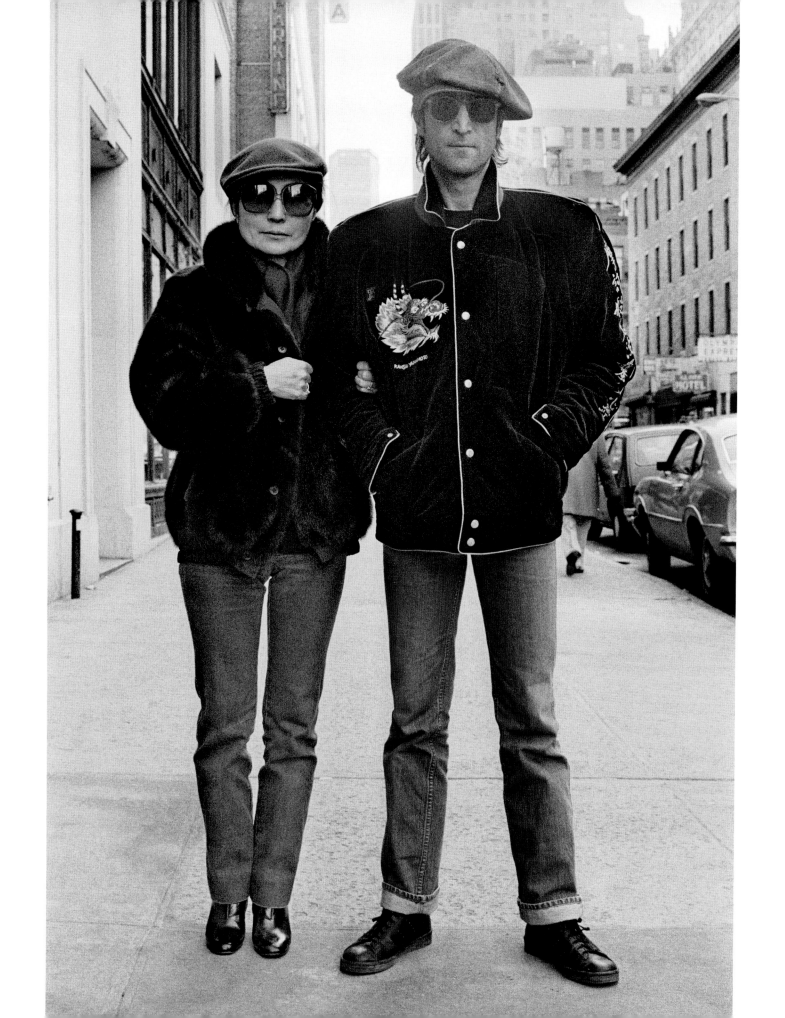

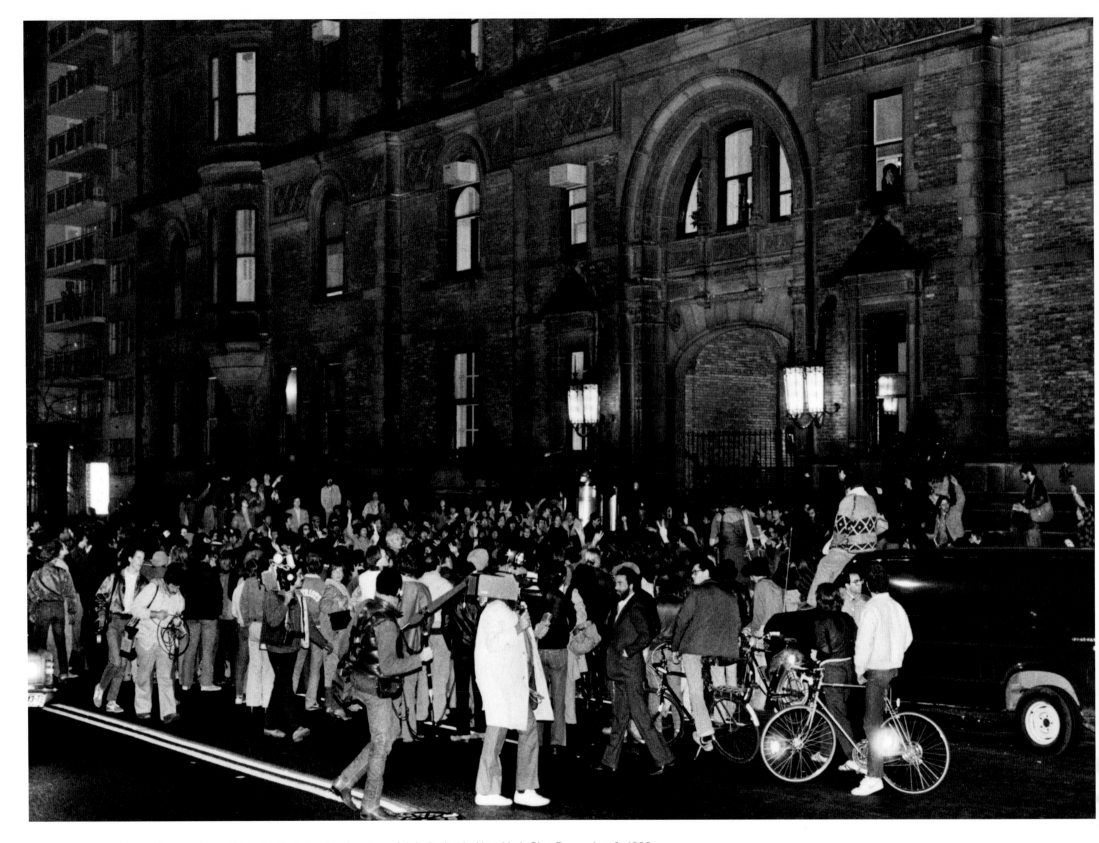

ABOVE Fans gather outside the Dakota after hearing of John's death, New York City, December 9, 1980.

RIGHT "Imagine" mosaic constructed in memory of John Lennon in Central Park, New York City, December 1992.

FOLLOWING SPREAD Yoko Ono taking the picture for the *Season of Glass* album cover at the Dakota, New York City, April 1981.

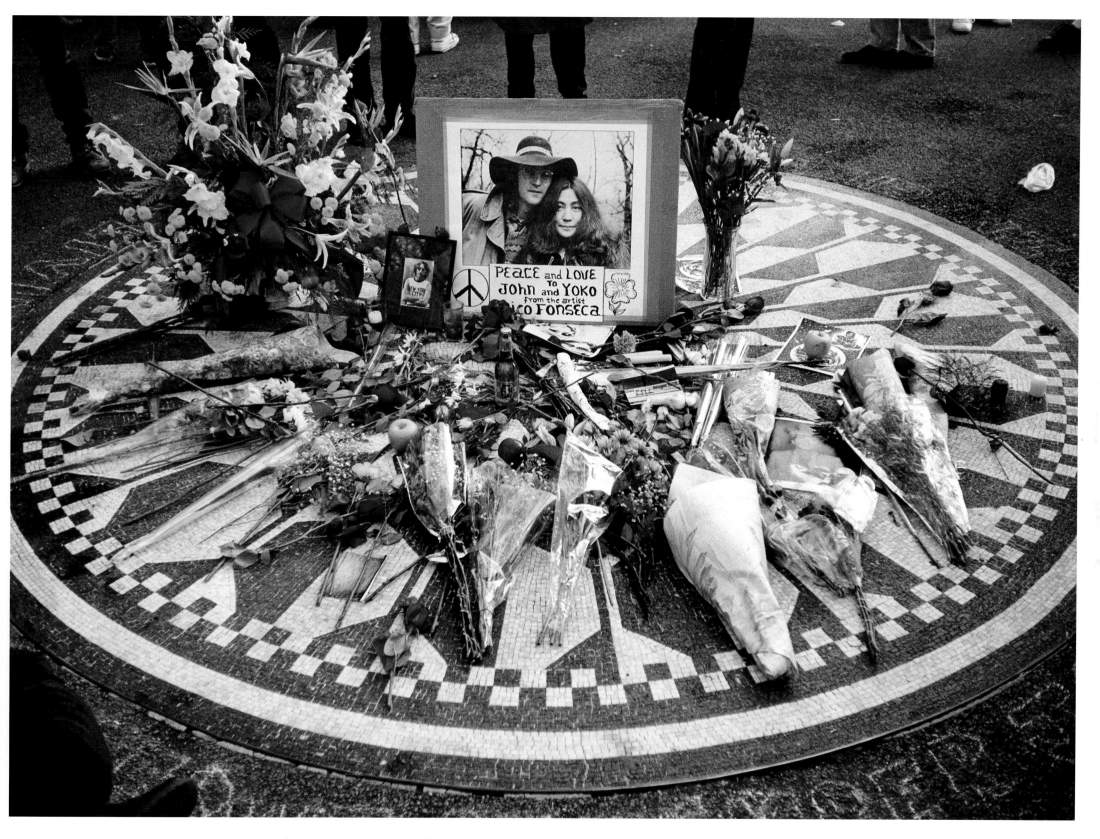

"December eighth, that's very, very heavy and very important. Everybody gathers there. And so everybody wants to put one candle and they bring their own candles or something to light up. And I put mine out there in the window . . . to say hello."

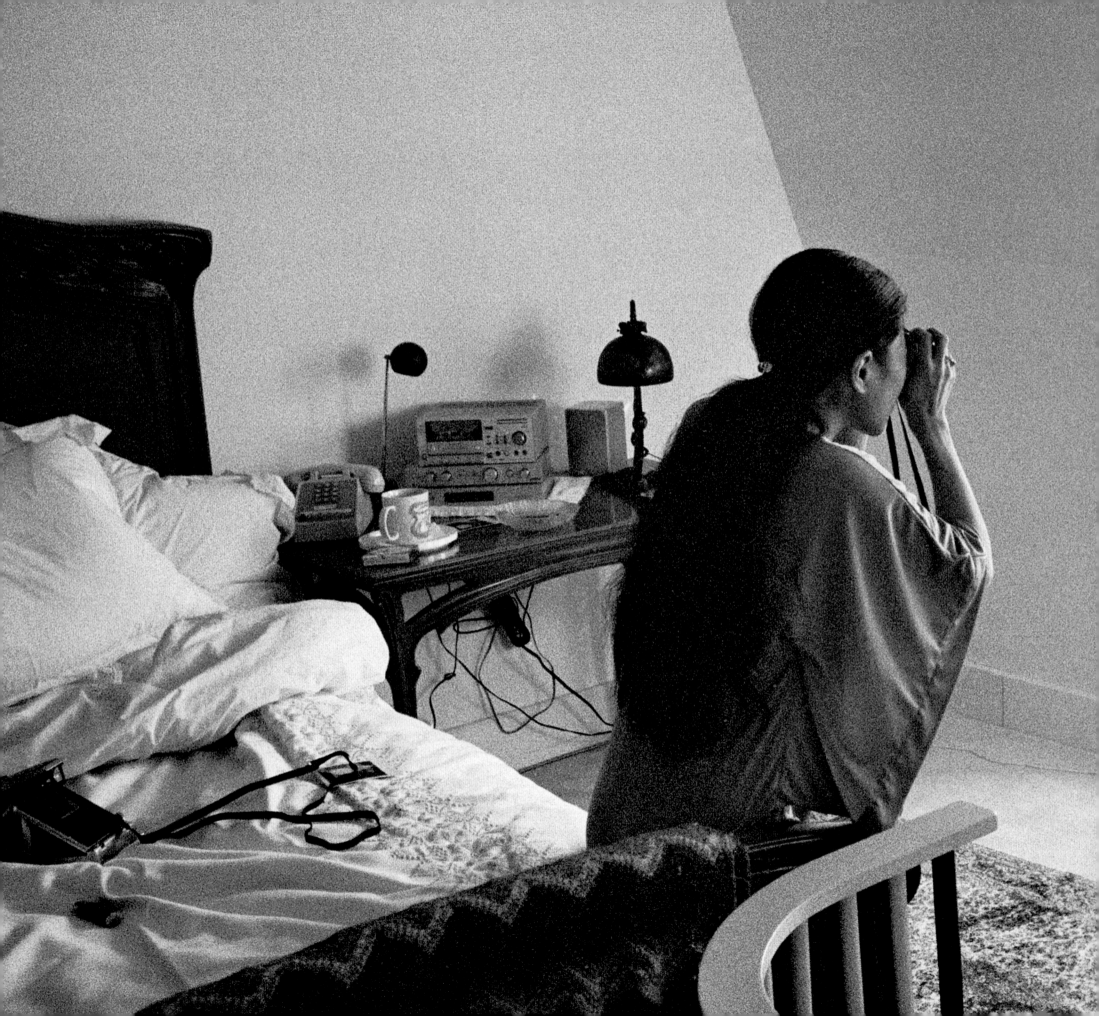

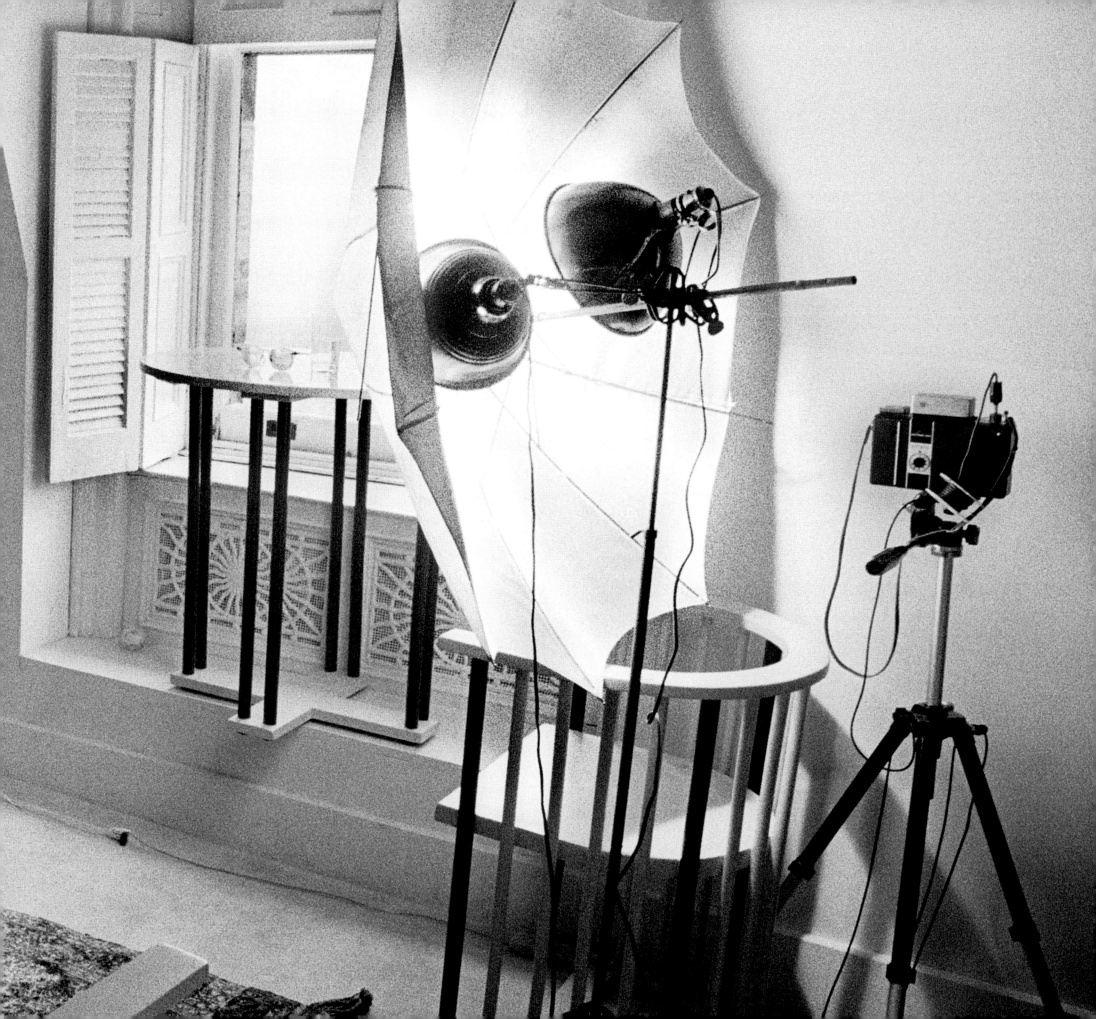

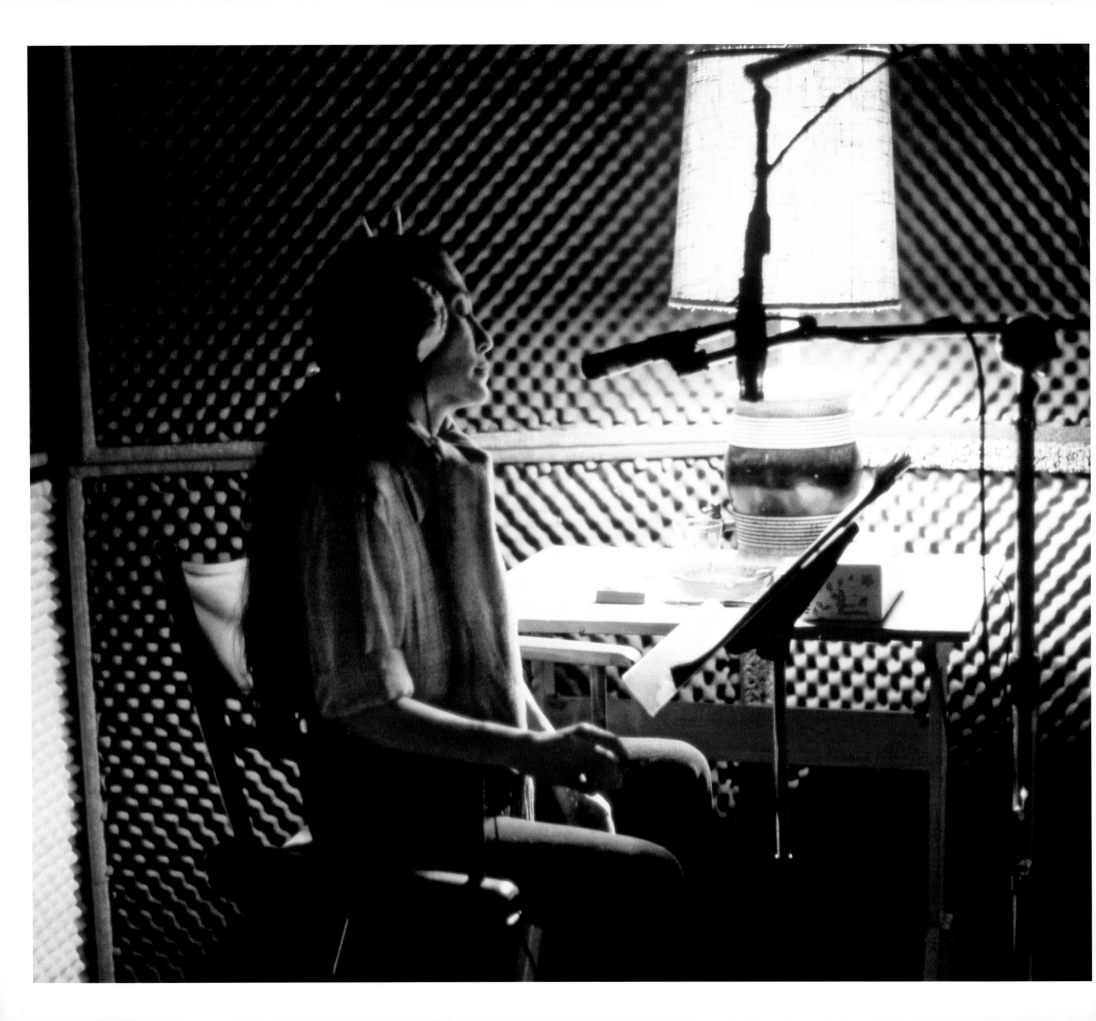

"There was so much sorrow, and it's very easy for me to get in a rut of just being very sad and angry and bitter. But just realistically or practically, it's not going to help no matter how sad I am, and we have to go on."

Yoko Ono during the recording of *Season of Glass* at the Hit Factory, New York City, March and April 1981.

"I wanted to say to John, 'You were good. You know, you were good.' And sadly, he was not right next to me. . . . And I couldn't say it. But now, when I listen to his songs, I realize that he was a very special songwriter for us all, for the world."

Sean Lennon and Yoko Ono, Mother's Day at the Dakota, New York City, May 10, 1981.

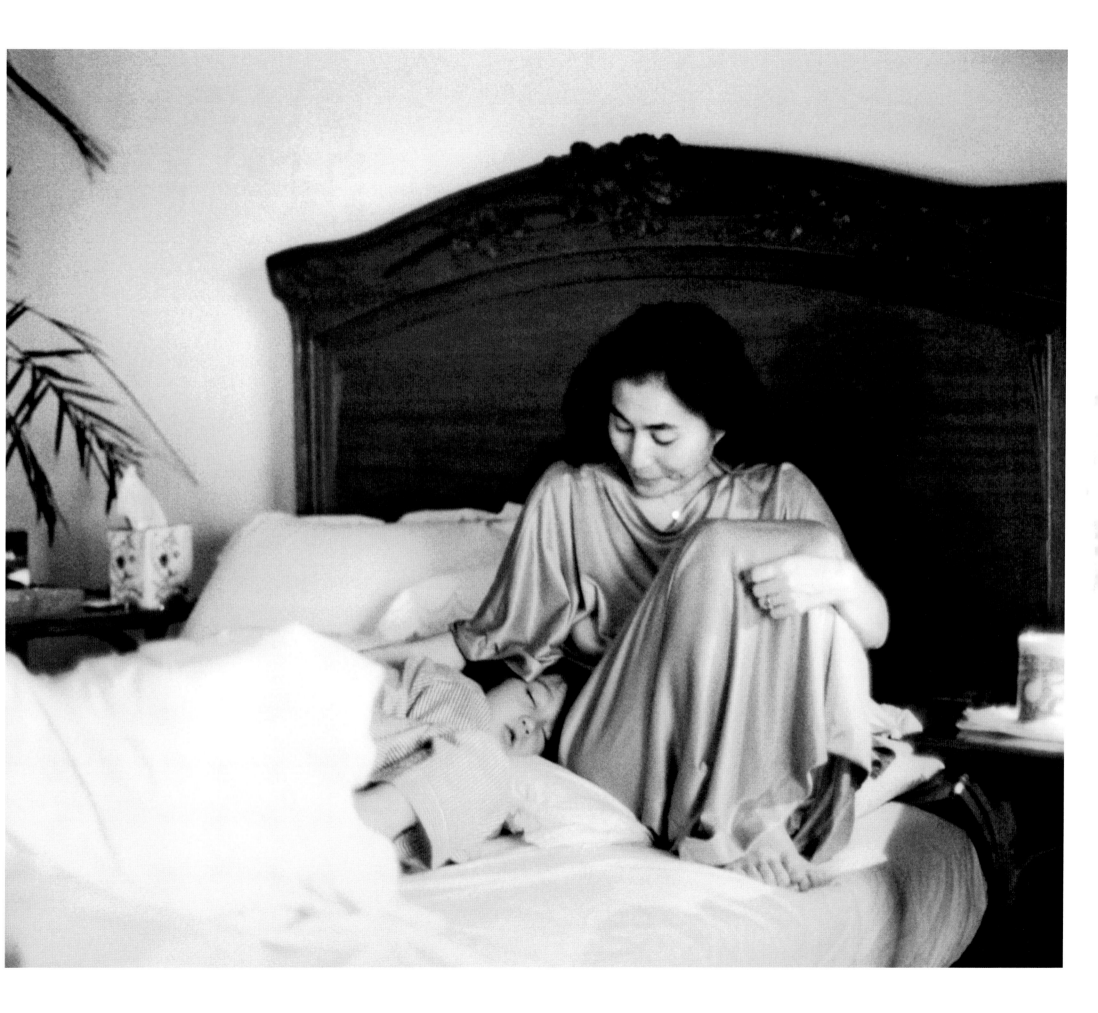

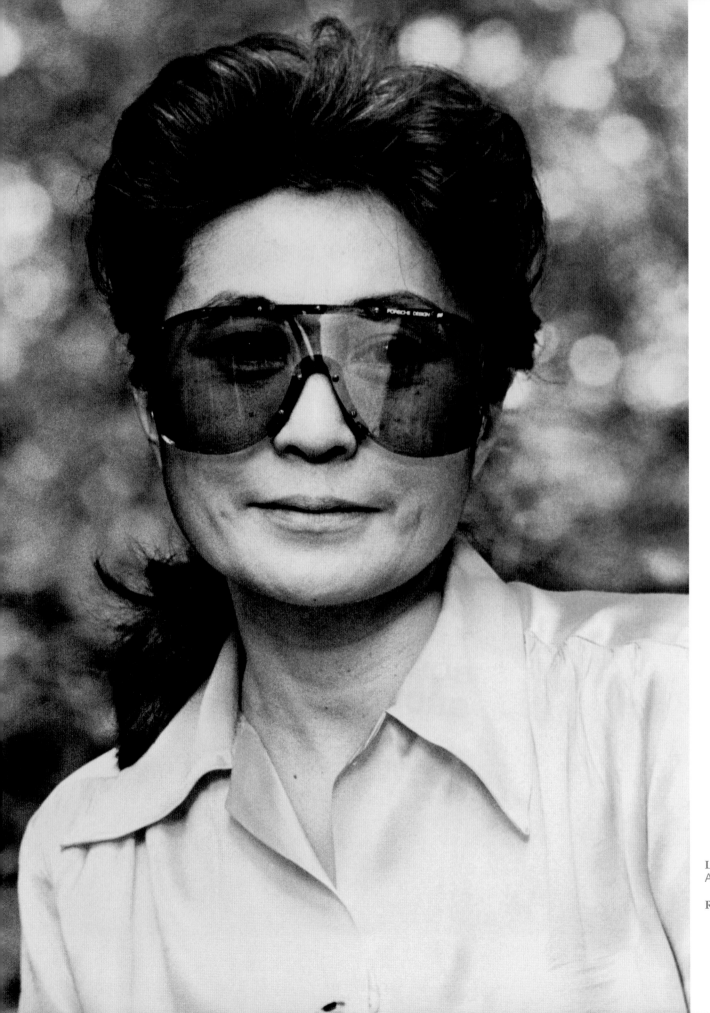

LEFT Yoko Ono in Central Park, New York City, August 1982.

RIGHT Yoko Ono, New York City, August 1982.

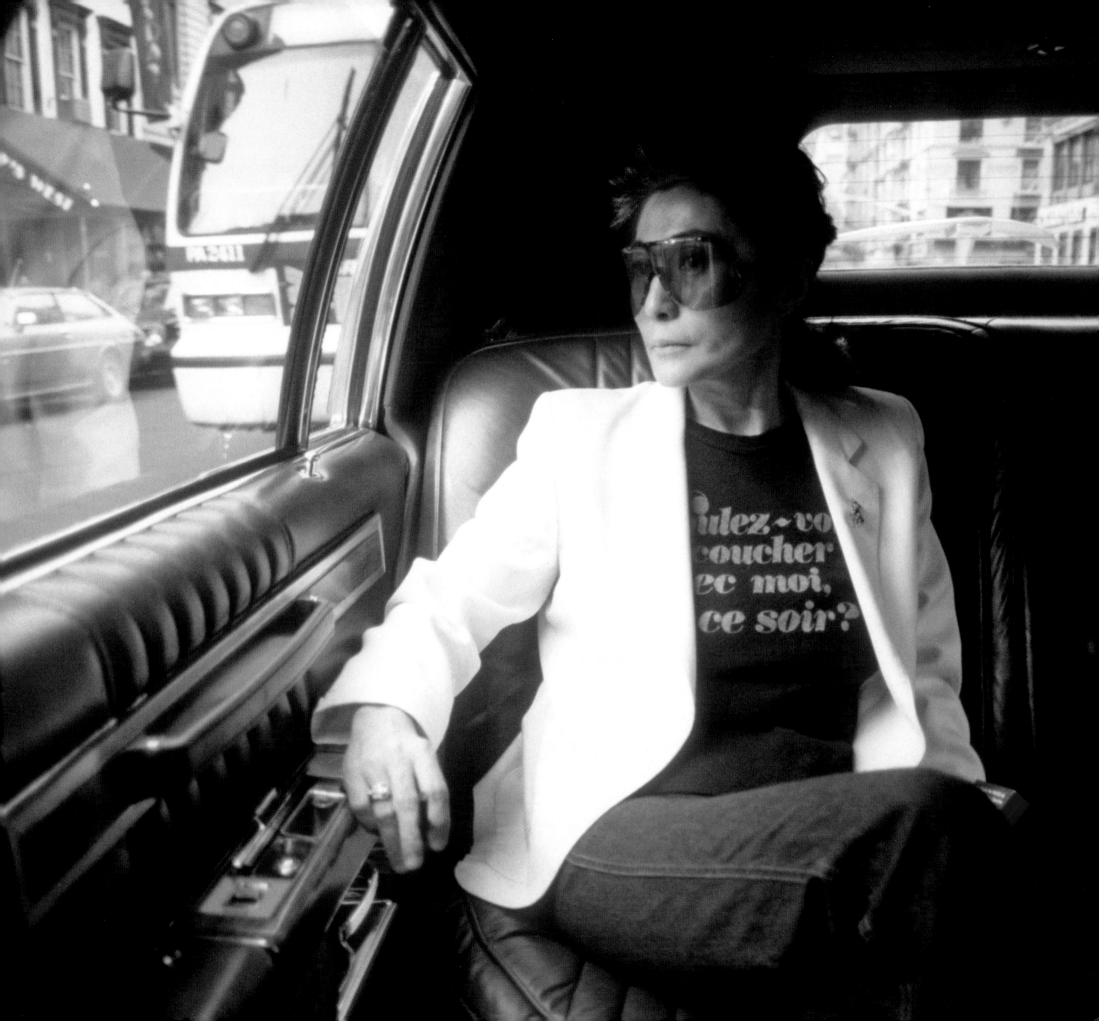

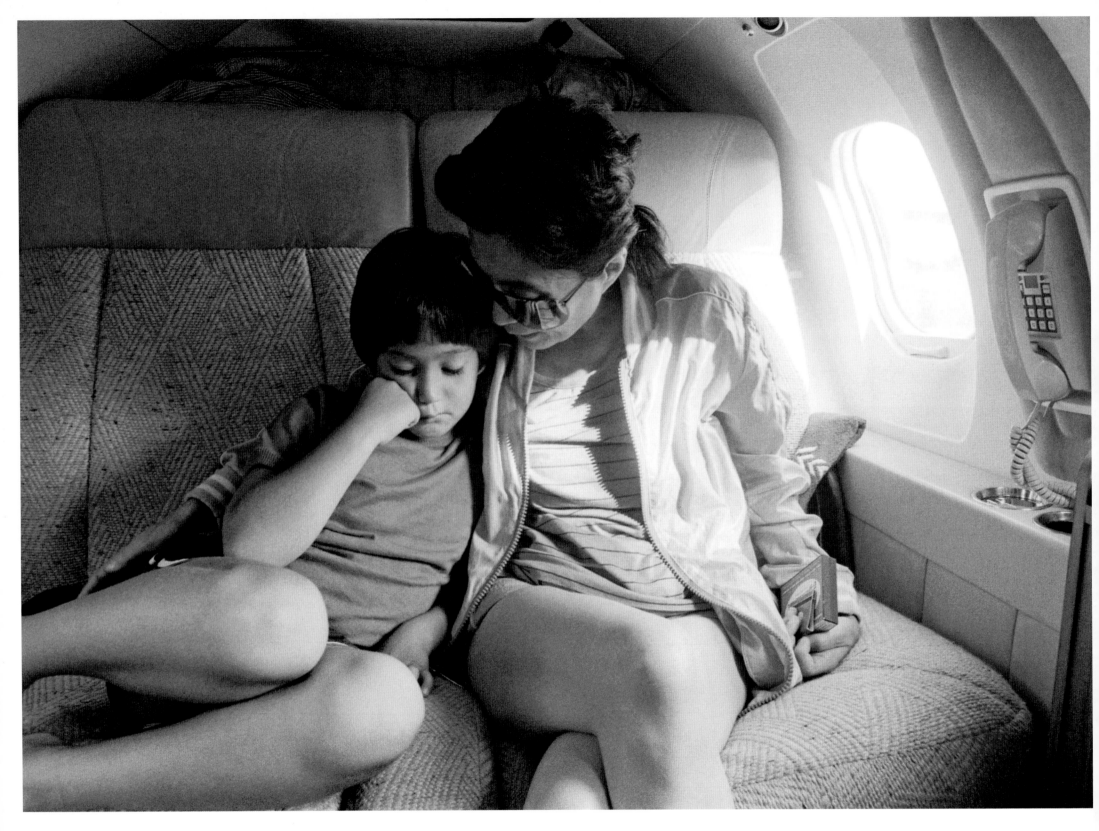

"We became closer, I must say, because of the tragedy, I think. And also he's a very gentle, kind person. And he knows that his mother went through something . . . difficult time."

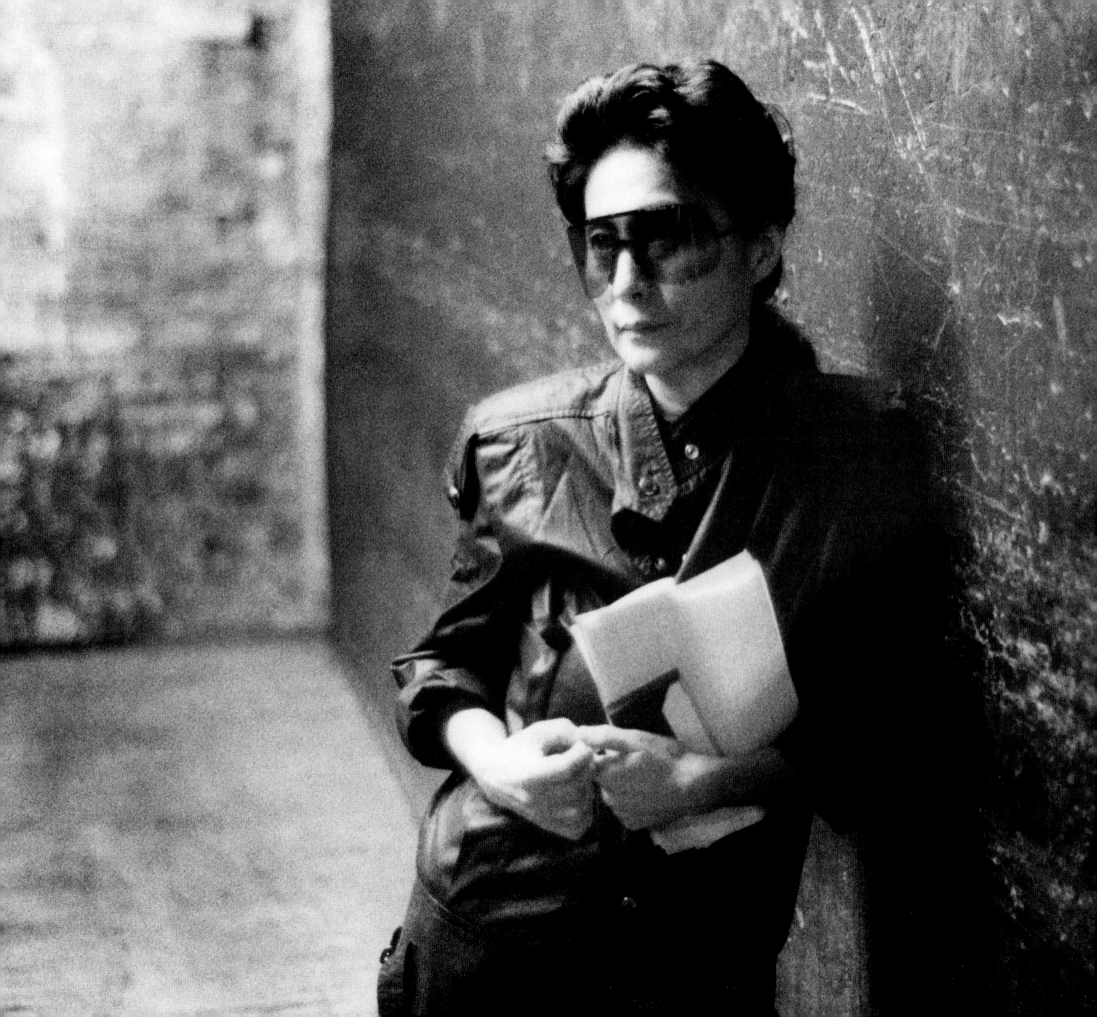

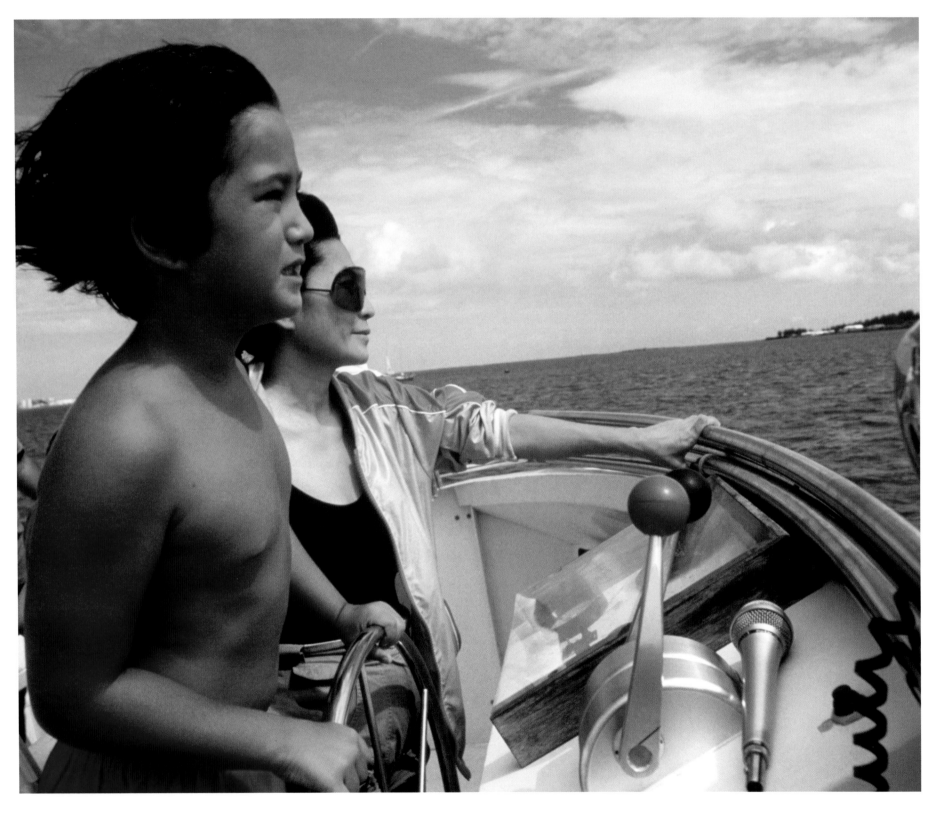

"Well, [Sean's] not John and he's not me, and I don't know how he's going to develop. He's just being himself. And in that sense, he's amazing."

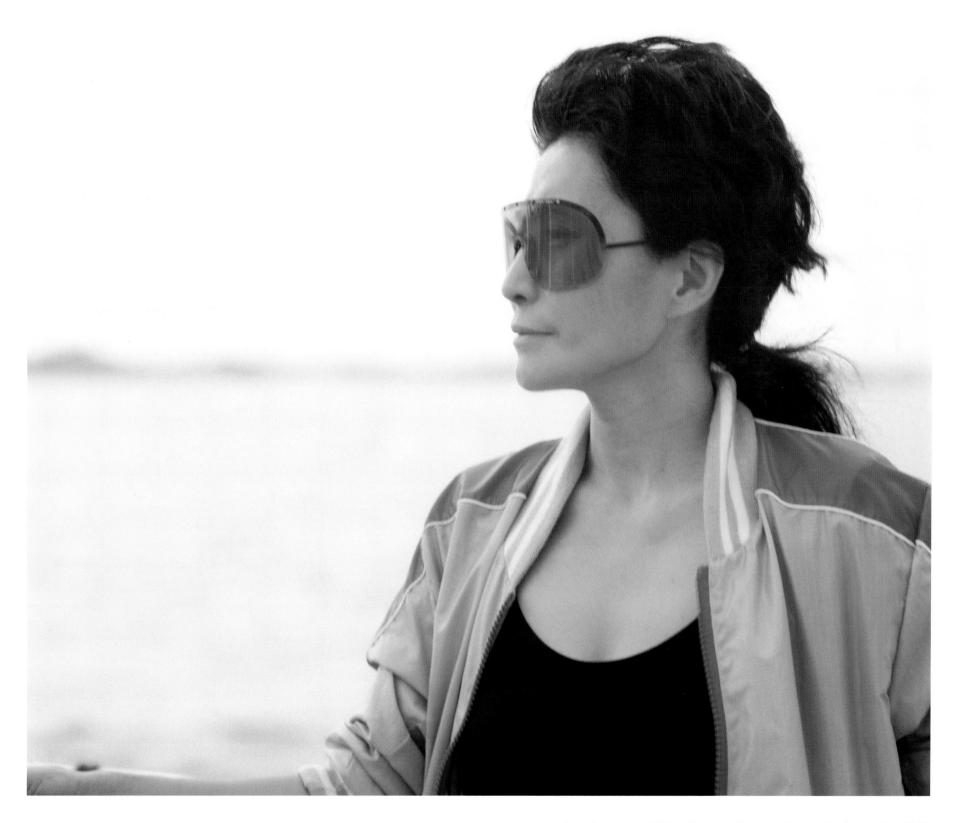

Sean Lennon and Yoko Ono vacationing in Bermuda, September 1982.

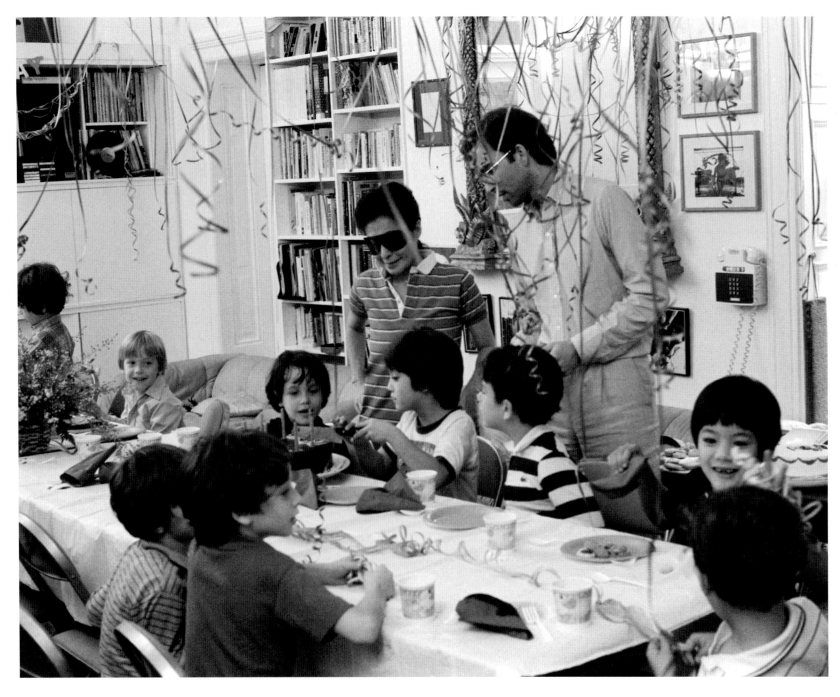

On John and Sean having the same birthday:

"[John and Sean sharing a birthday is] very sweet. Because you see, the feeling that I have, and probably Sean does too, is the fact that John is still around, and looking over us and protecting us. So his birthday is really a happy moment for us, a happy day for us."

Sean Lennon and Yoko Ono during Sean's seventh birthday party at the Dakota, New York City, October 1982.

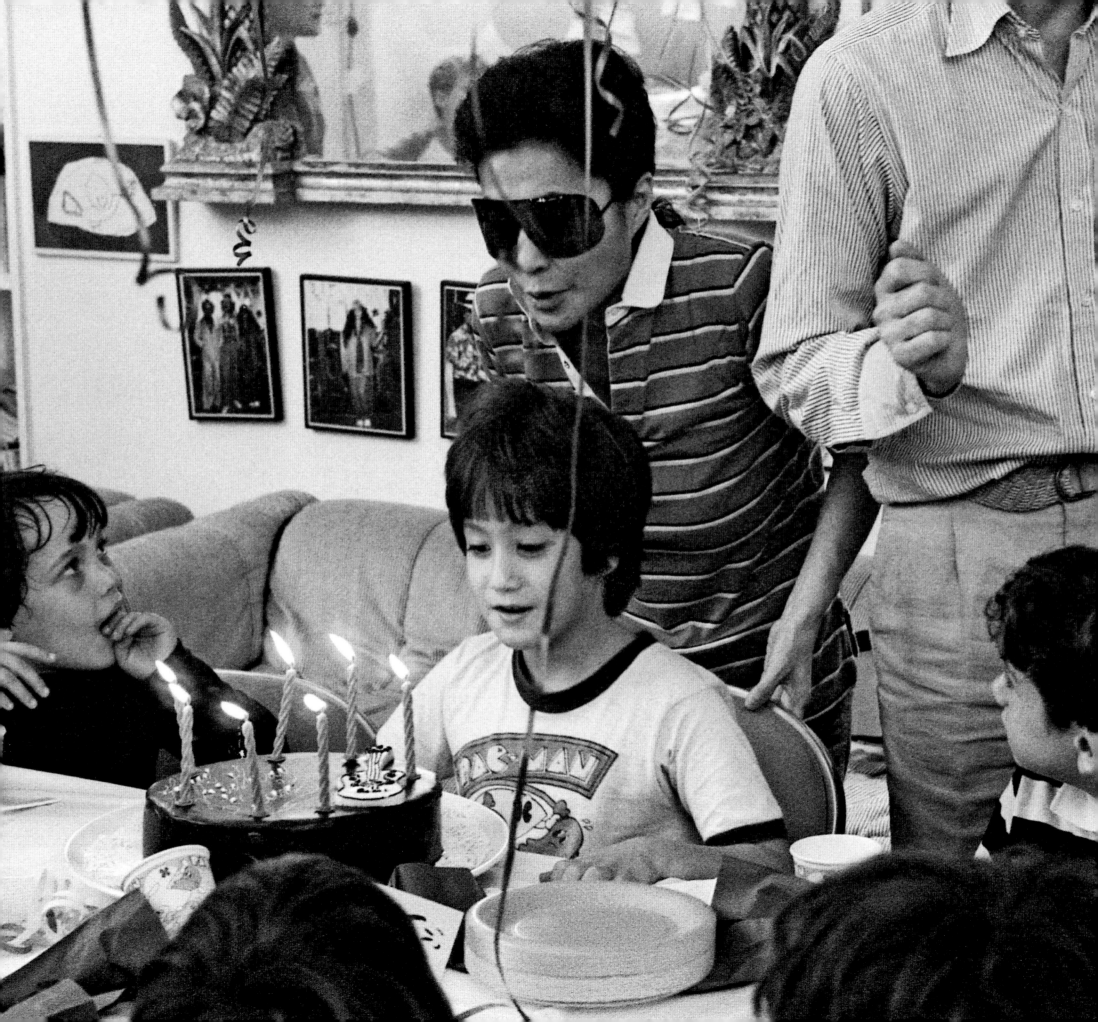

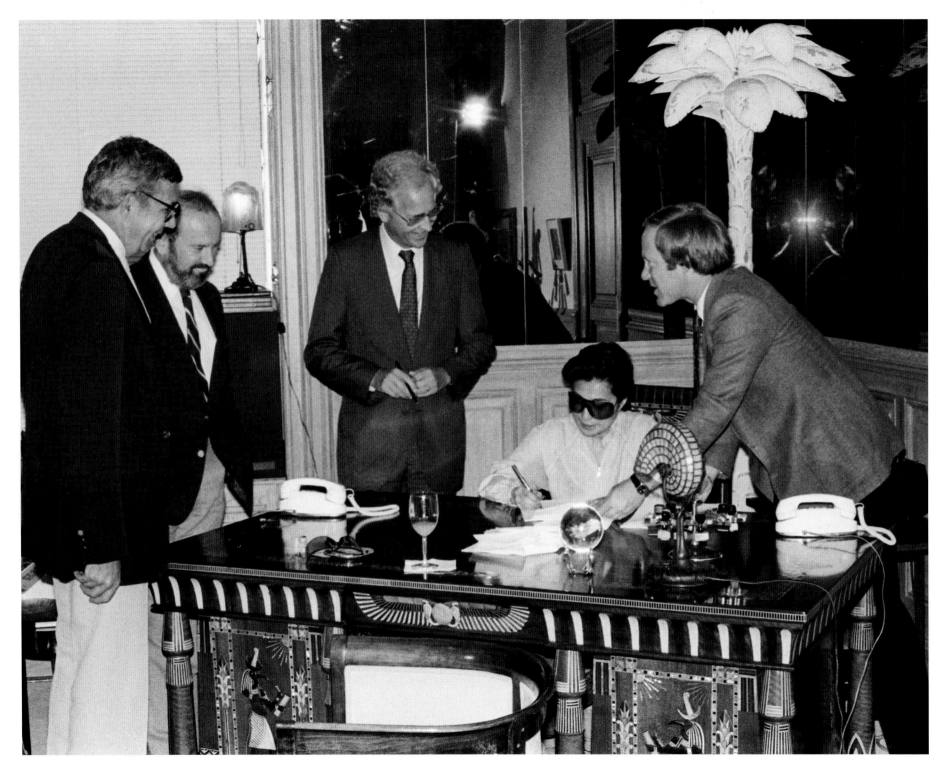

ABOVE Yoko Ono signing with Polygram Records executives at the Dakota, New York City, November 1982.

RIGHT Yoko Ono filming the "My Man" video at the Dakota, New York City, November 1982.

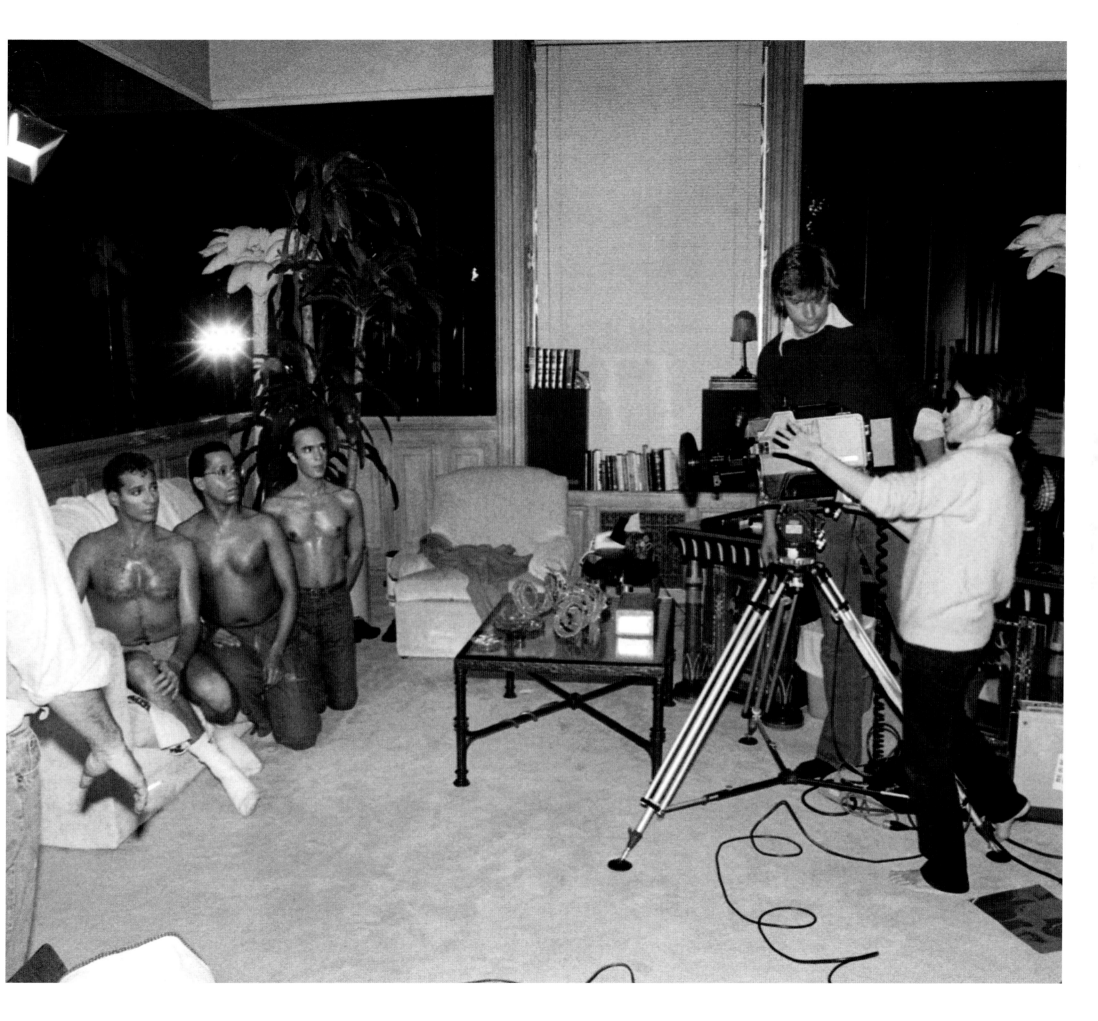

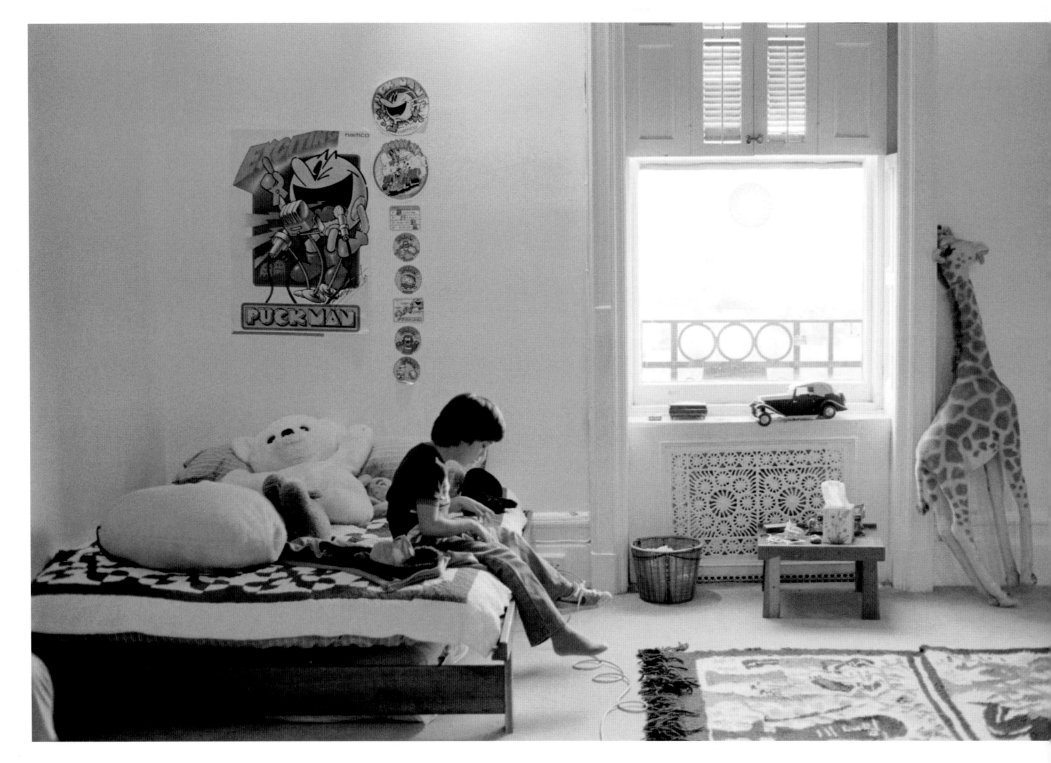

"I don't want to push [Sean] into anything, but also, I don't want to discourage him. It's a very delicate balance there, I think."

ABOVE Sean Lennon in his bedroom at the Dakota, New York City, October 1982.

RIGHT Sean Lennon in the video editing room at the Dakota, New York City, November 1982.

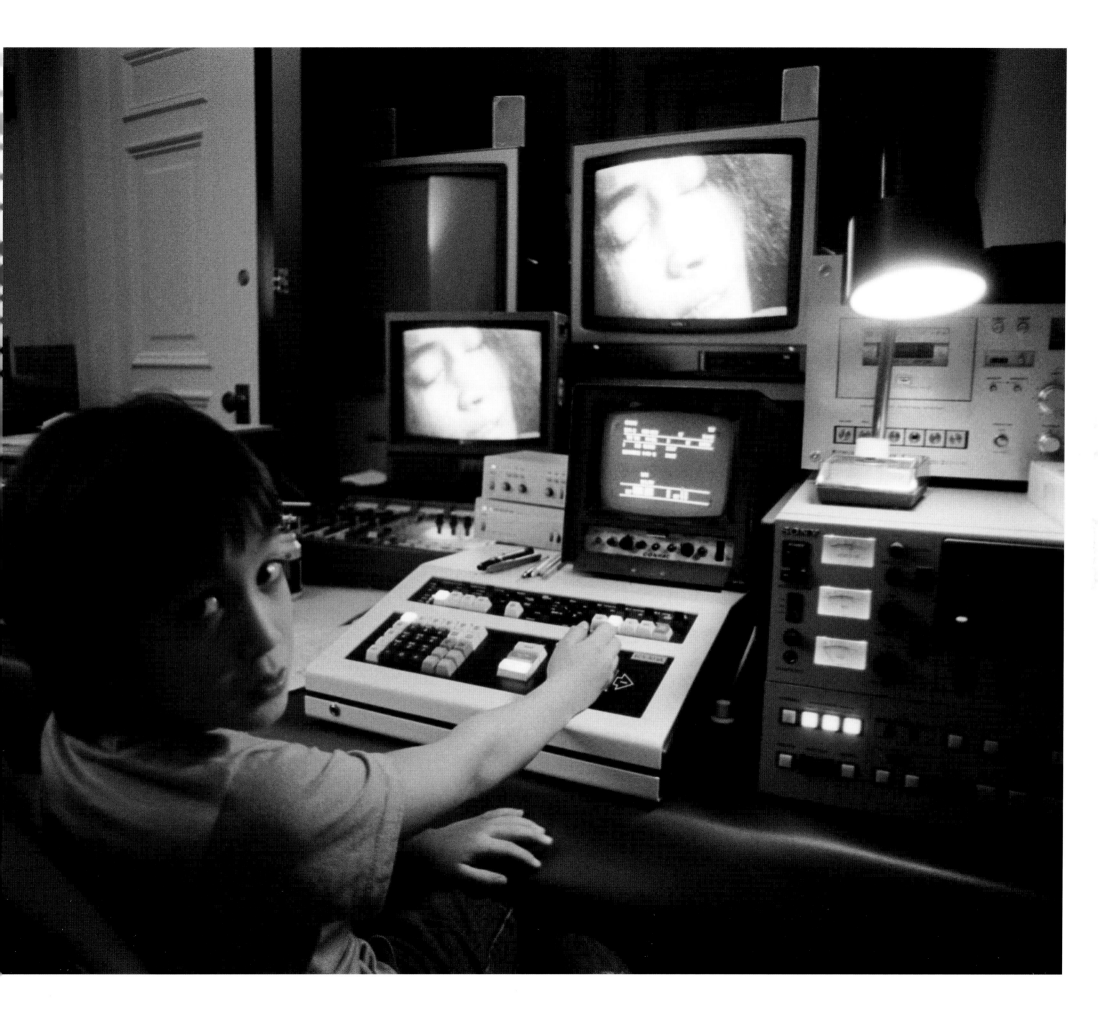

"I think Sean is amazing. Well, children are amazing and there's no exception with Sean."

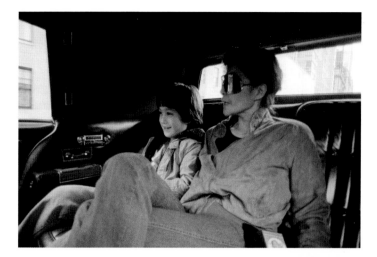

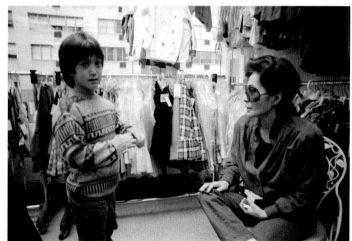

"Sean is like a friend. And of course, as a mother I do try to take care of a few things, too, oversee things."

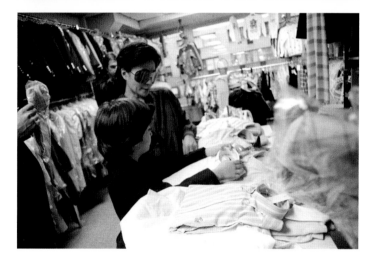

LEFT Sean Lennon running through the halls at the Dakota, New York City, November 1982.

ABOVE Sean Lennon and Yoko Ono shopping in New York City, November 1982.

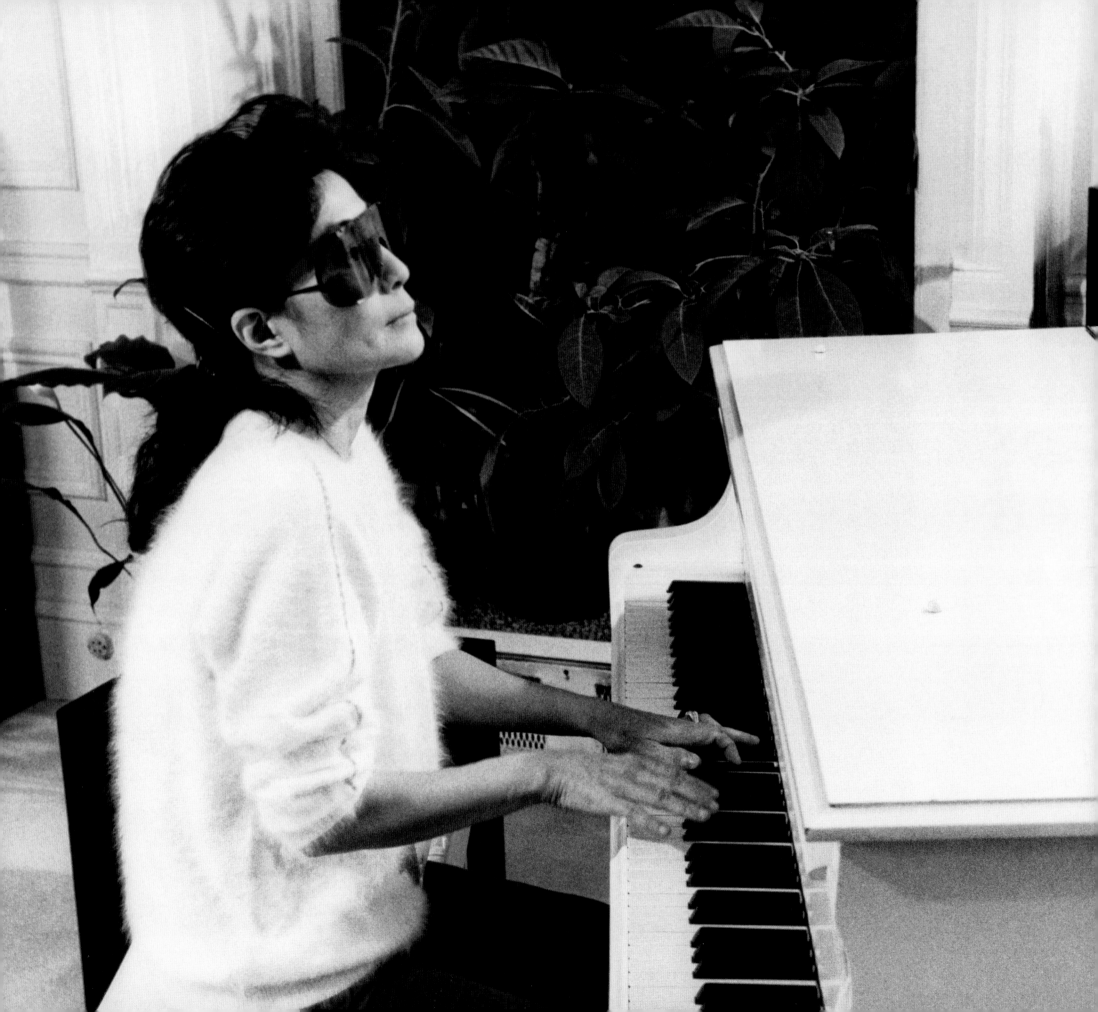

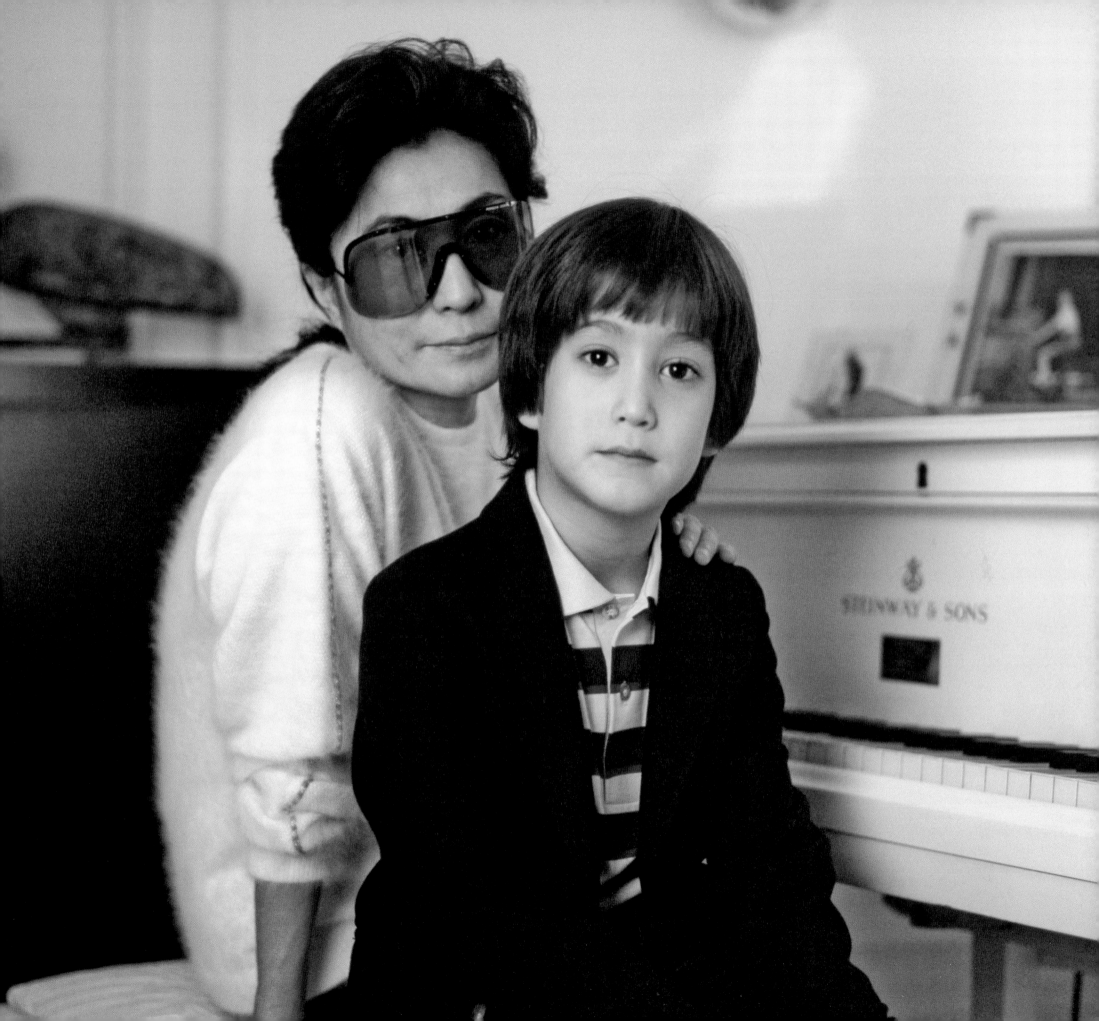

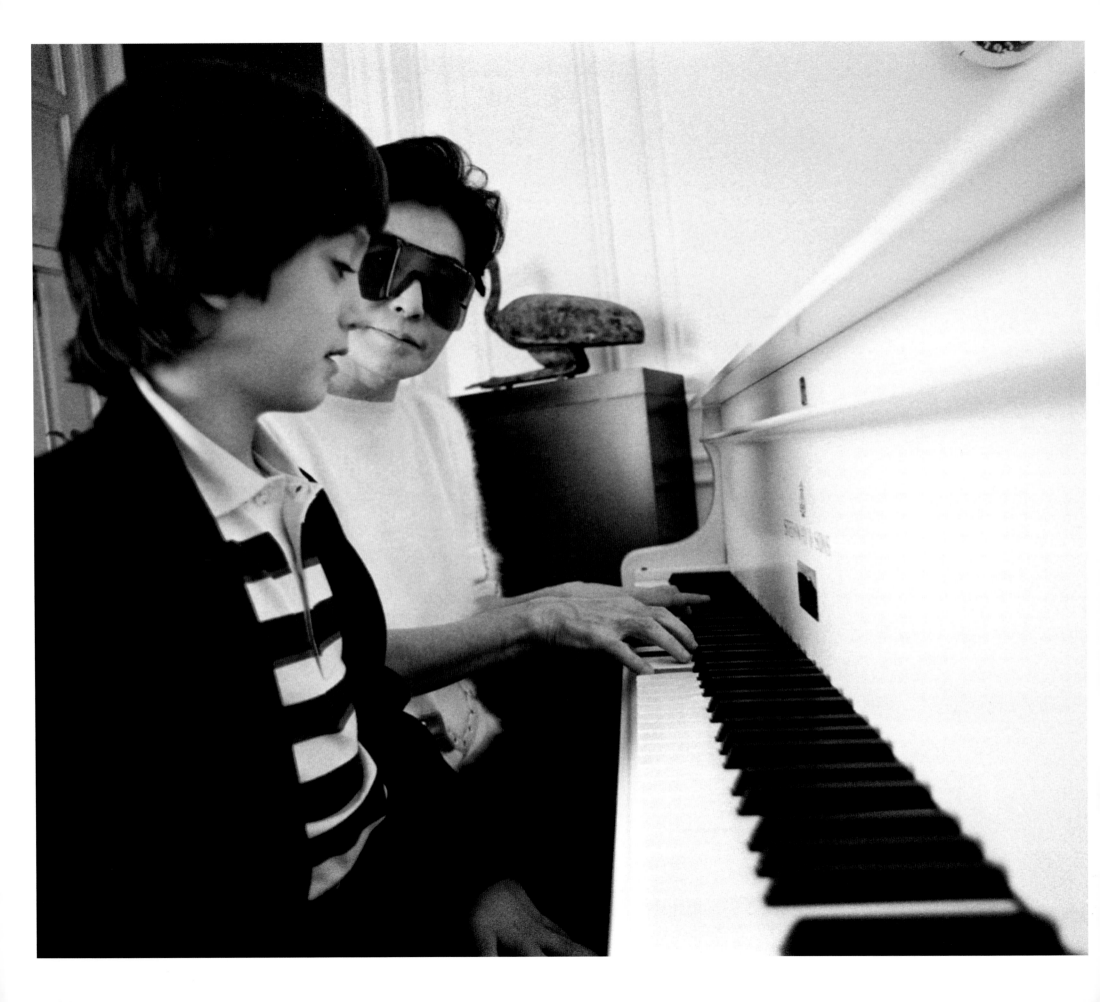

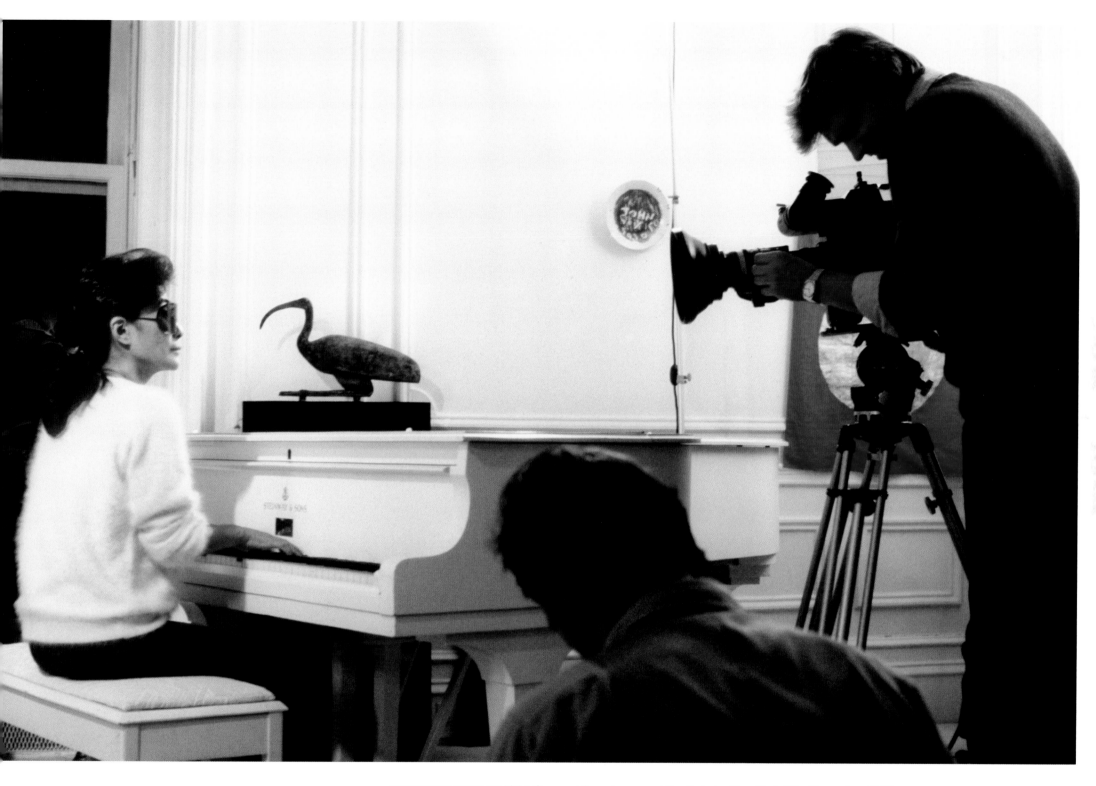

PREVIOUS SPREAD Yoko Ono and Sean Lennon at the Dakota, New York City, November 1982.

LEFT Yoko Ono and Sean Lennon at the Dakota, New York City, November 1982.

ABOVE Yoko Ono during the filming of the "My Man" video at the Dakota, New York City, November 1982.

FOLLOWING SPREAD Sean Lennon playing on the rooftop of the Dakota, New York City, November 1982.

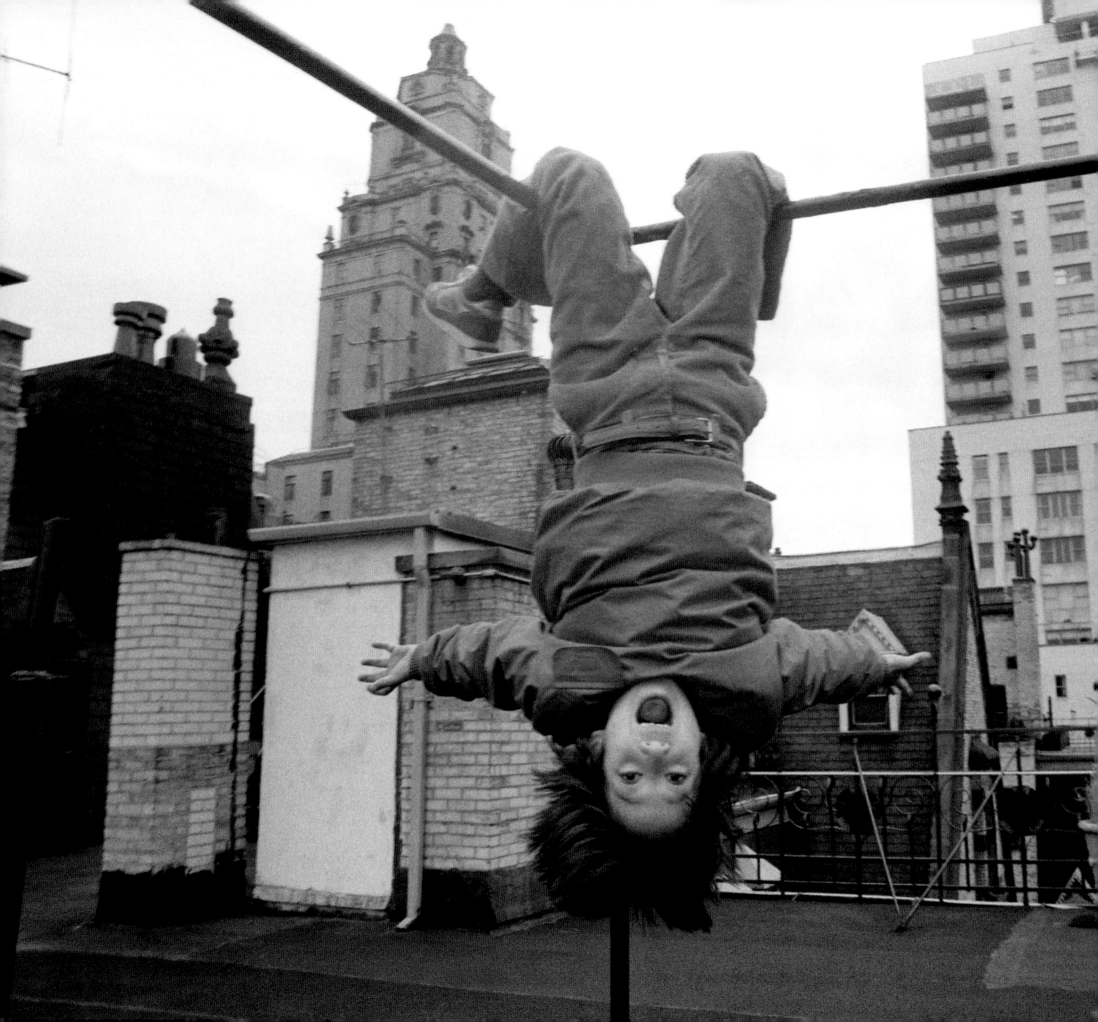

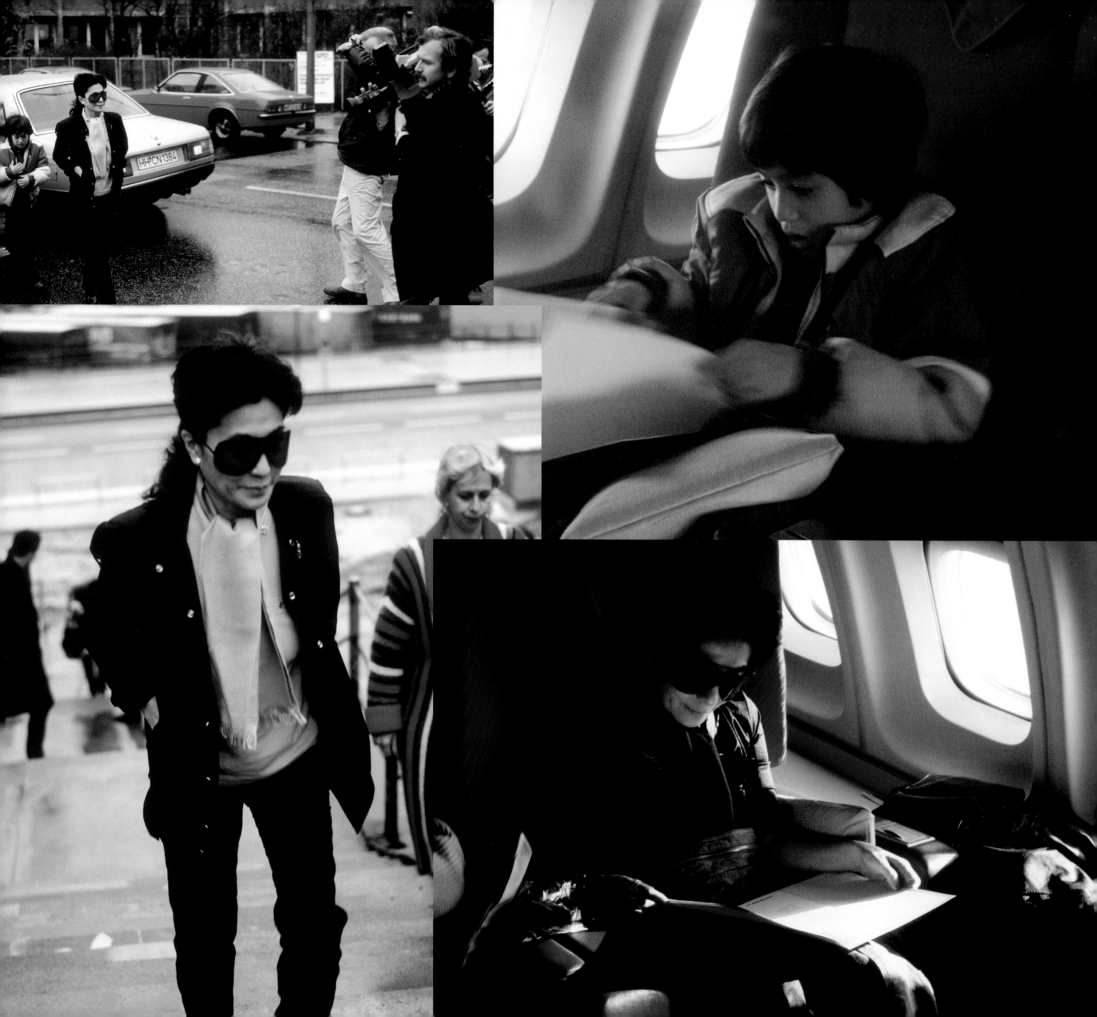

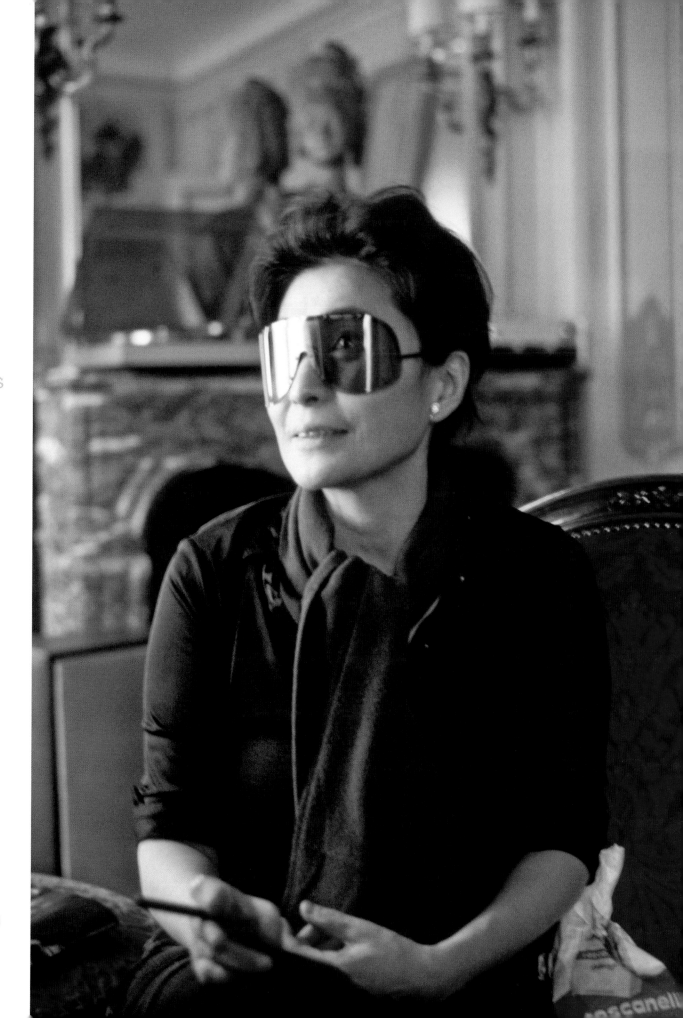

"Well, I have about three or four very important facets of my life. The first thing is being a mother, I'm a mother to Sean and that comes first. This is a very surprising statement for me, but it is important. And then I'd like to think that my own personal work is something I treasure a lot, too. But business is another very important aspect of my life because I have that responsibility. And there's also John's sudden leaving. It wasn't meant to be like that, so there's a lot of things still unfinished."

LEFT Sean Lennon and Yoko Ono on a plane, and in Hamburg, Germany, November 1982.

RIGHT Yoko Ono at her hotel room in Europe, November 1982.

FOLLOWING SPREAD Yoko Ono and Sean Lennon in their hotel room in Europe, November 1982.

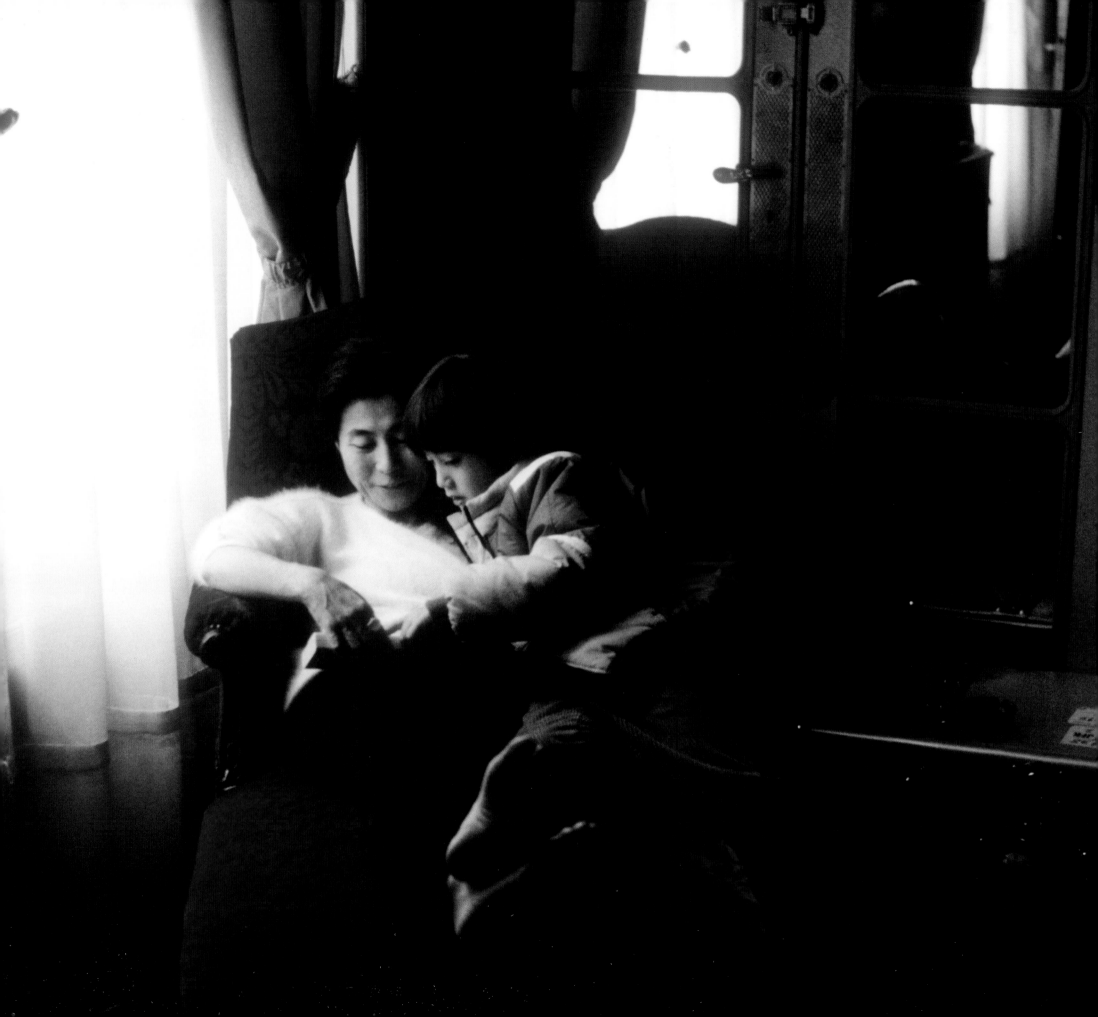

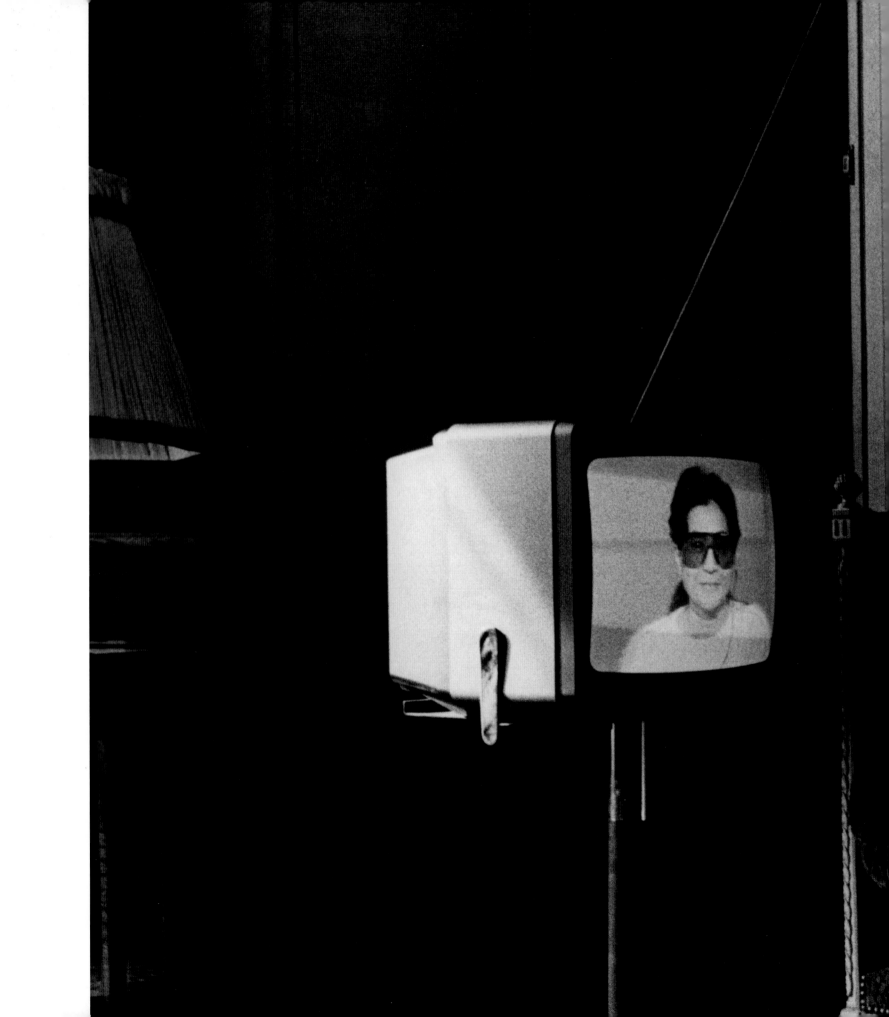

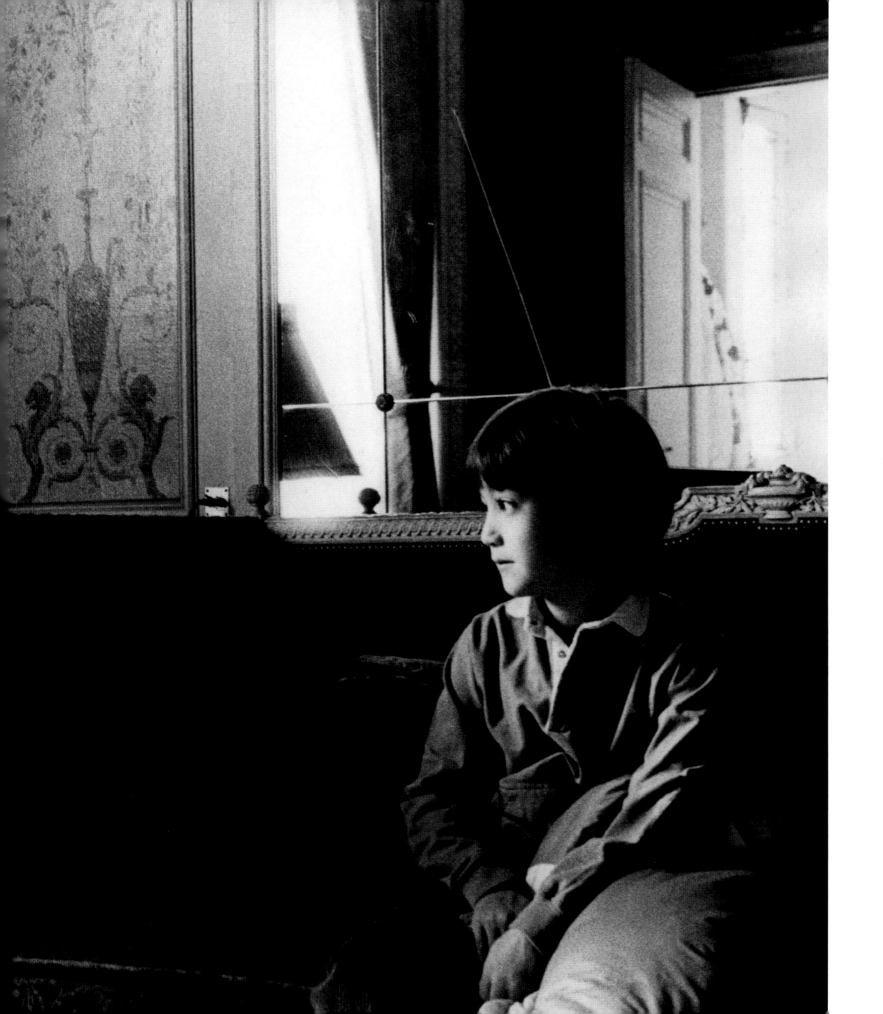

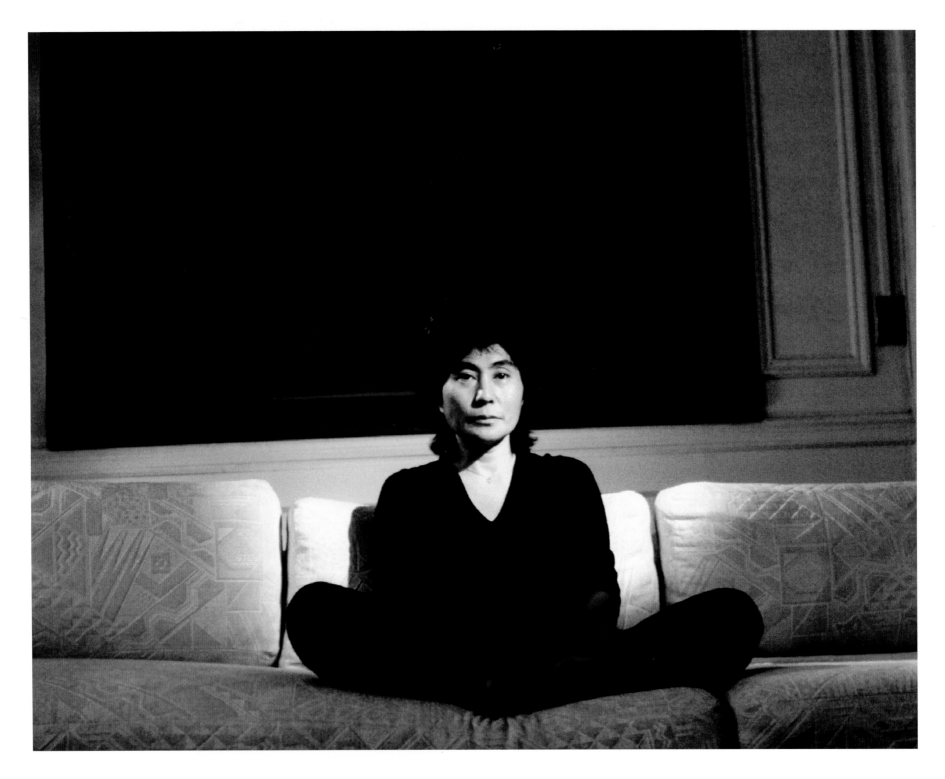

"I'm totally focused on my present life. Otherwise, you know my life would go haywire. I am taking care of myself. And I'm trying to keep myself centered and everything and doing things daily."

PREVIOUS SPREAD Sean Lennon watching Yoko Ono on the television at his hotel room in Europe, November 1982.

ABOVE Yoko Ono at the Dakota, New York City, June 1983.

RIGHT Yoko Ono, New York City, 1983.

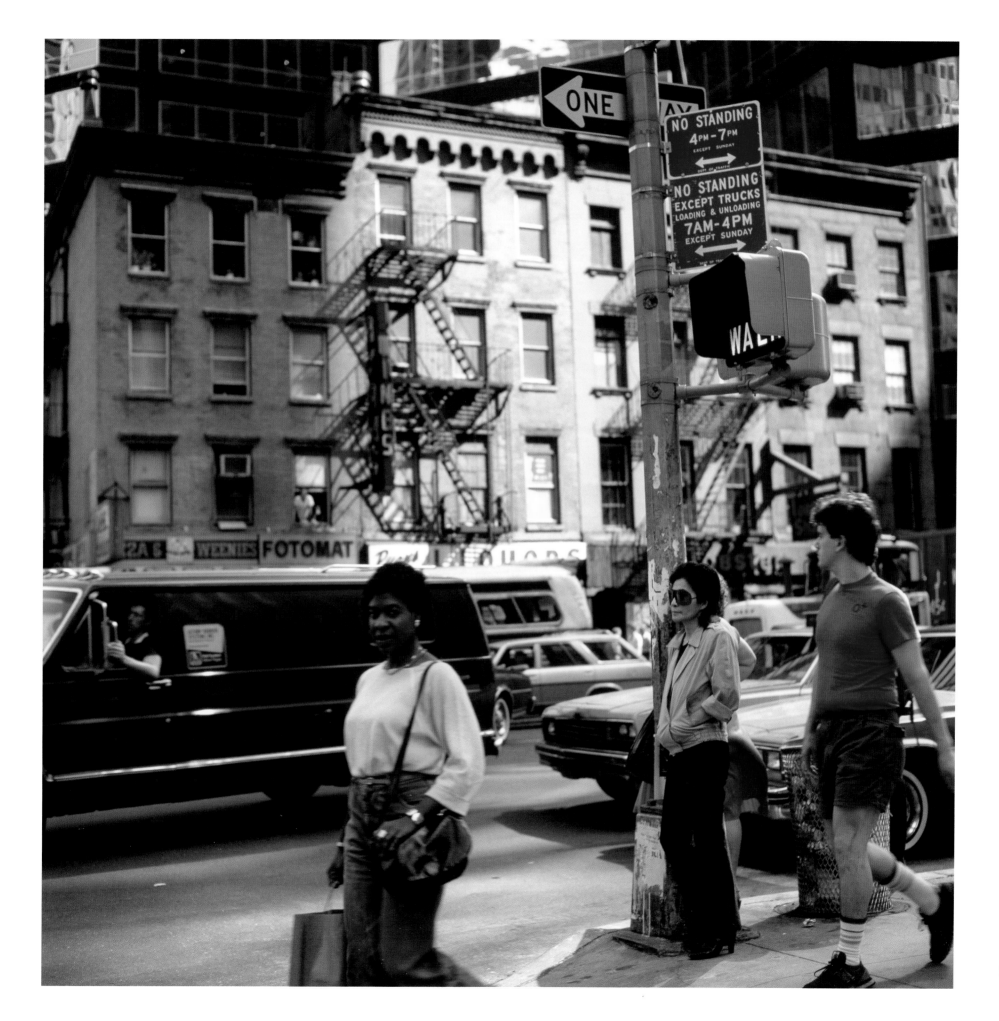

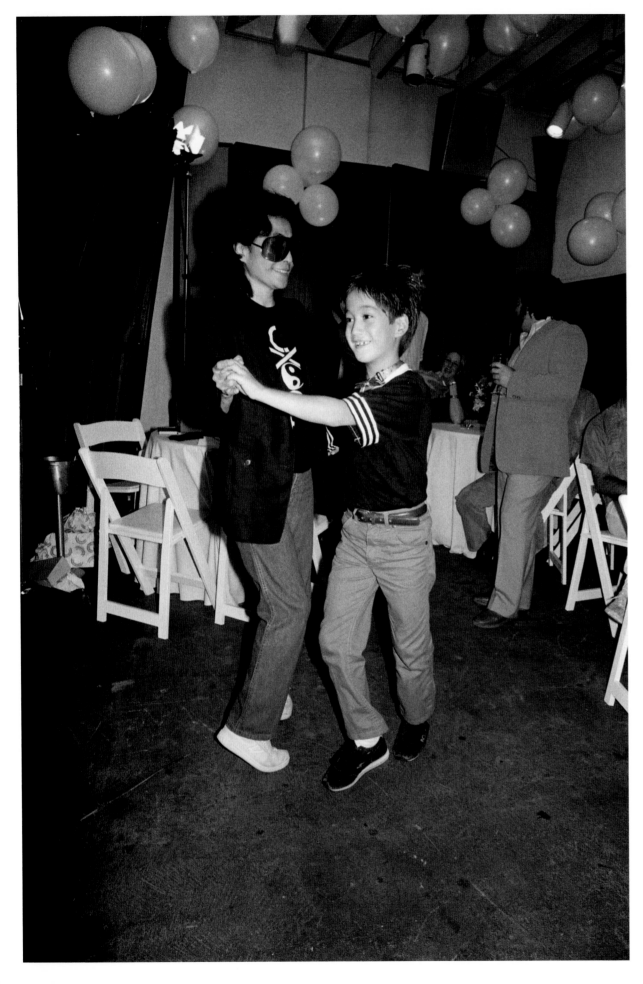

"Both John and I never encouraged [Sean] to listen to us, music or anything like that. I mean, John didn't even tell him about the Beatles. He found out about it, and he found out about my songs, too, and I don't know where he got them. He seems to know all the lyrics, every lick, everything. . . ."

LEFT Yoko Ono and Sean Lennon dancing, New York City, August 1983.

RIGHT Yoko Ono relaxing at the Dakota, New York, May 1983.

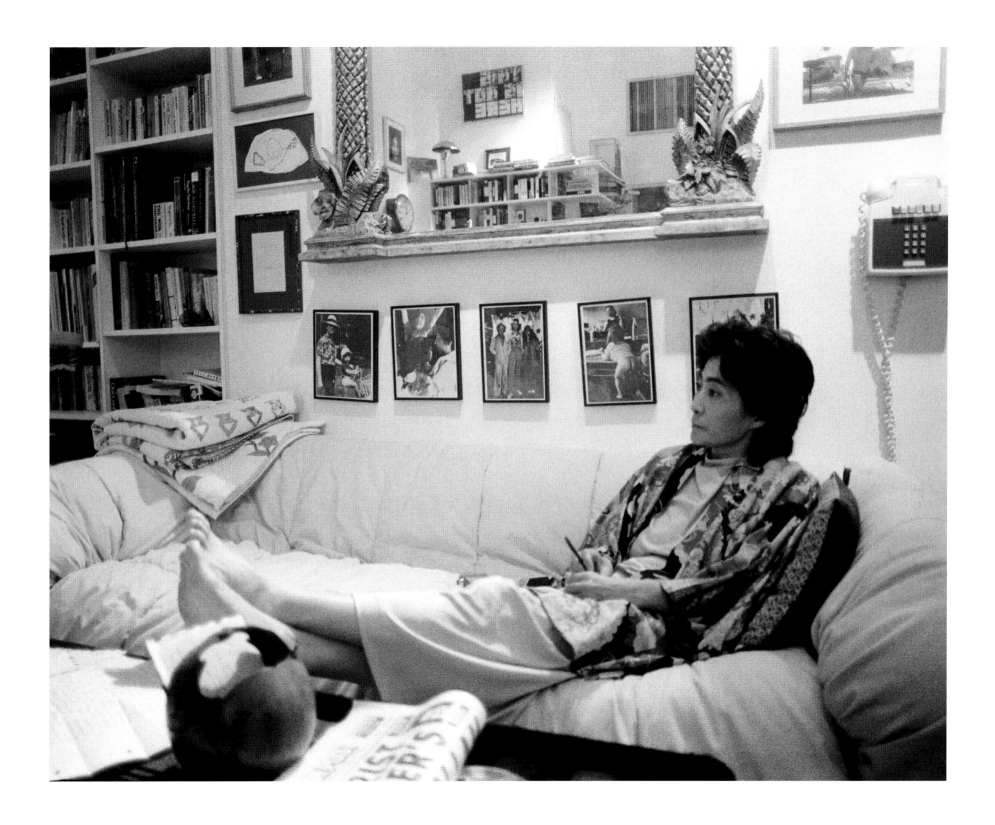

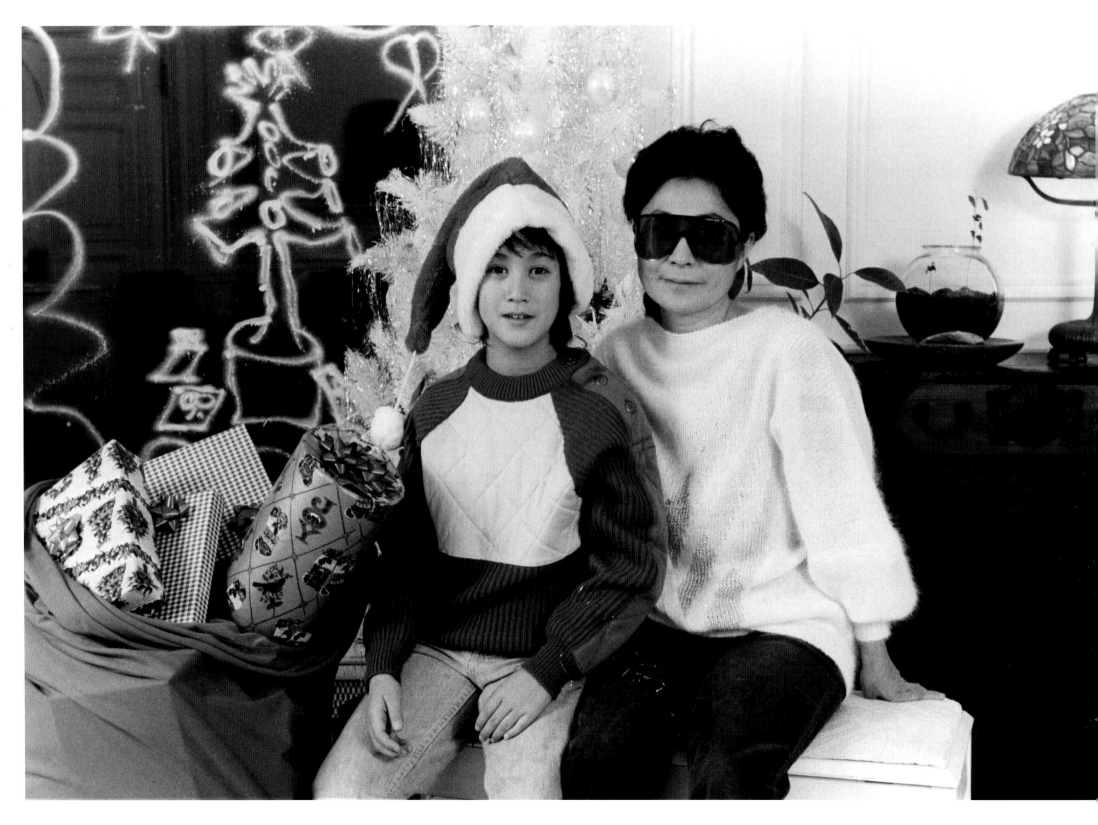

ABOVE Sean Lennon and Yoko Ono posing for their Christmas card at the Dakota, New York City, November 1984.

RIGHT Yoko Ono and Sean Lennon playing with weights at the Dakota, New York City, August 21, 1984.

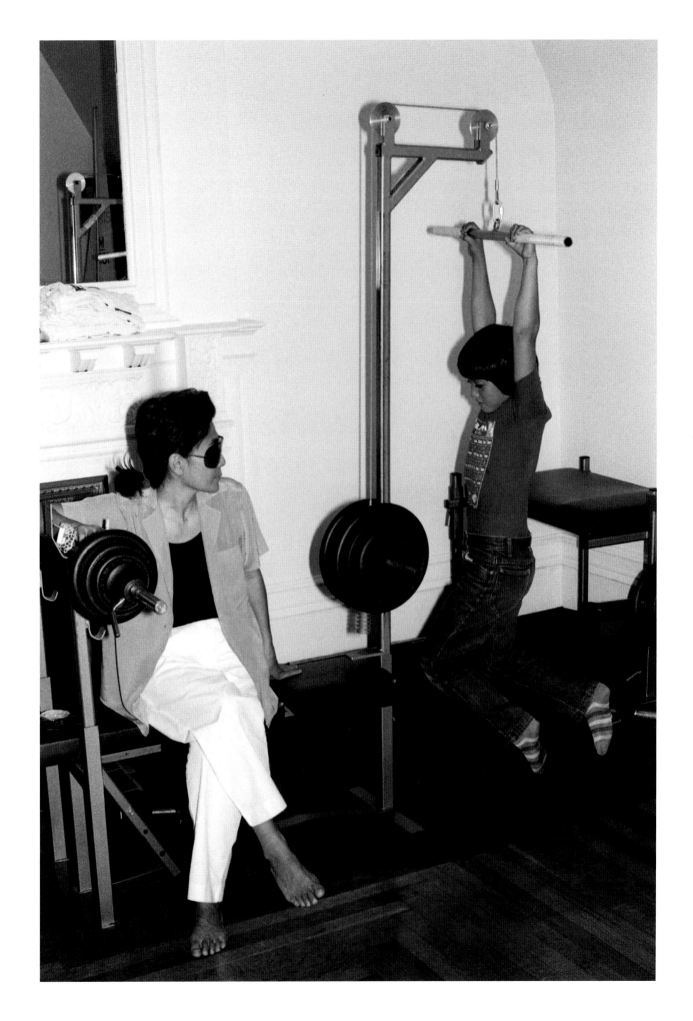

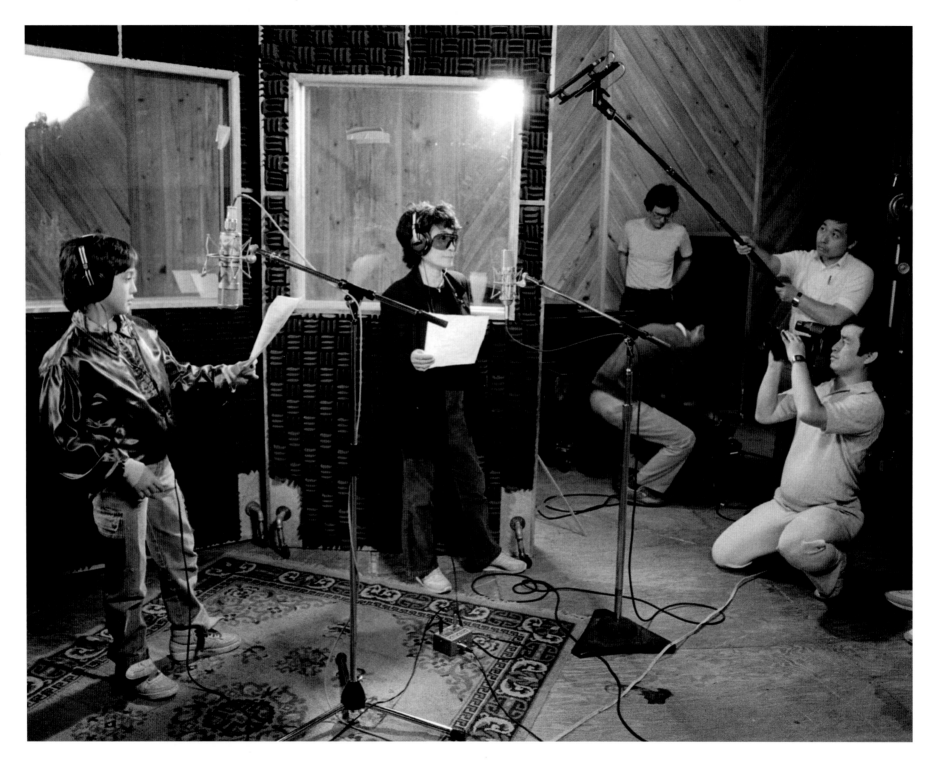

"Well I enjoy work. I think work is an incredible thing that's given to us in a way."

ABOVE Sean Lennon and Yoko Ono recording *Starpeace* at the Hit Factory, New York City, June 27, 1985.

RIGHT Yoko Ono and actors filming the "Hell in Paradise" video, New York City, September 1985.

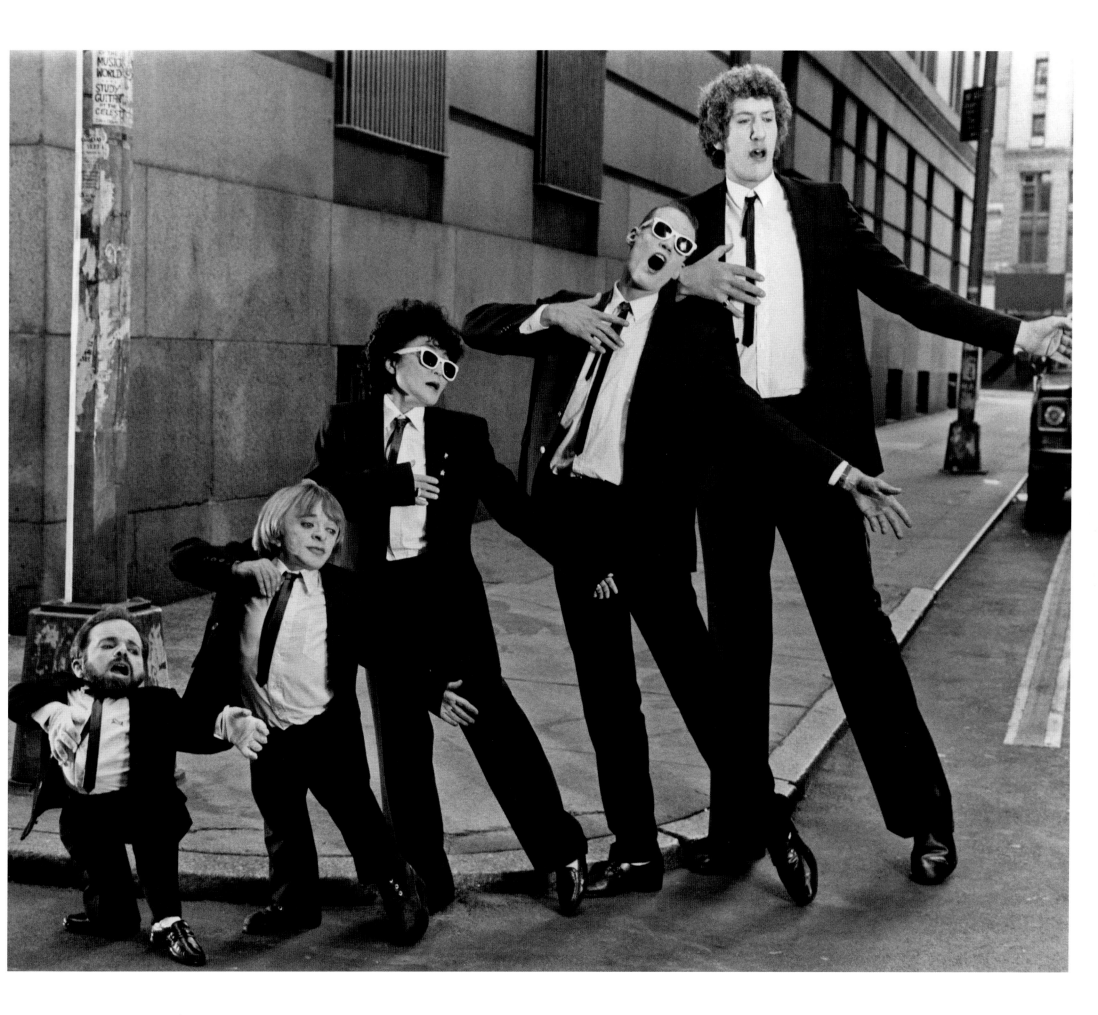

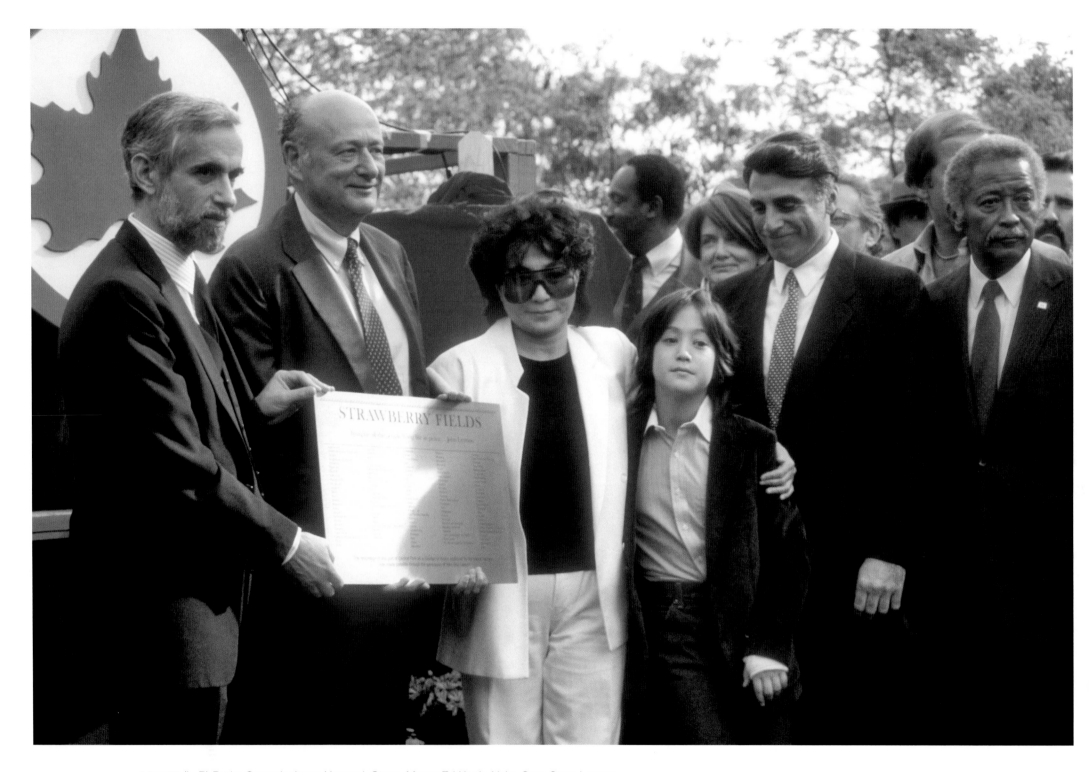

ABOVE (L–R) Parks Commissioner Henry J. Stern, Mayor Ed Koch, Yoko Ono, Sean Lennon, Andrew Stein, and David Dinkins during the Strawberry Fields opening ceremony in Central Park, New York City, October 9, 1985.

RIGHT (L–R) Mayor Ed Koch, Yoko Ono, Sean Lennon, and Julian Lennon during the Strawberry Fields groundbreaking ceremony in Central Park, New York City, March 21, 1984.

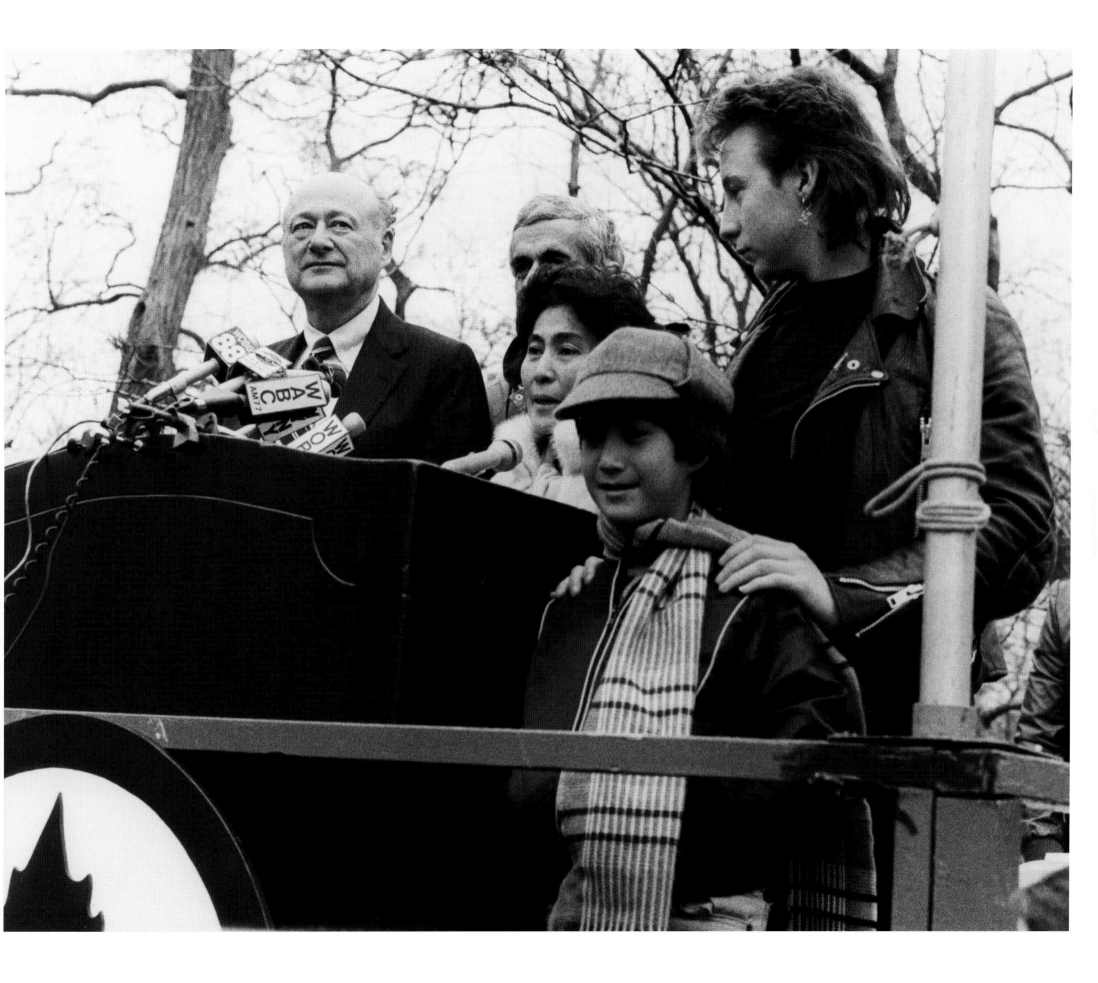

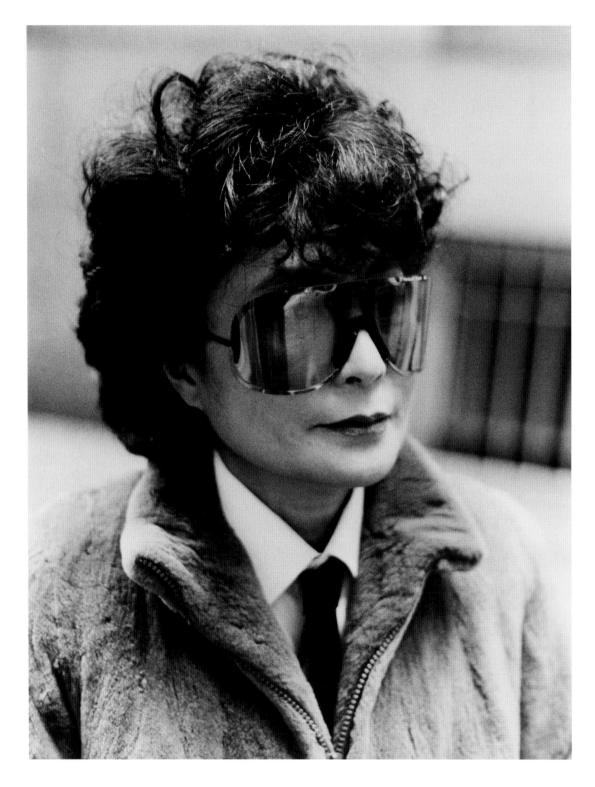

ABOVE Yoko Ono during the filming of the "Hell in Paradise" video, New York City, September 1985.

RIGHT Yoko Ono next to the "Imagine" mosaic in Central Park, New York City, July 1985.

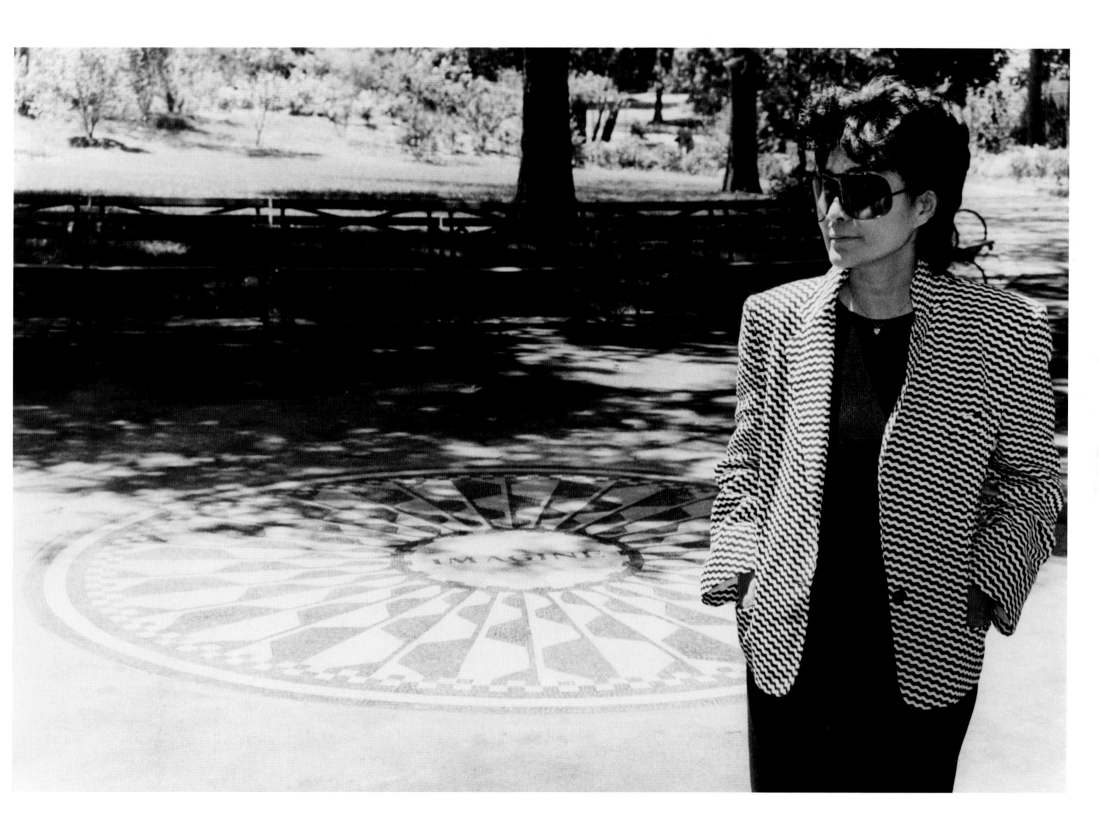

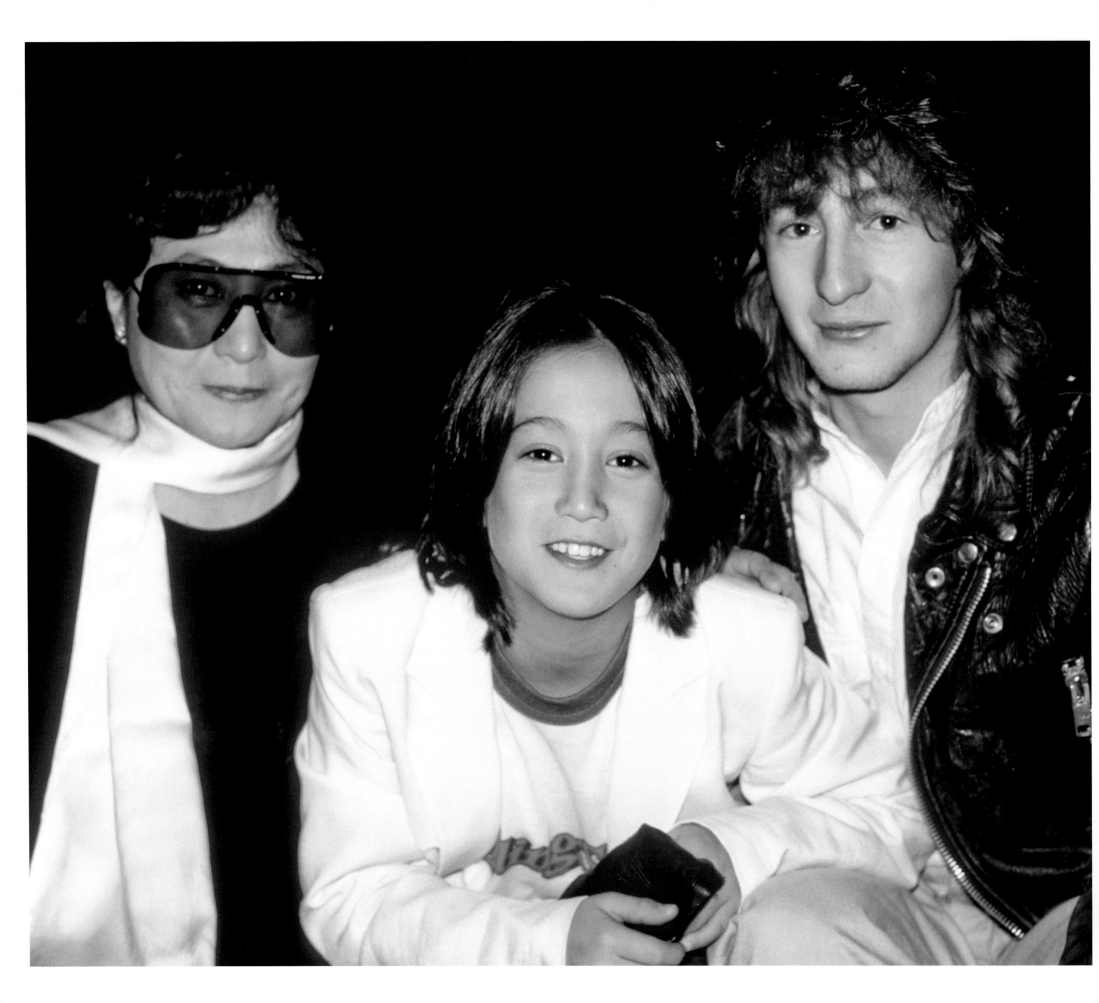

"Sean likes the fact that because he was the only child—he was always saying, 'I'm the only child, I mean, I don't have anybody around me' or something so it was good that he got together with Julian, and also, by the way, he got together with Kyoko too."

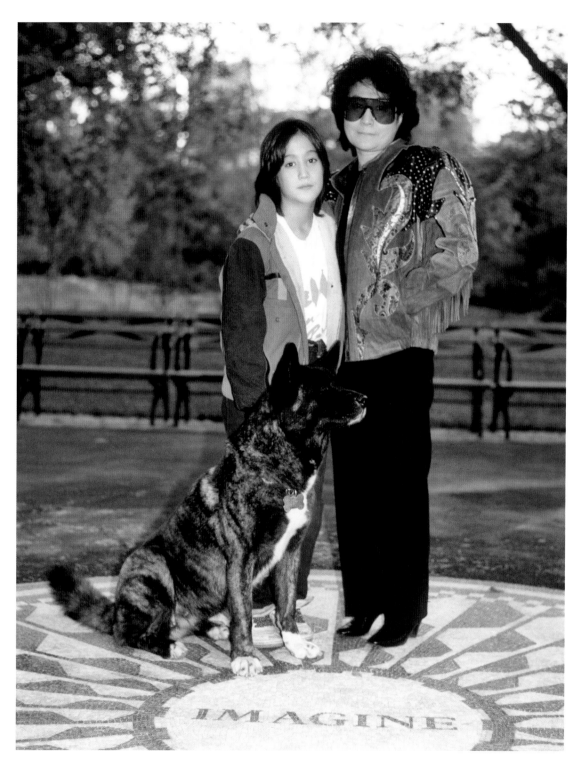

LEFT (L–R) Yoko Ono, Sean Lennon, and Julian Lennon during the *Stand by Me: A Portrait of Julian Lennon* film premiere at Carnegie Hall Cinema, New York City, December 1985.

ABOVE Sean Lennon, Yoko Ono, and Merry standing on the "Imagine" mosaic in Central Park, New York City, October 8, 1985.

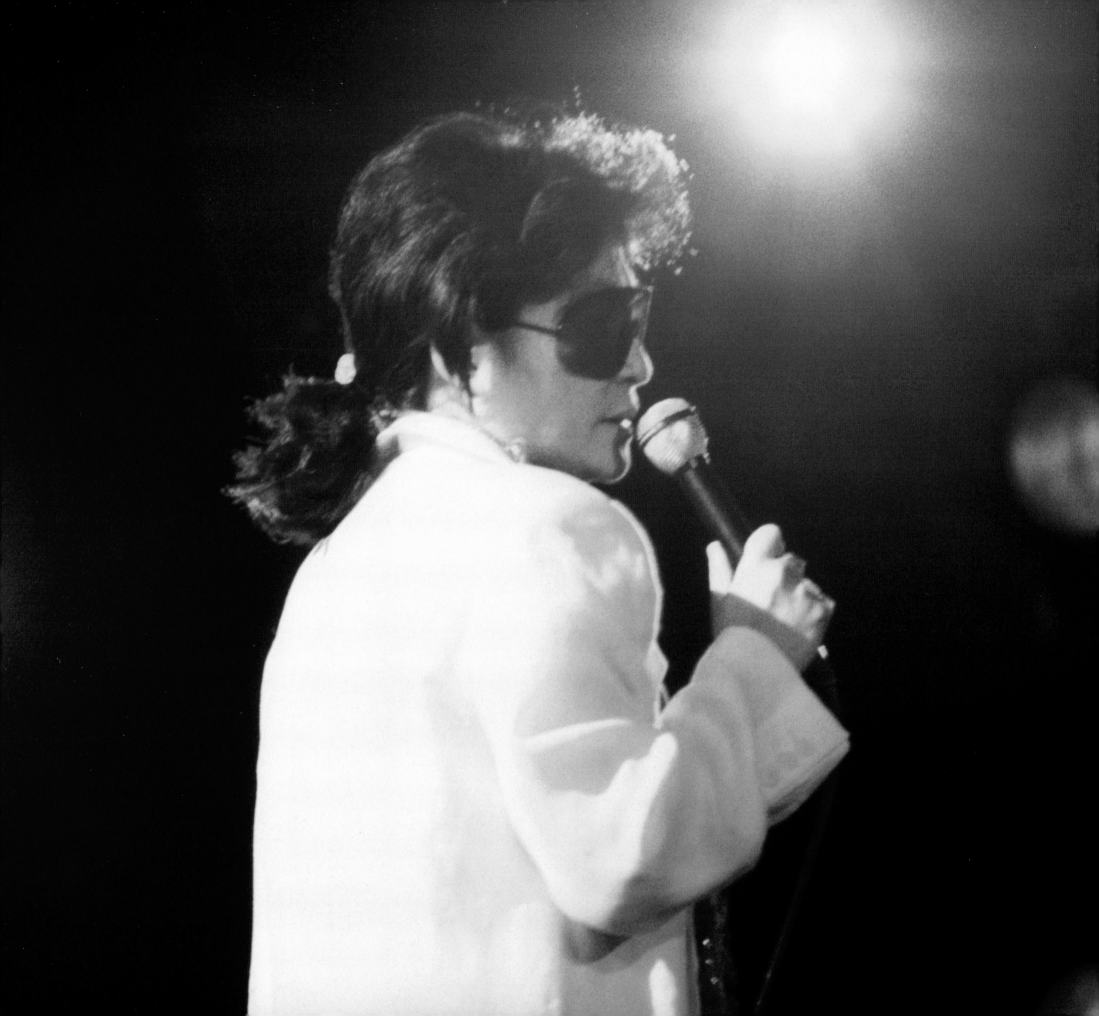

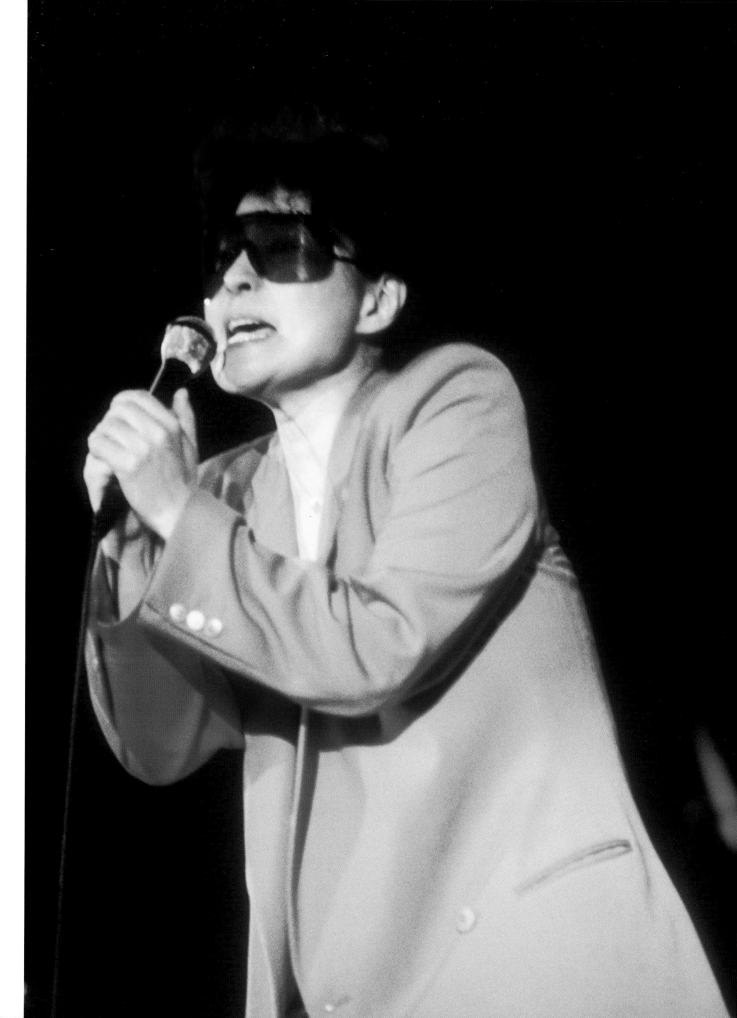

"I was attracted to what the voice expresses in terms of the humanity or the human suffering or whatever it was. And I was not attracted to that pristine, clear, trained vocal, which only expressed like nothing but just the notation of the composer or something like that."

LEFT Yoko Ono onstage during the *Starpeace* tour in London, England, March 1986.

RIGHT Yoko Ono onstage during the *Starpeace* tour in Budapest, Hungary, March 1986.

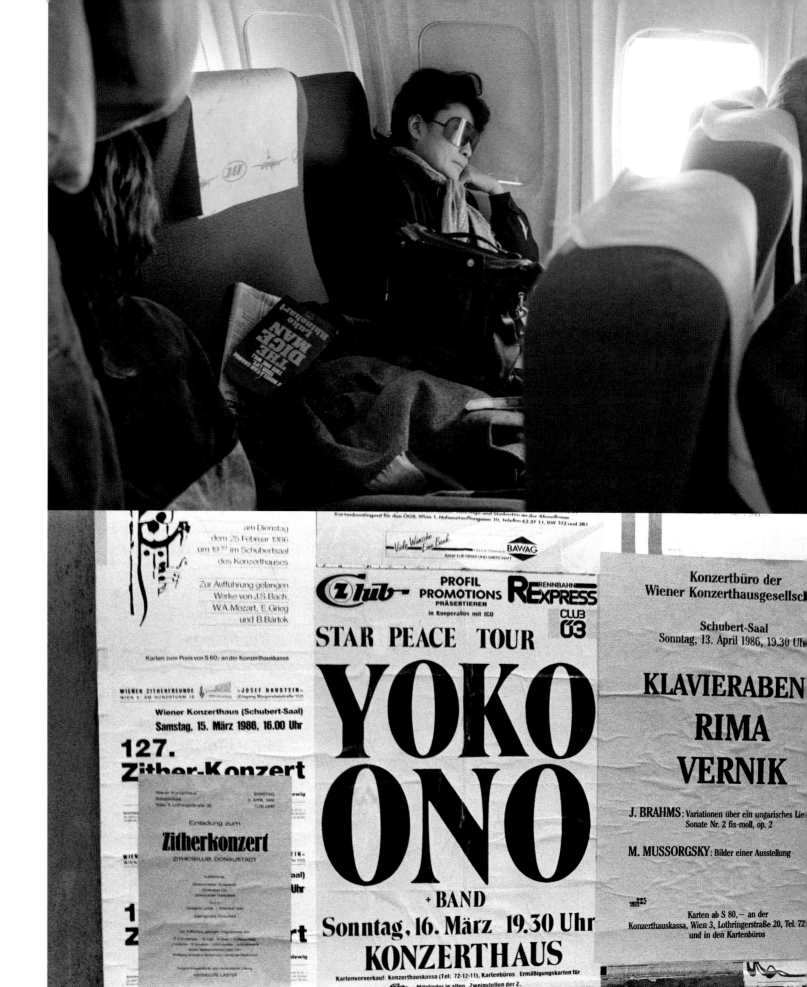

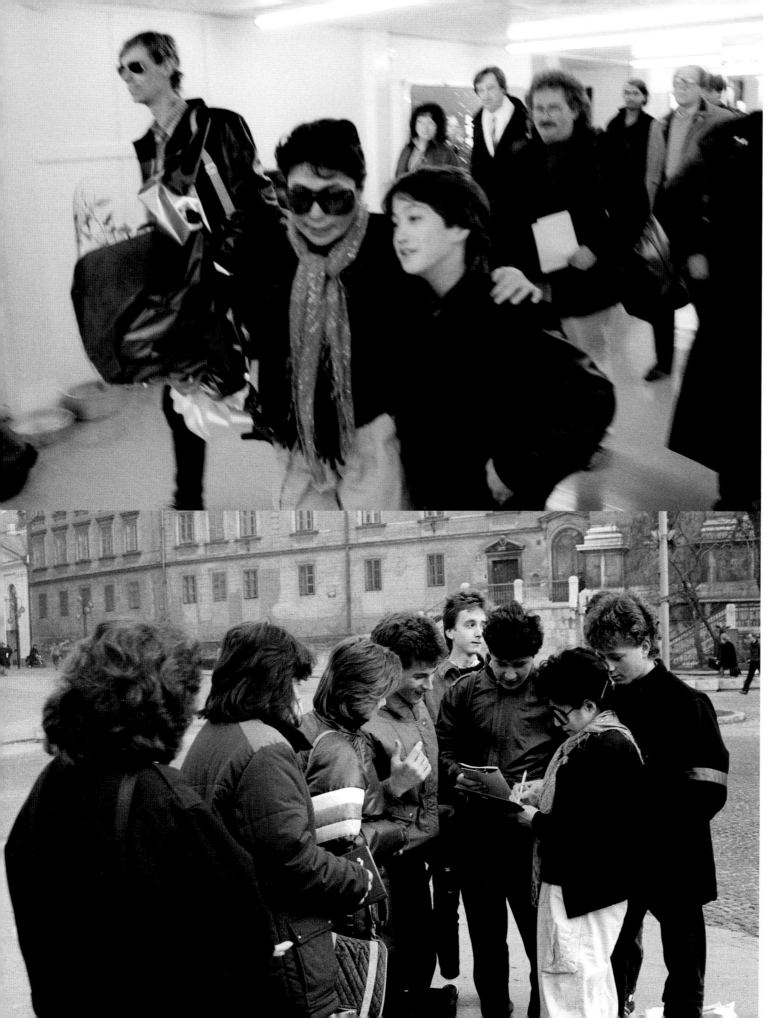

TOP LEFT Yoko Ono on a plane to London, England, March 1986.

BOTTOM LEFT Yoko Ono's *Starpeace* tour poster hanging in Vienna, Austria, March 1986.

TOP RIGHT Yoko Ono and Sean Lennon arriving in London, England, March 1986.

BOTTOM RIGHT Yoko Ono signing autographs on the streets of Yugoslavia, March 1986.

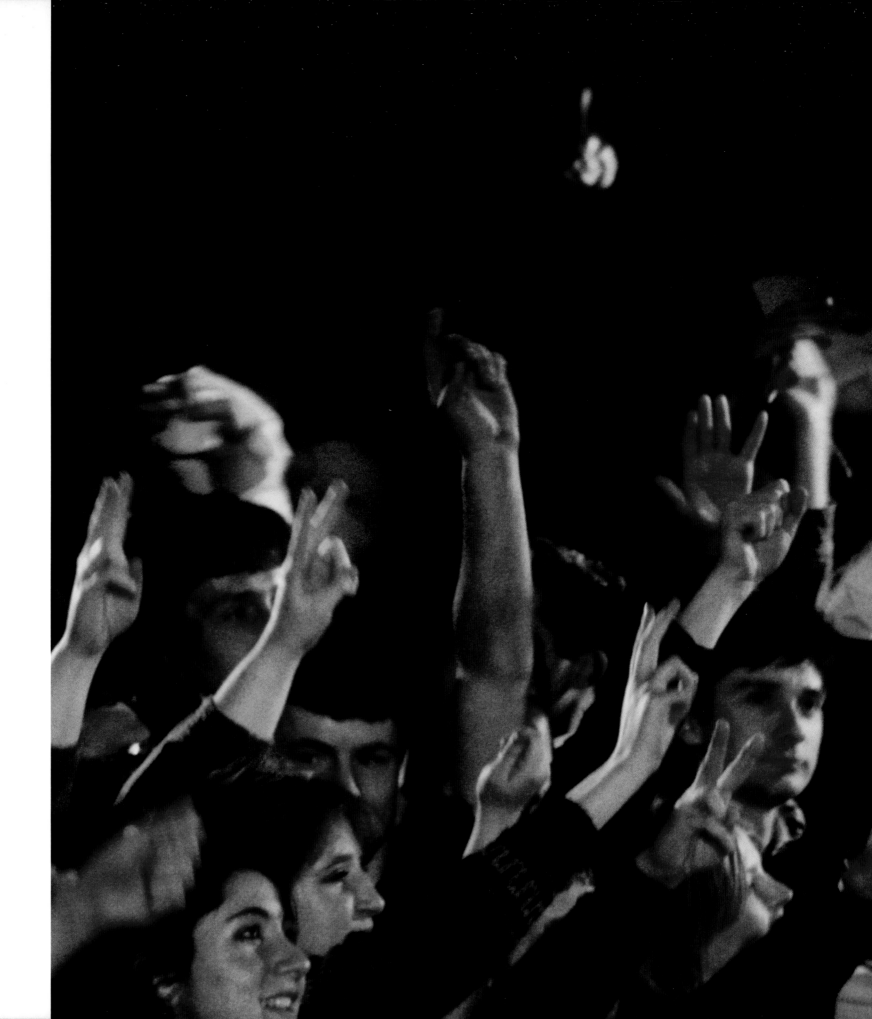

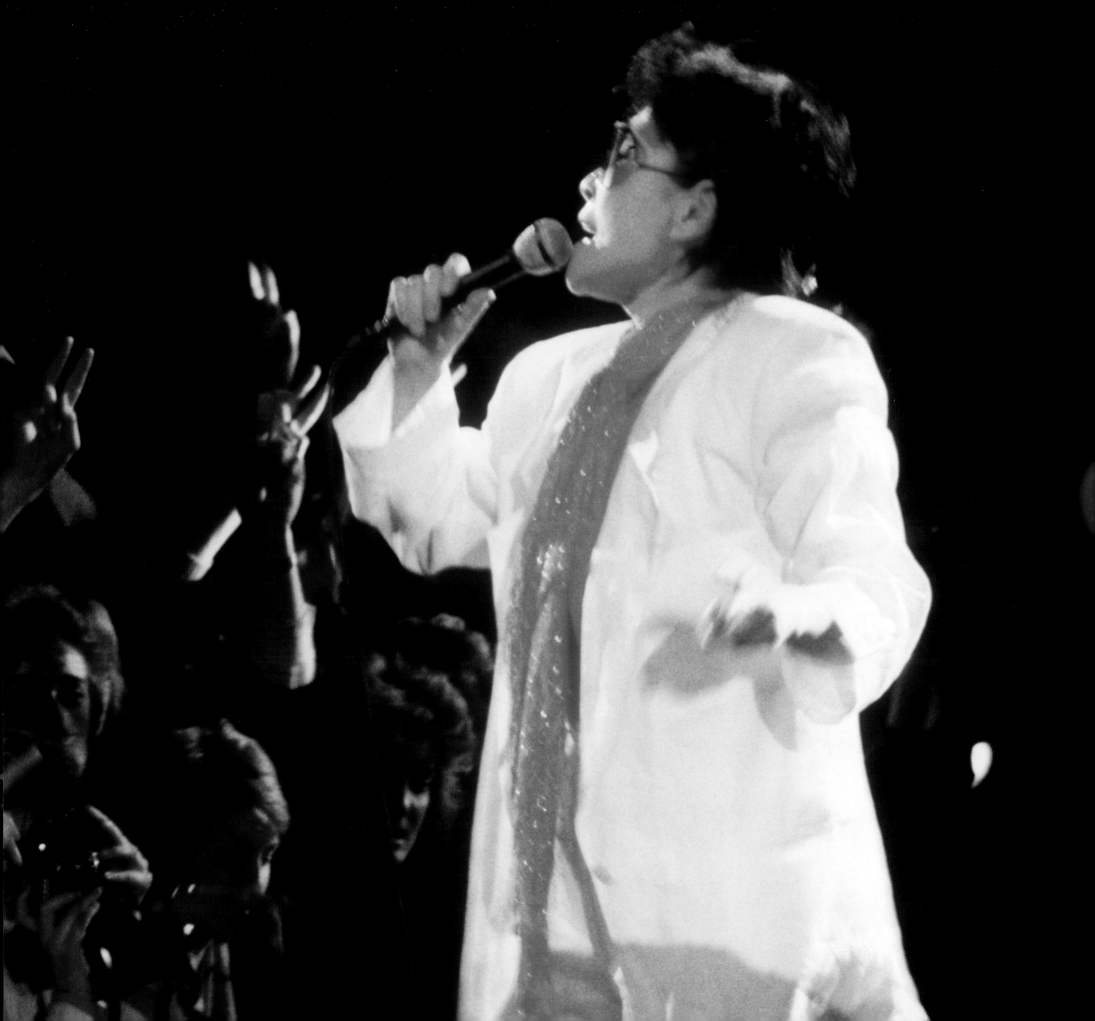

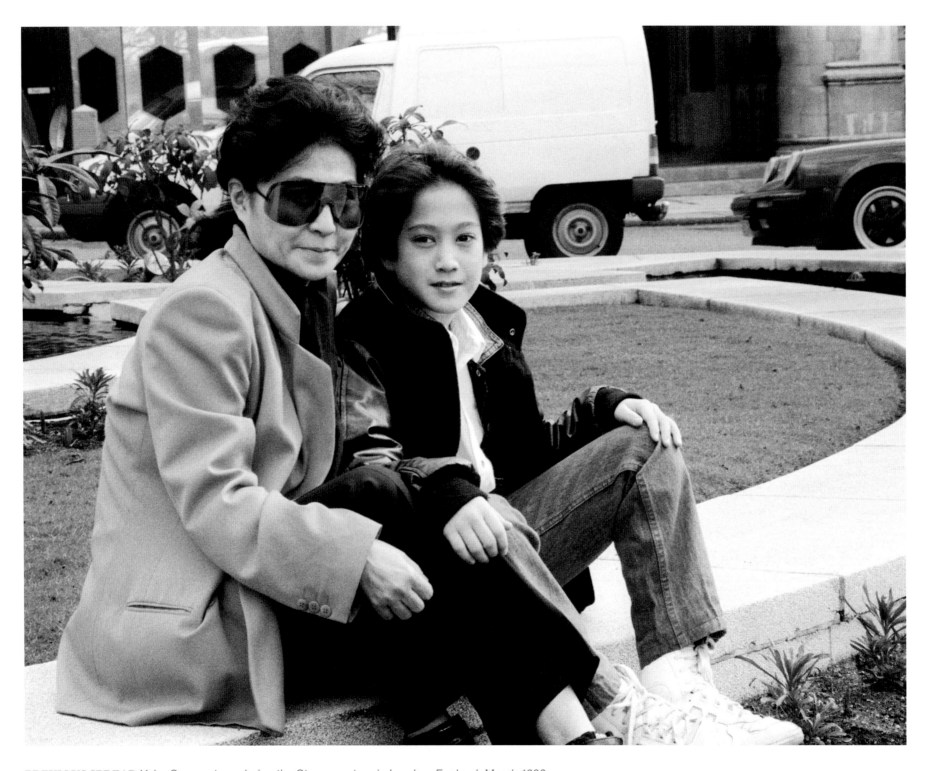

PREVIOUS SPREAD Yoko Ono onstage during the *Starpeace* tour in London, England, March 1986.

ABOVE Yoko Ono and Sean Lennon in London, England, March 1986.

RIGHT Yoko Ono in Yugoslavia, March 1986.

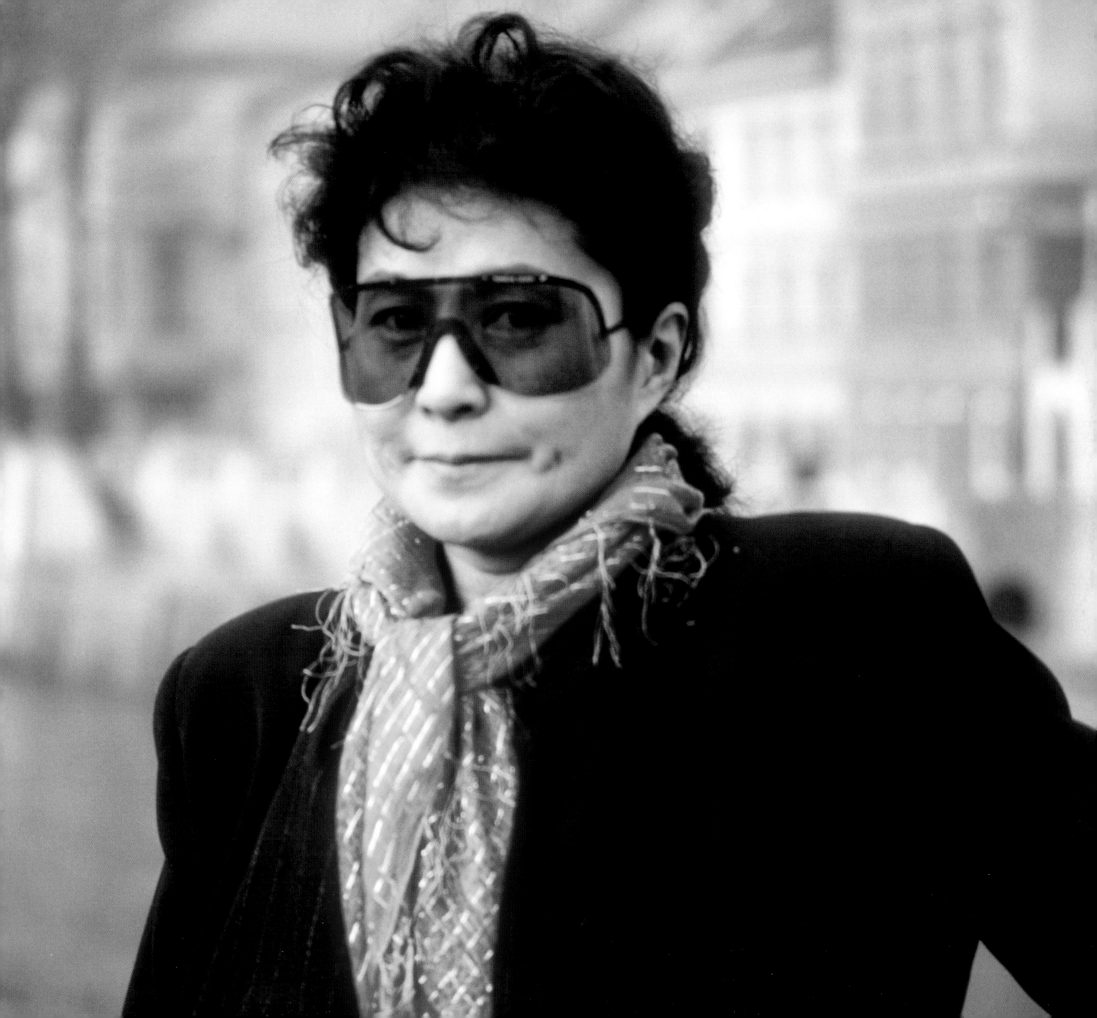

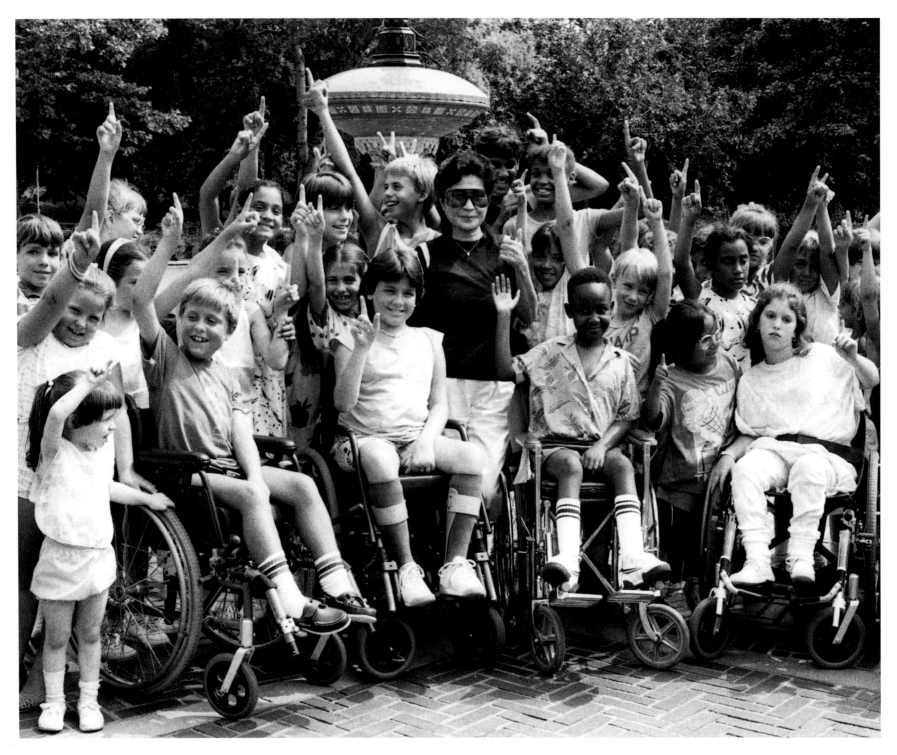

ABOVE Yoko Ono and students from Cardinal Spellman day school promoting the Muscular Dystrophy Association telethon in Central Park, New York City, July 23, 1986.

LEFT Yoko Ono and Liza Minnelli manning the phones for the Muscular Dystrophy Association telethon, New York City, July 23, 1986.

"Anything can inspire you. The inspiration is actually within you. And if you are inspired, even the drop of a leaf is going to inspire you. We were just doing what we can do."

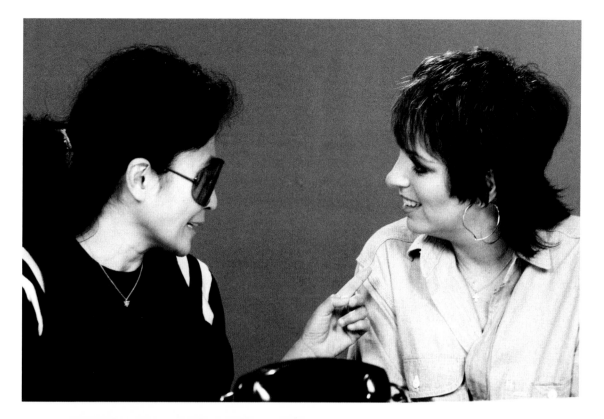

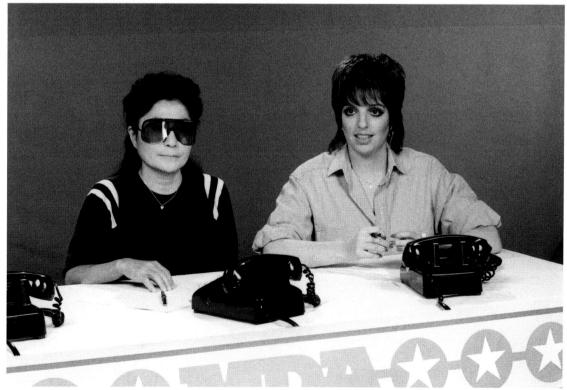

131

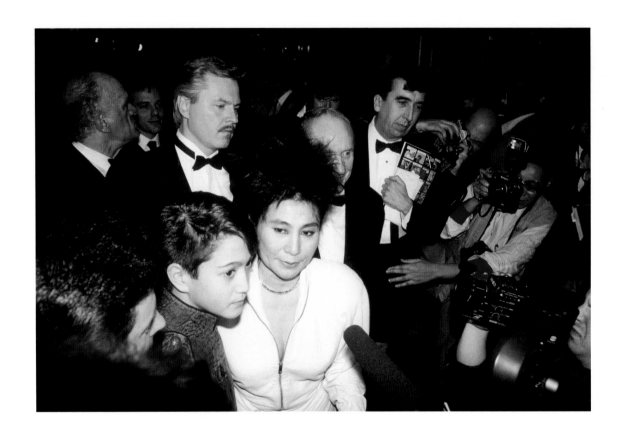

George Harrison, Ringo Starr, Yoko Ono, Sean Lennon, and Julian Lennon during the induction of the Beatles into the Rock and Roll Hall of Fame at the Waldorf-Astoria, New York City, January 20, 1988.

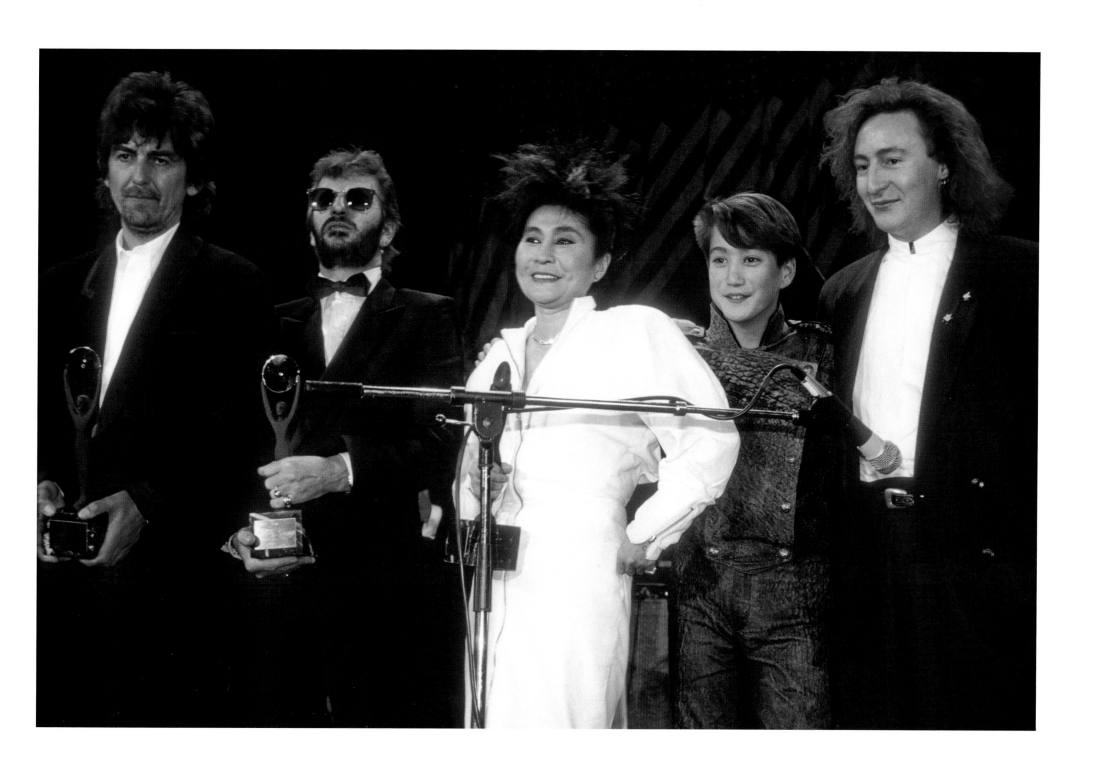

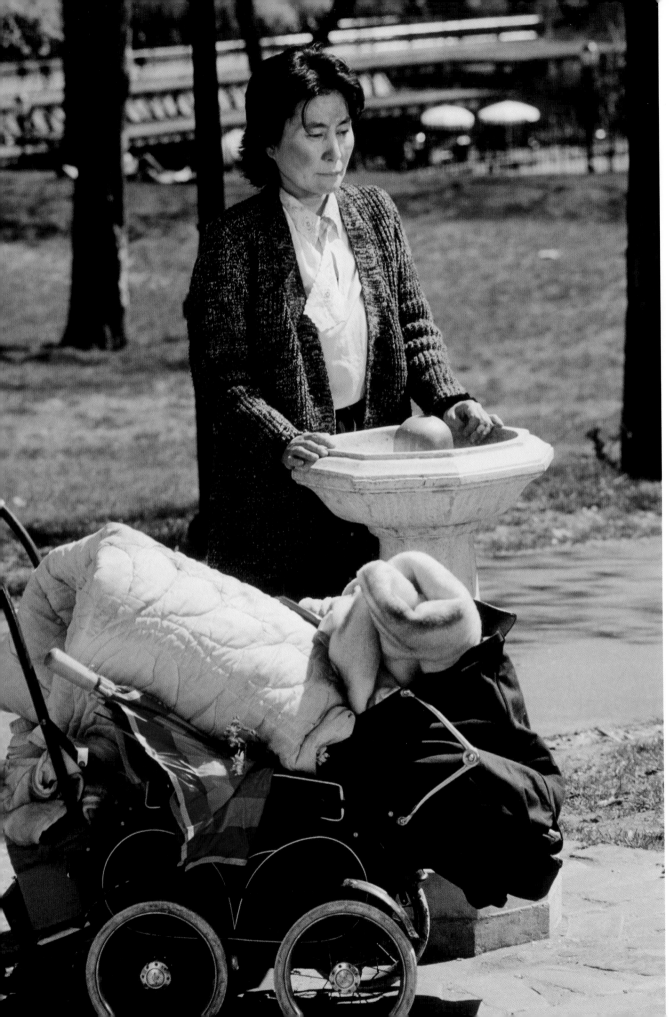

"We're all together really. We're just one body and part of our bodies are kind of asleep and we have to wake up everything to really create a beautiful world. And the world is not so beautiful now. And one of the reasons is because half of the room—half of the world, which is women . . . you're not using women's power. And that is actually very sad for the whole of the world, not just for women."

Yoko Ono during production of the film *Homeless* in Central Park, New York City, April 1989.

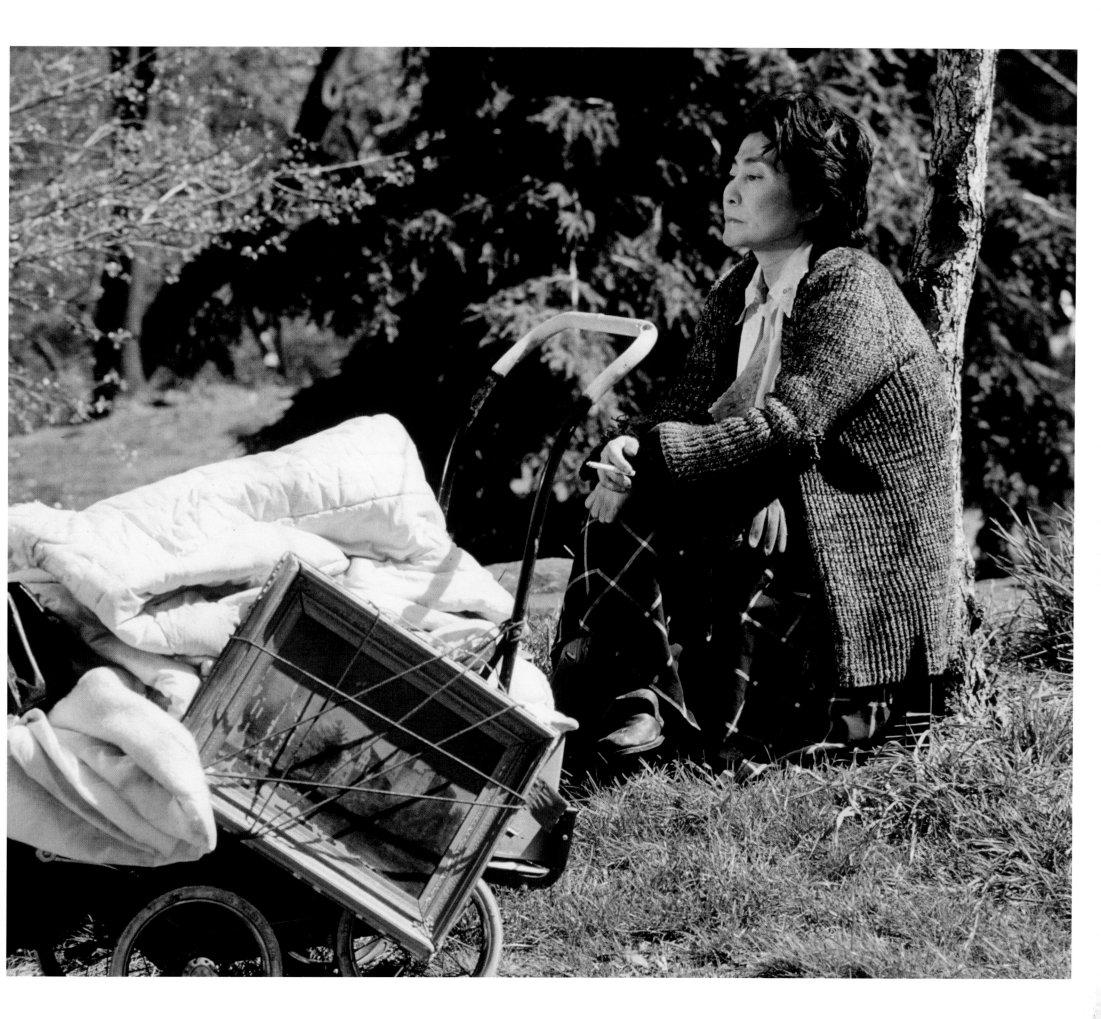

Yoko Ono presenting "Imagine" at the United Nations, New York City, October 1990.

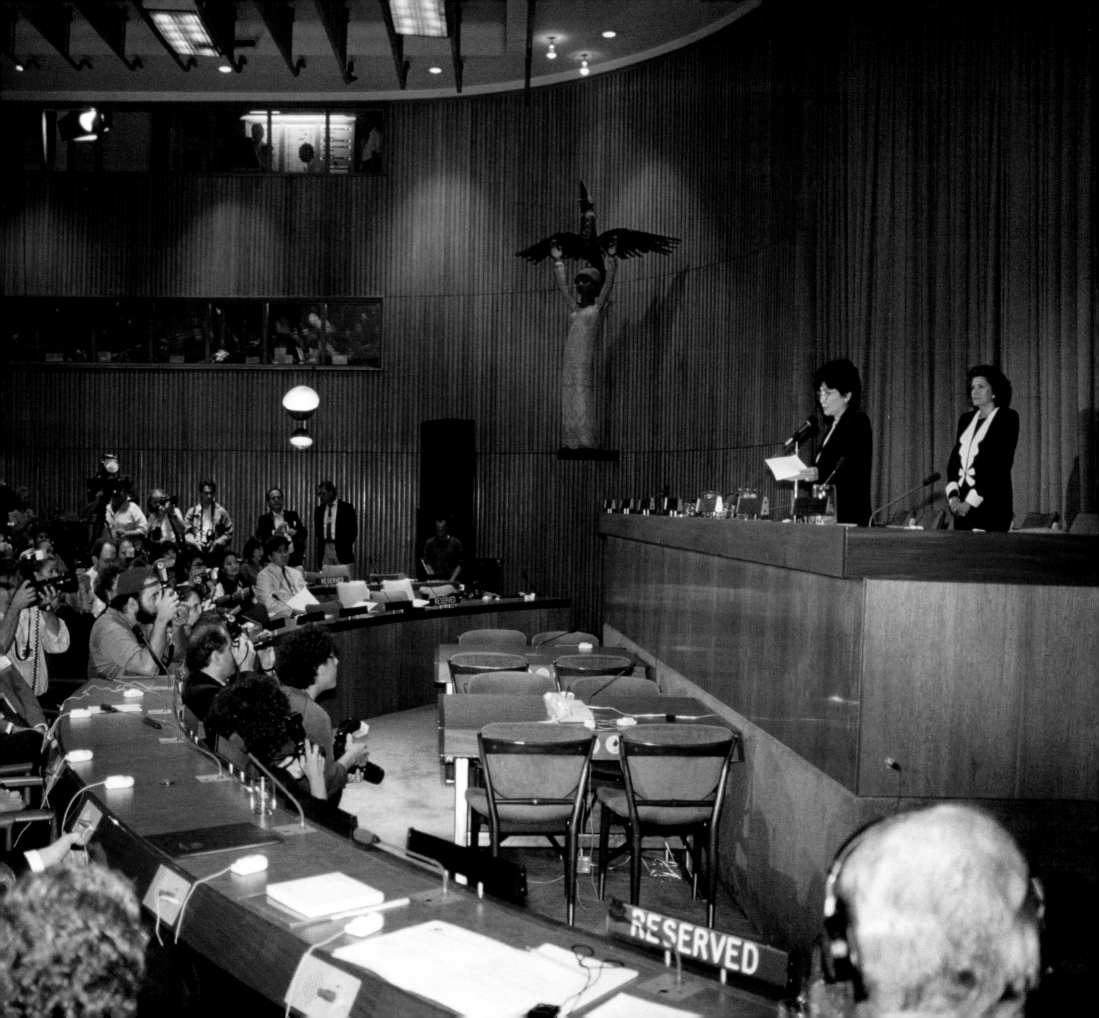

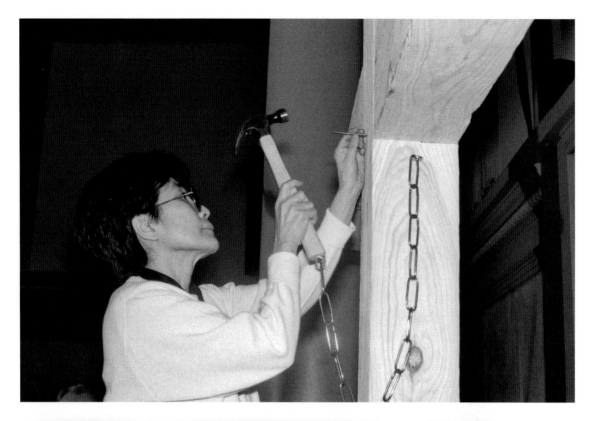

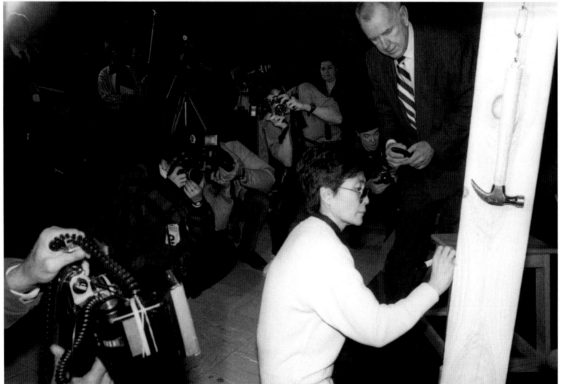

"I really think that if you started to create art for money, and if you don't get the money, I think you feel like a fool. But if you're not doing it for money, but you're doing it for art, then you know what the value of it is. It's not money."

ABOVE Yoko Ono with her piece *Painting to Hammer a Nail In No. 4* at Judson Memorial Church, New York City, January 19, 1990.

RIGHT Yoko Ono and Sean Lennon with her piece *Play It by Trust*, New York City, September 1991.

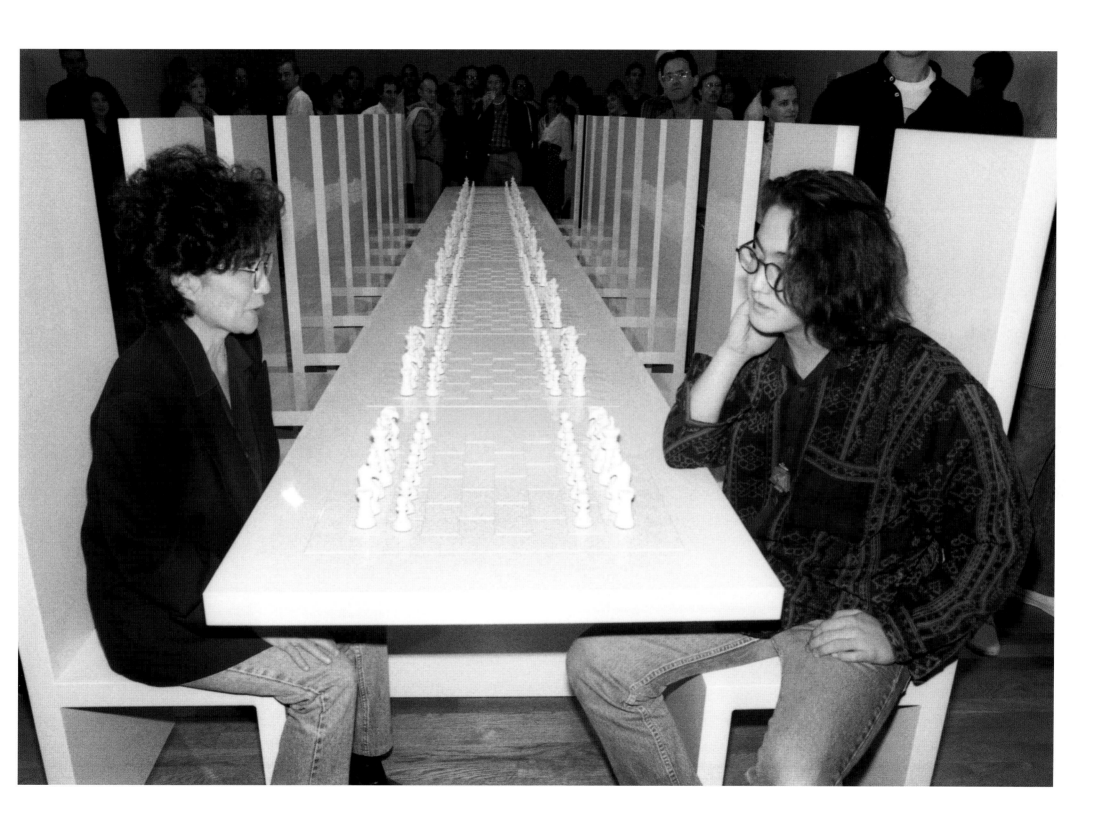

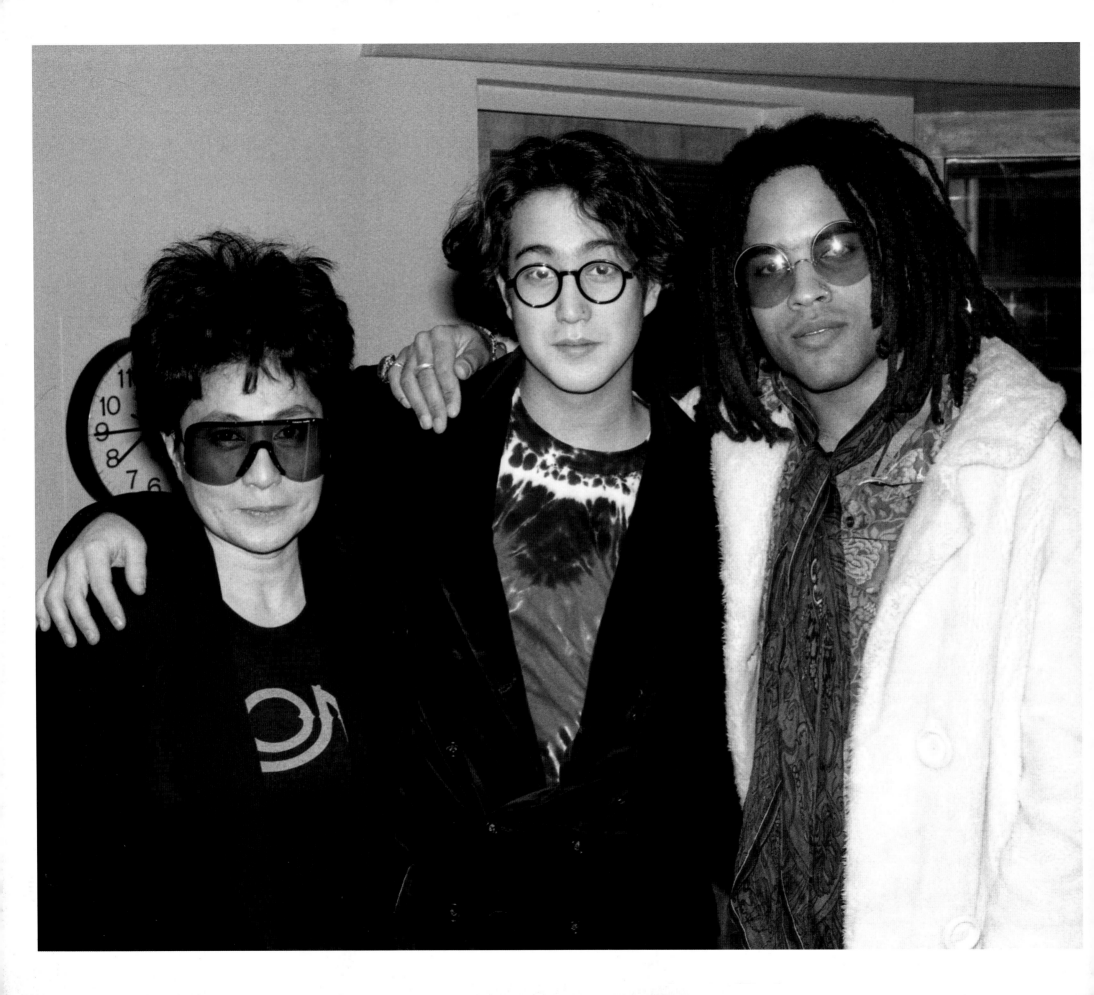

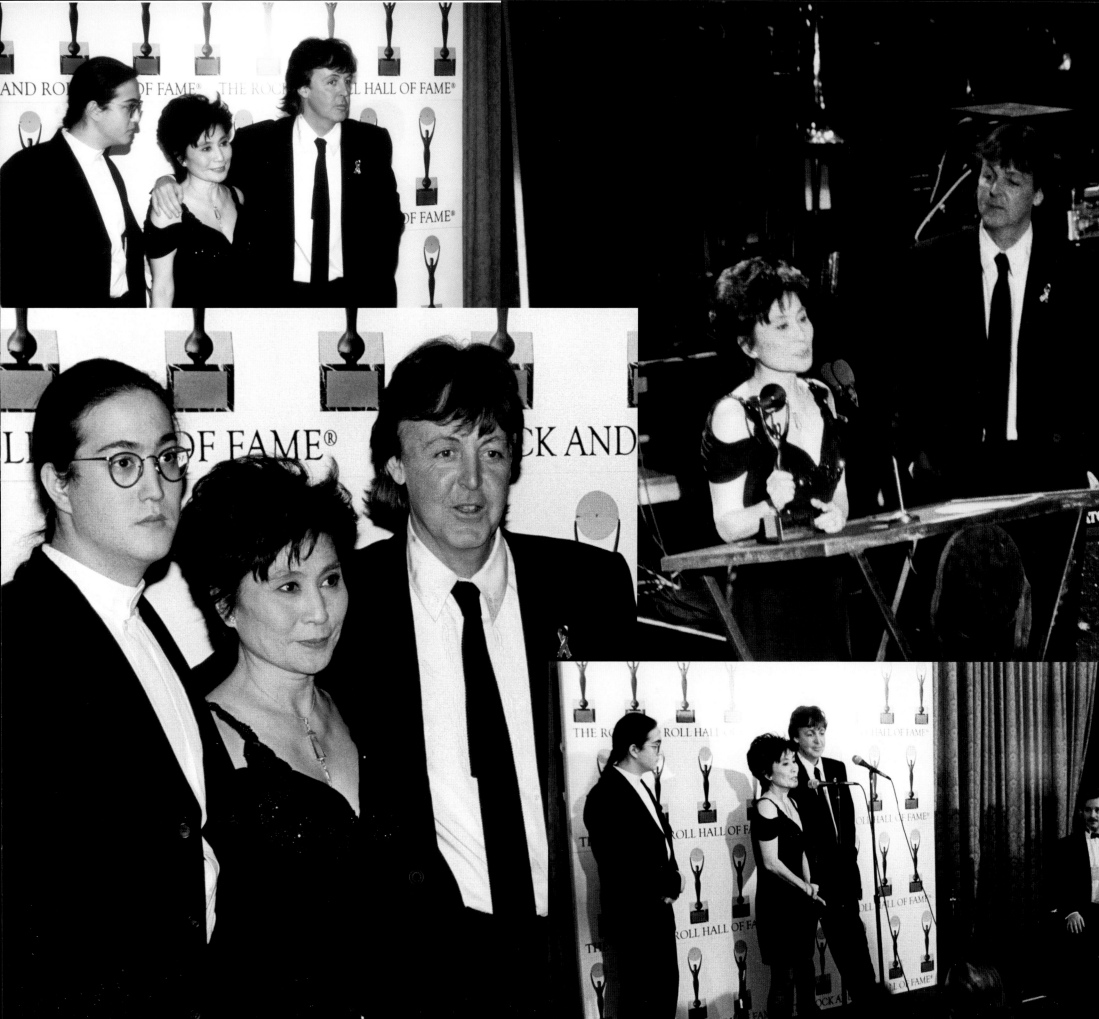

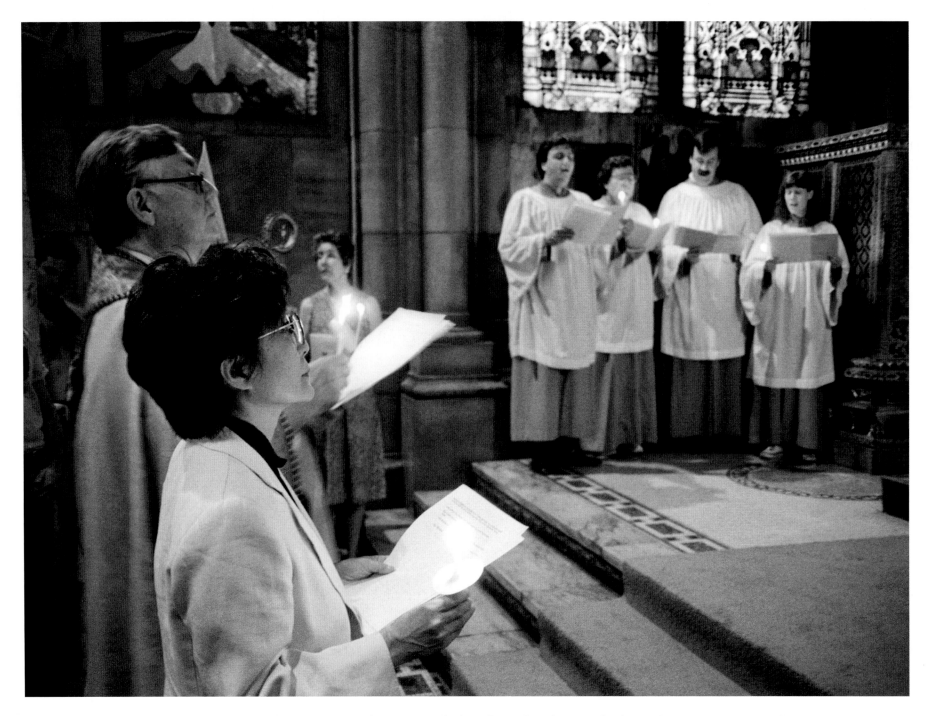

"I think that I'm in touch with my emotions and that's why I can bring them out maybe. That's my thing."

PREVIOUS SPREAD, LEFT Yoko Ono, Sean Lennon, and Lenny Kravitz, New York City, January 1991.

PREVIOUS SPREAD, RIGHT Sean Lennon, Yoko Ono, and Paul McCartney during the induction of John Lennon into the Rock and Roll Hall of Fame at the Waldorf-Astoria, New York City, January 19, 1994.

ABOVE Yoko Ono viewing the Keith Haring altarpiece at the Cathedral Church of St. John the Divine, New York City, June 1994.

RIGHT Sean Lennon and Yoko Ono onstage at the Knitting Factory, New York City, March 6, 1996.

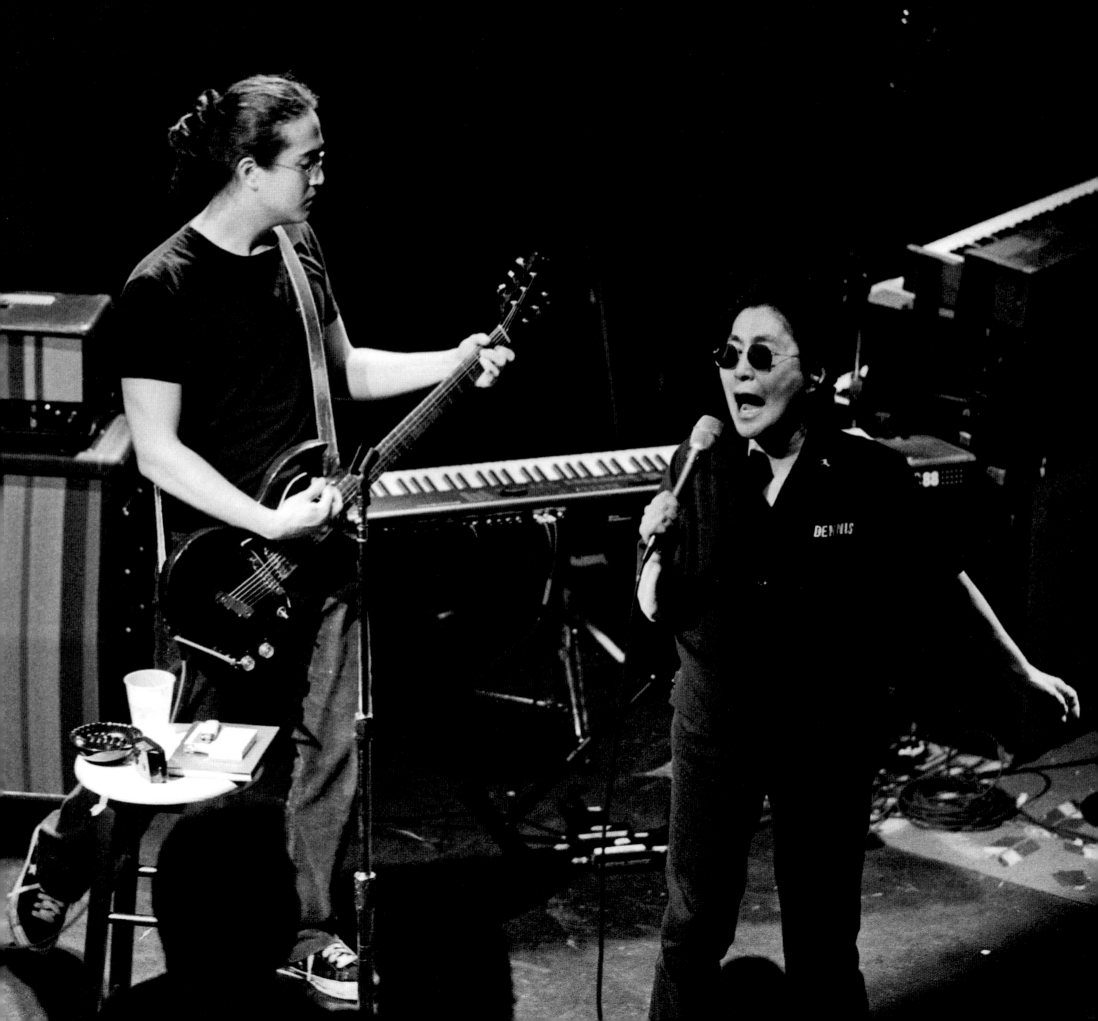

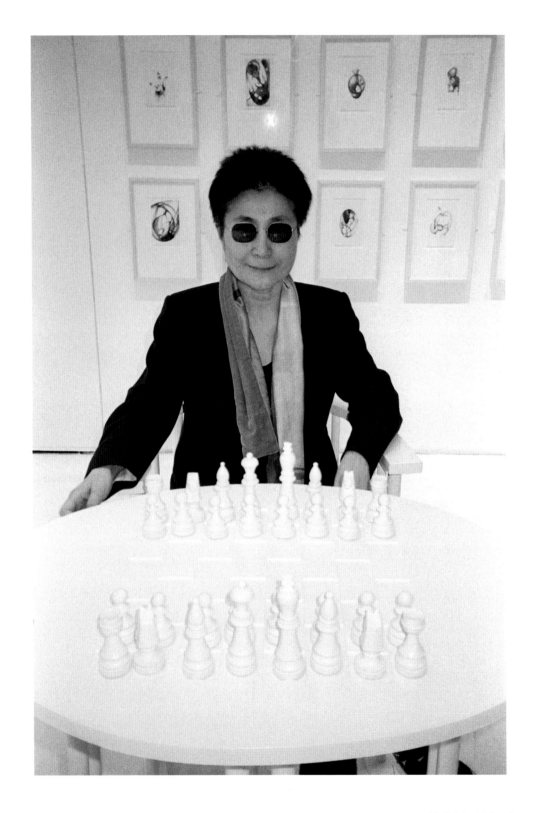

Kyoko Helfrich, Yoko Ono, and Sean Lennon during Yoko's show
at the André Emmerich Gallery, New York City, April 1998.

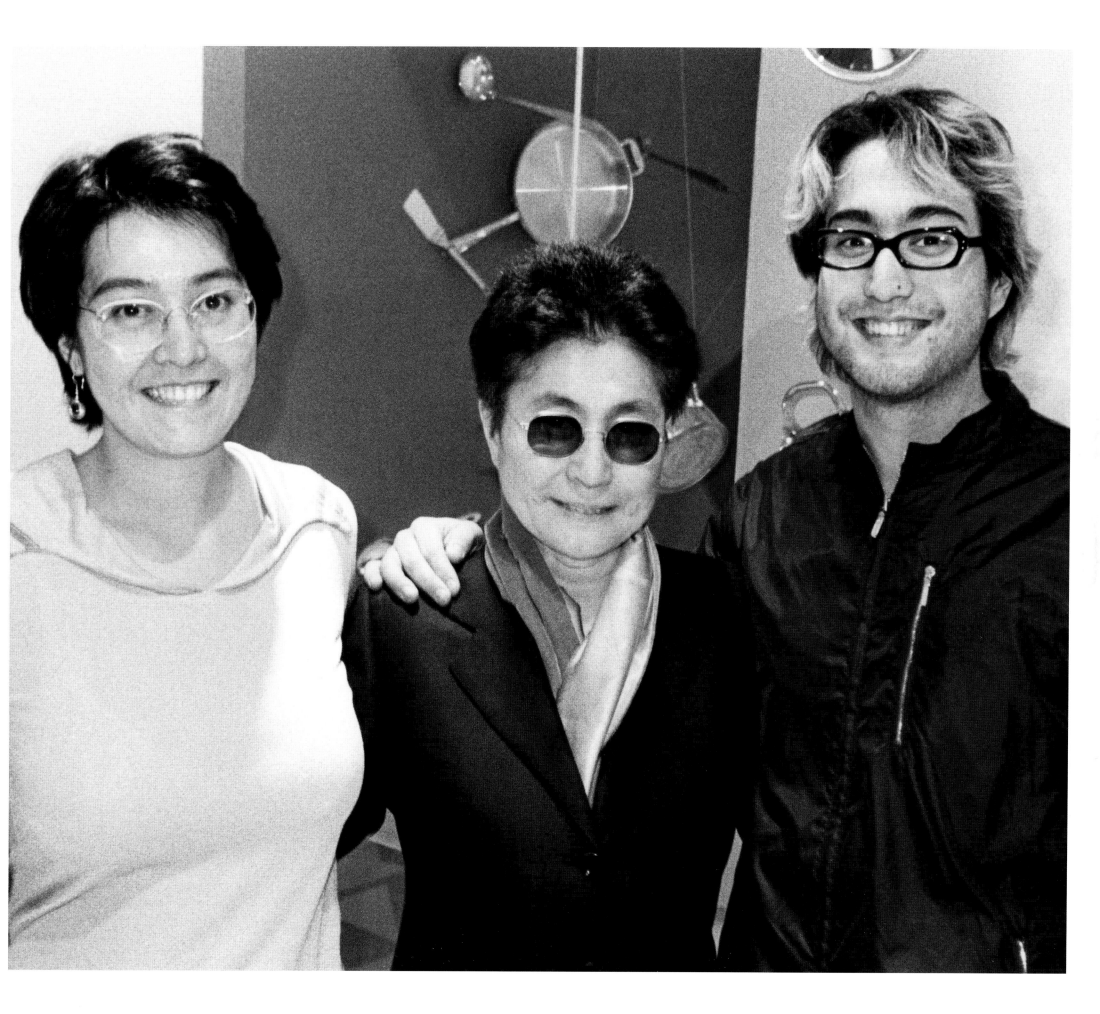

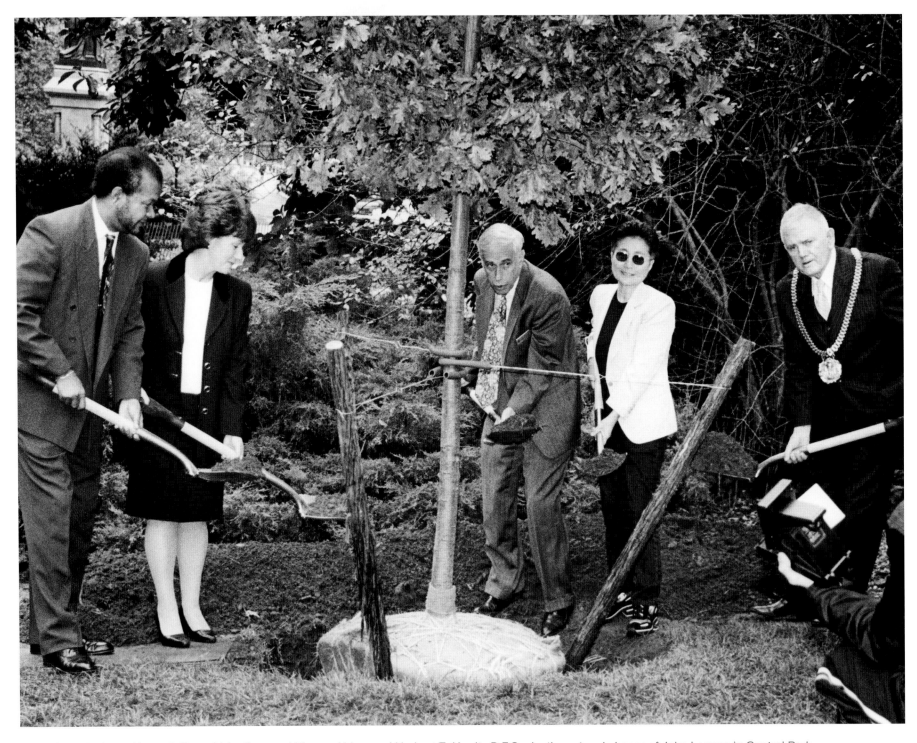

Parks Commissioner Henry J. Stern, Yoko Ono, and Mayor of Liverpool Herbert E. Herrity D.F.C. planting a tree in honor of John Lennon in Central Park, New York City, October 1998.

"Now we're in the process of really making Strawberry Fields come true."

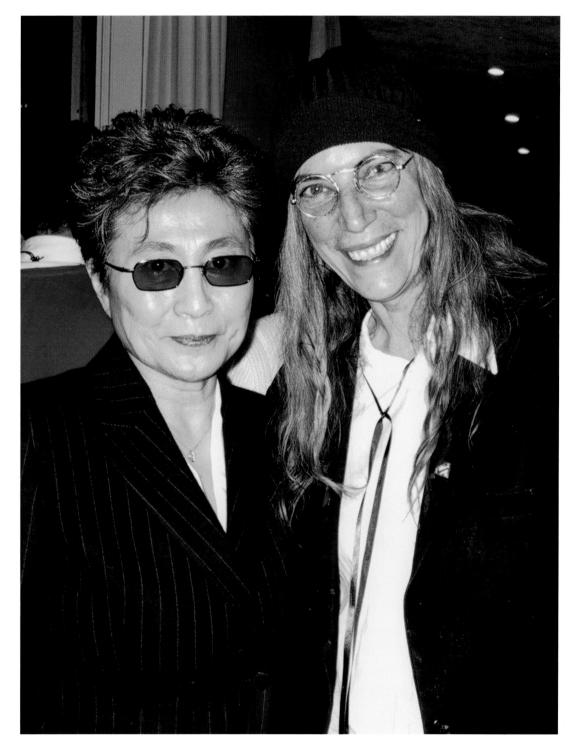

Yoko Ono and Patti Smith during the presentation of the first-ever LennonOno Peace Grant at the United Nations, New York City, October 9, 2002.

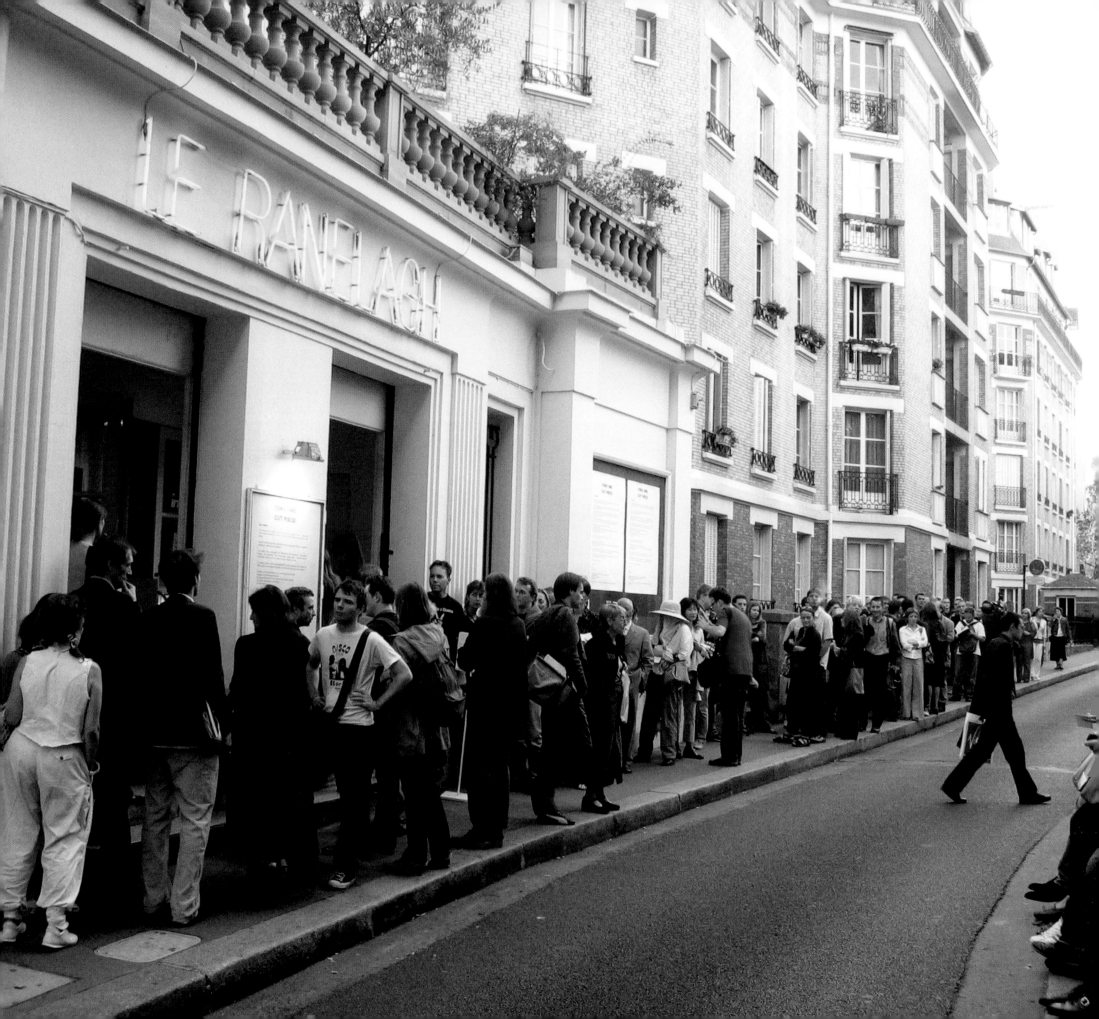

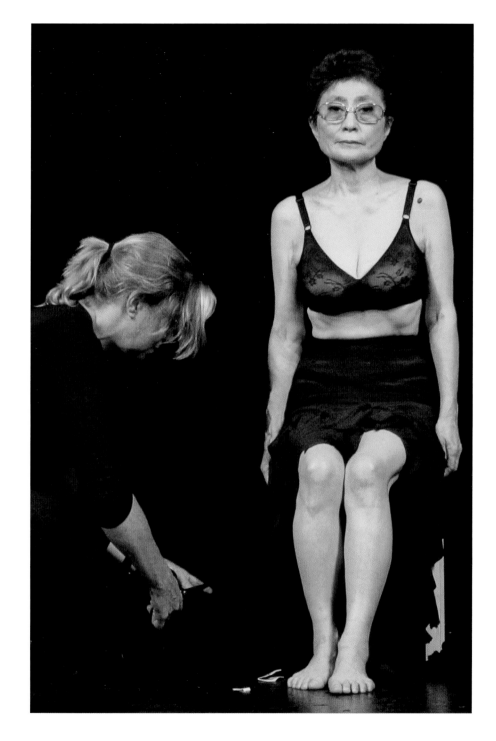

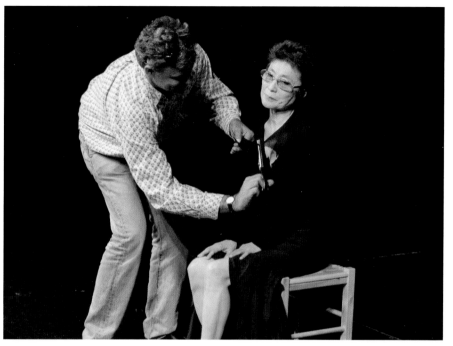

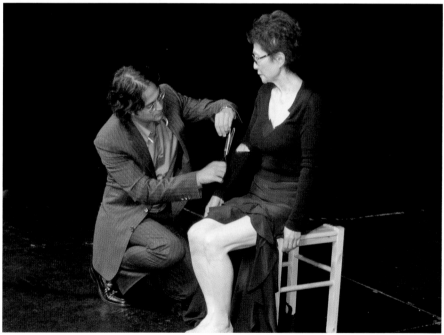

LEFT The line to see Yoko's *Cut Piece* at the Théâtre du Ranelagh in Paris, France, September 15, 2003.

ABOVE, LEFT Elizabeth Gregory-Gruen, **ABOVE, TOP RIGHT** Unknown, **ABOVE, BOTTOM RIGHT** Sean Lennon and Yoko Ono during a performance of *Cut Piece* at the Théâtre du Ranelagh in Paris, France, September 15, 2003.

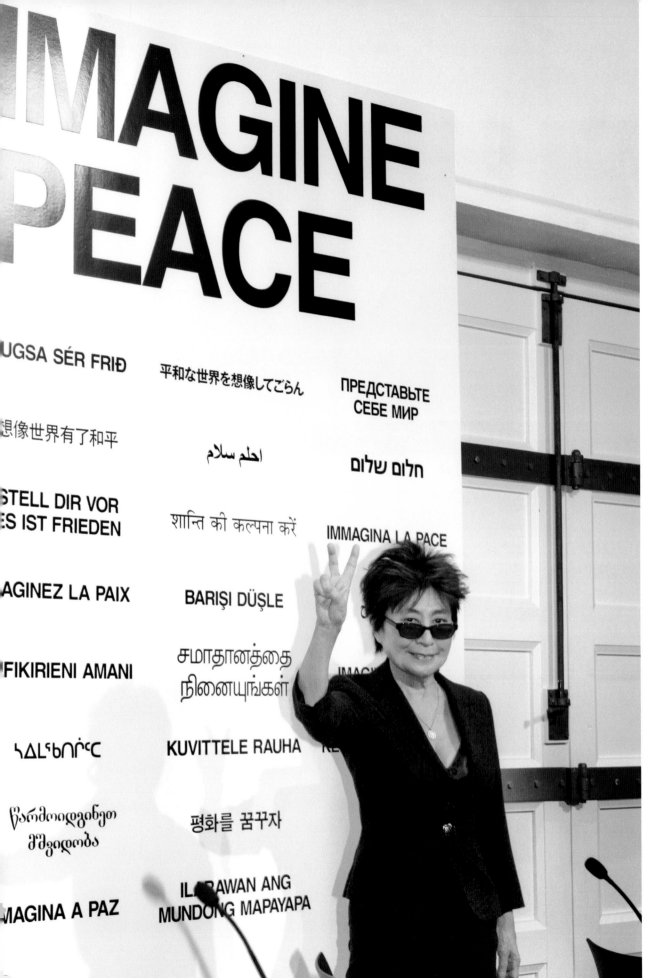

"[The Imagine Peace Tower is in Iceland] because Iceland is the northern[most] country, and in terms of direction, Oriental direction, north is the wisdom and the power, and you want that wisdom to spread all the way [down] from the north."

Sean Lennon, Yoko Ono, Ringo Starr, and Olivia Harrison during the unveiling of the Imagine Peace Tower in Reykjavík, Iceland, October 9, 2007.

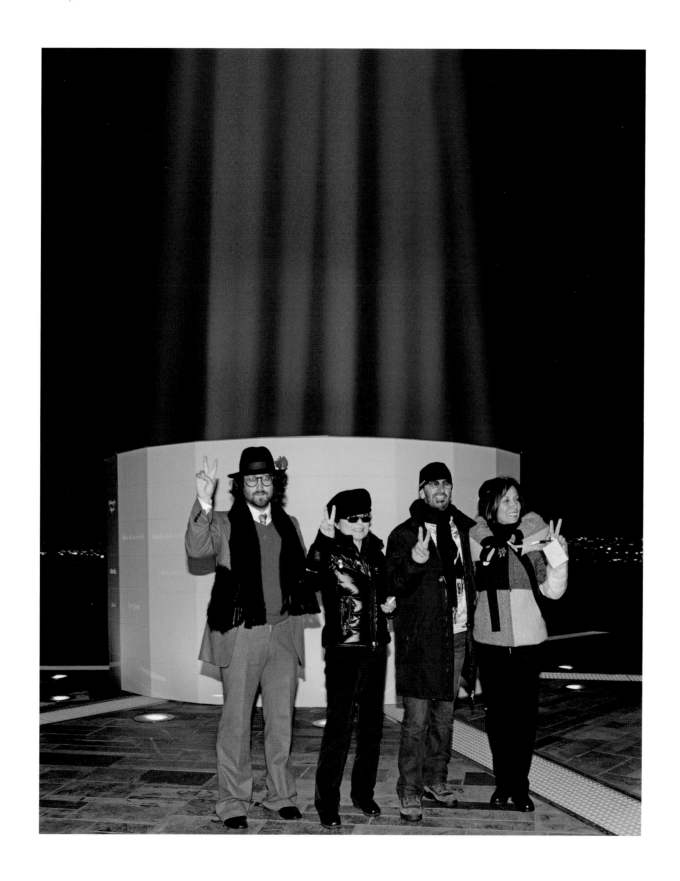

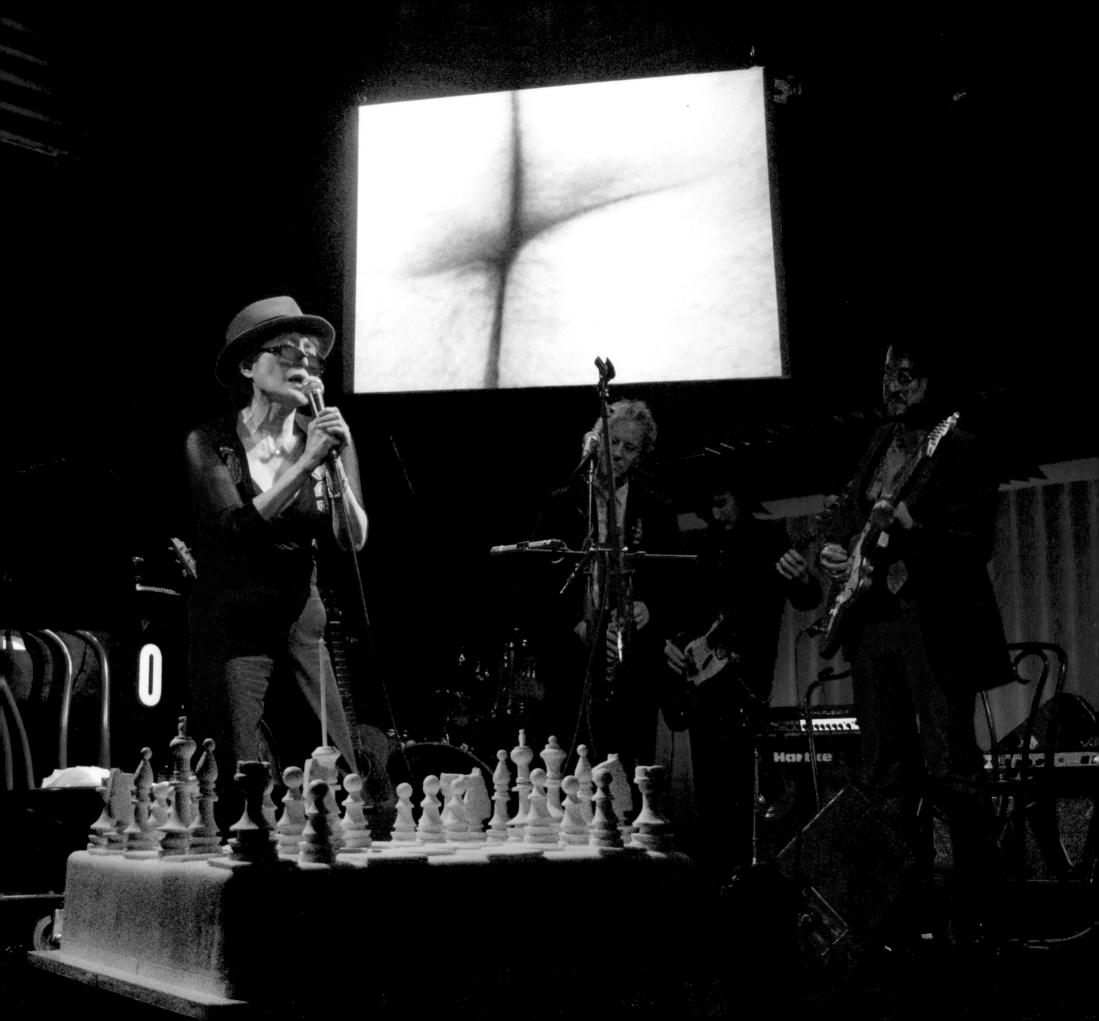

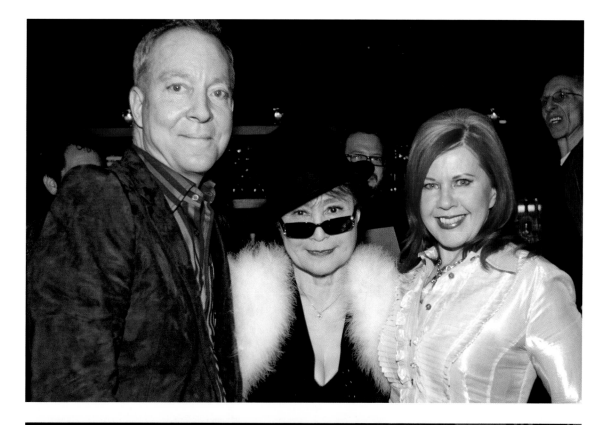

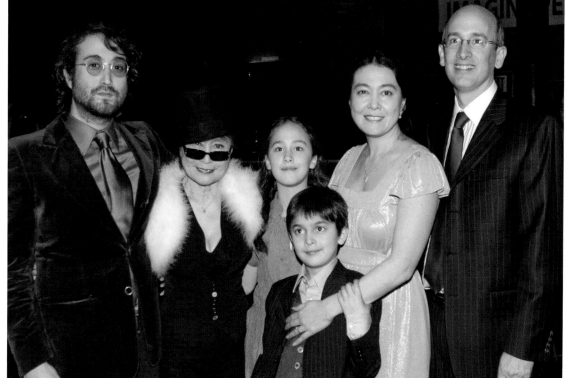

LEFT Yoko Ono, Sean Lennon, and their band performing during Yoko's seventy-fifth birthday party at Joe's Pub, New York City, February 18, 2008.

TOP Yoko Ono with Fred Schneider and Kate Pierson of the B-52's during Yoko's seventy-fifth birthday party at Joe's Pub, New York City, February 18, 2008.

BOTTOM (L–R) Sean Lennon, Yoko Ono, Emi, Jack, Kyoko, and Jim Helfrich during Yoko's seventy-fifth birthday party at Joe's Pub, New York City, February 18, 2008.

On reuniting with her daughter, Kyoko:

"What happened was, [Kyoko] came out and said that 'We are planning to have a child and my husband thinks that I should get in touch with you before I have a child.' So it was her husband that made it well for us."

153

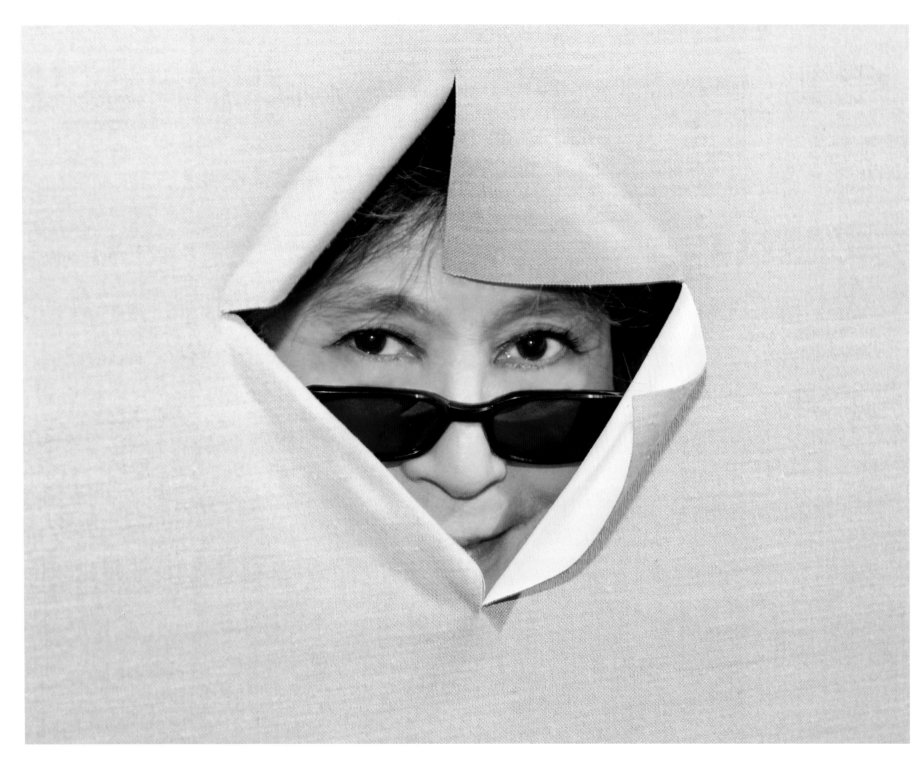

Yoko Ono during her retrospective show at Galerie Lelong, New York City, April 18, 2008.

On her art objects:

"Each piece had something to do with my own life, and how to deal with my life. So in a way it was something that made me move on."

154

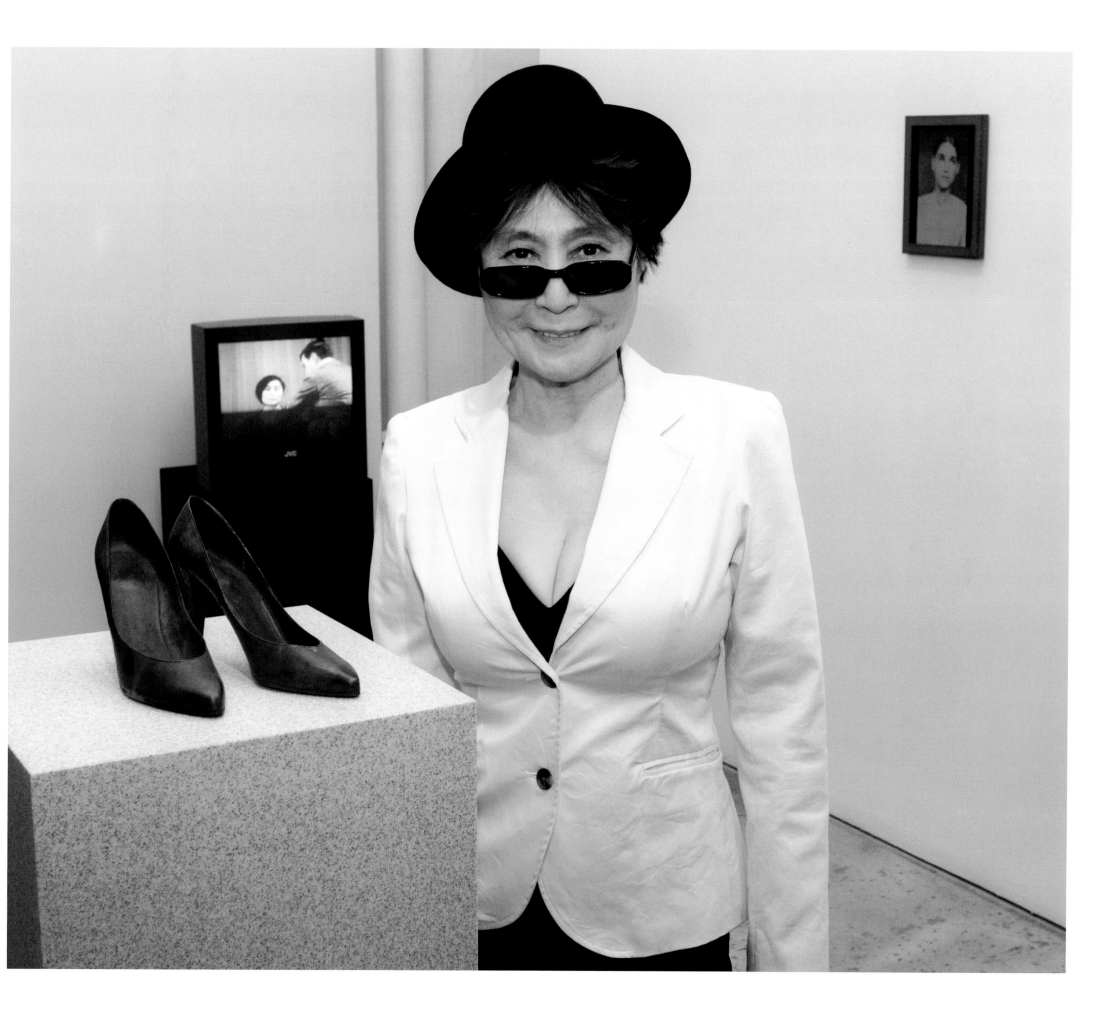

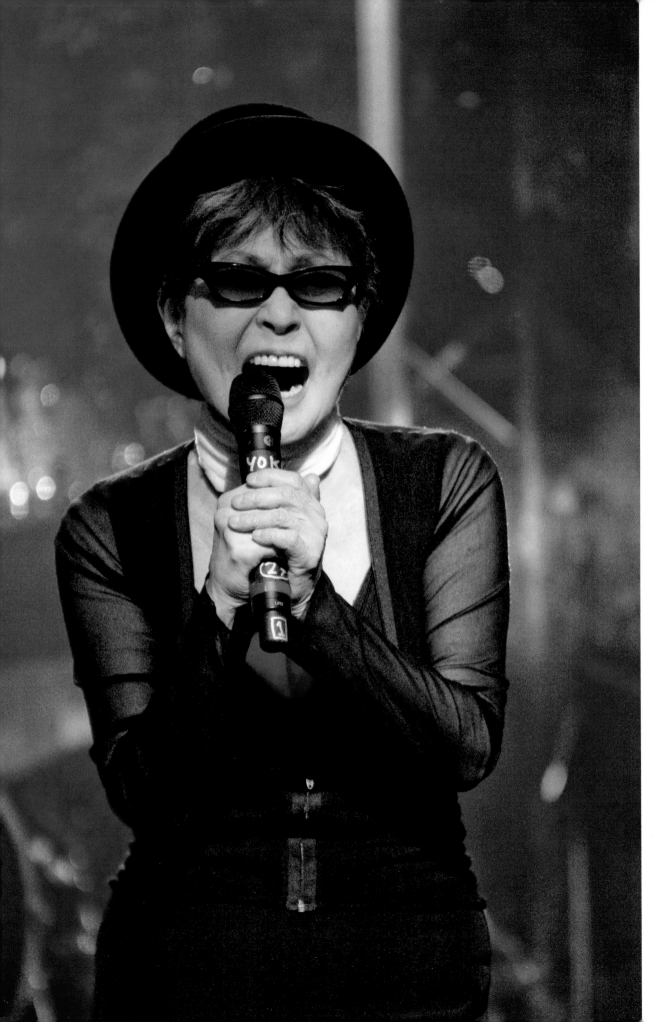

"Yes, well you know, I have an infamous voice. See there's a very interesting difference between how to sing opera and how to sing German lieder and French chanson, so I did get trained in all that. But I wanted to break that. I wanted to break out of that."

Yoko Ono onstage at the Brooklyn Academy of Music in Brooklyn, New York, February 16, 2010.

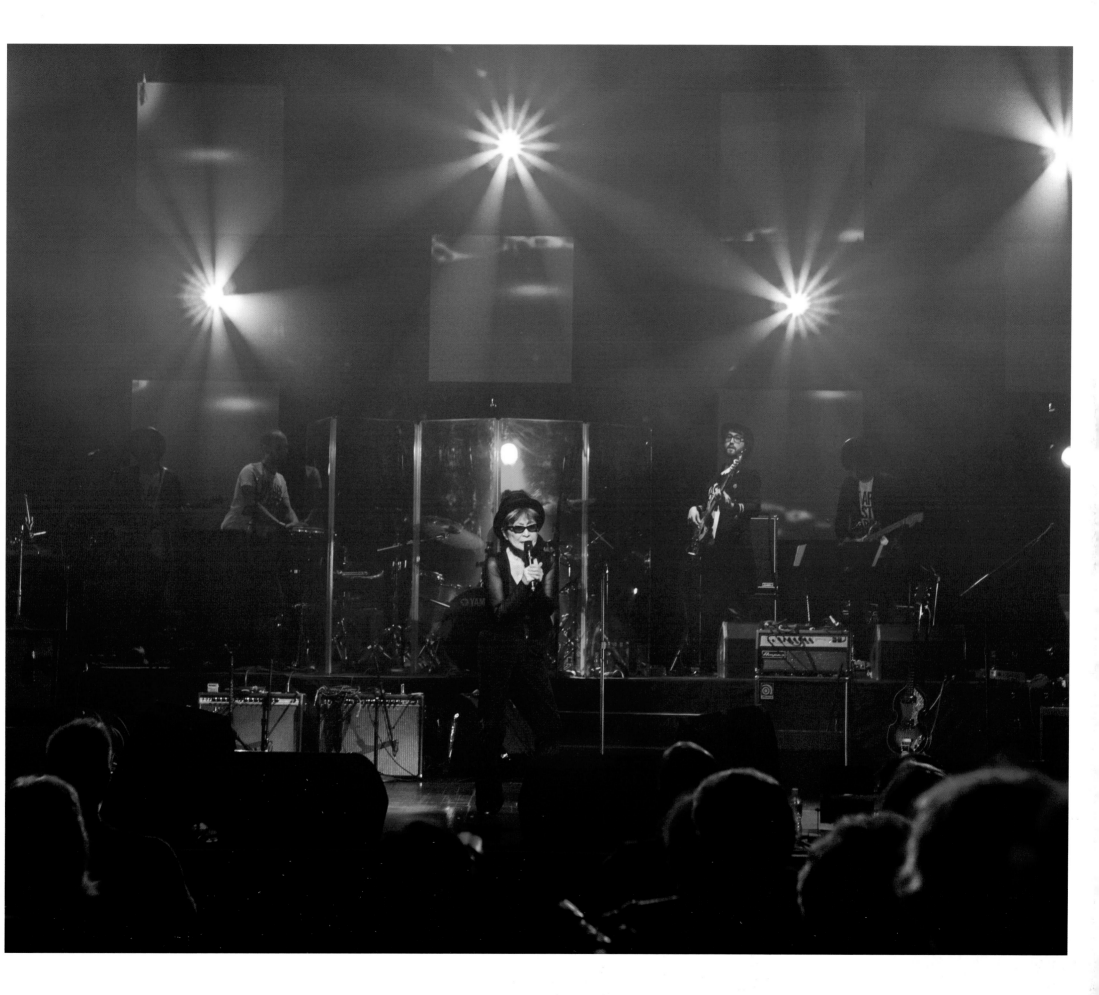

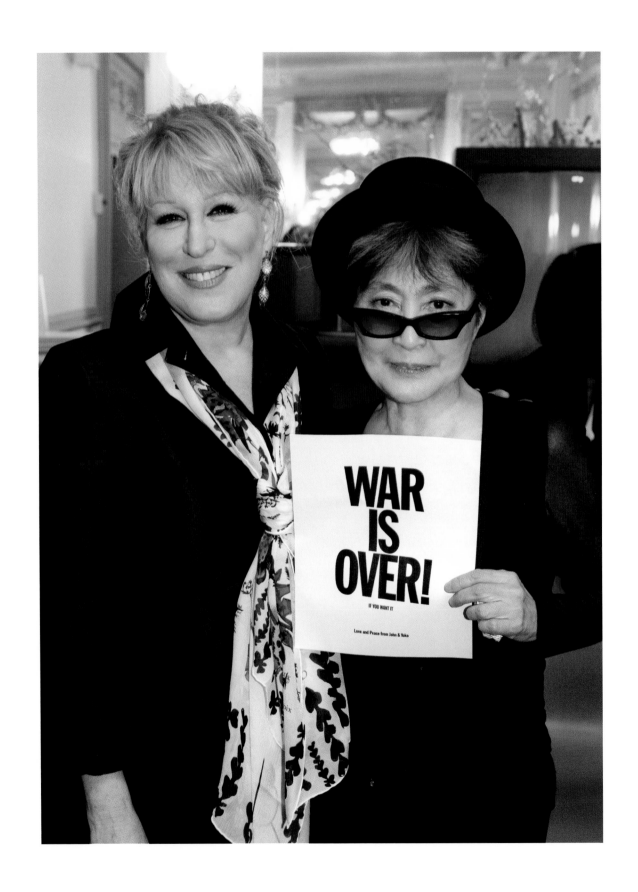

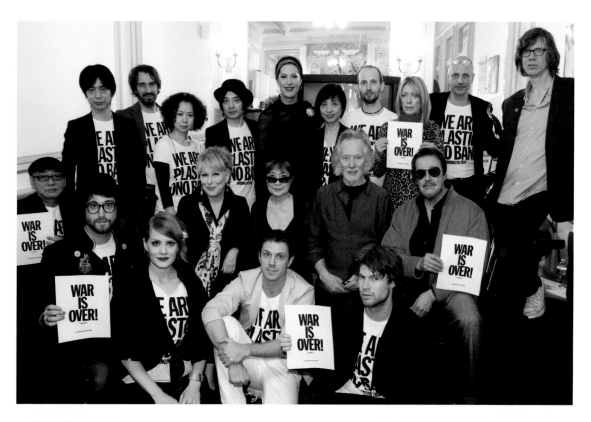

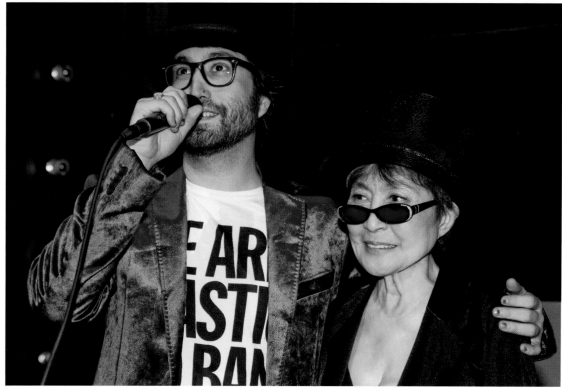

Sean Lennon, Bette Midler, Yoko Ono, and We Are Plastic Ono Band backstage at the Brooklyn Academy of Music in Brooklyn, New York, February 16, 2010.

FOLLOWING SPREAD Yoko Ono onstage at Háskólabíó in Reykjavík, Iceland, October 9, 2010.

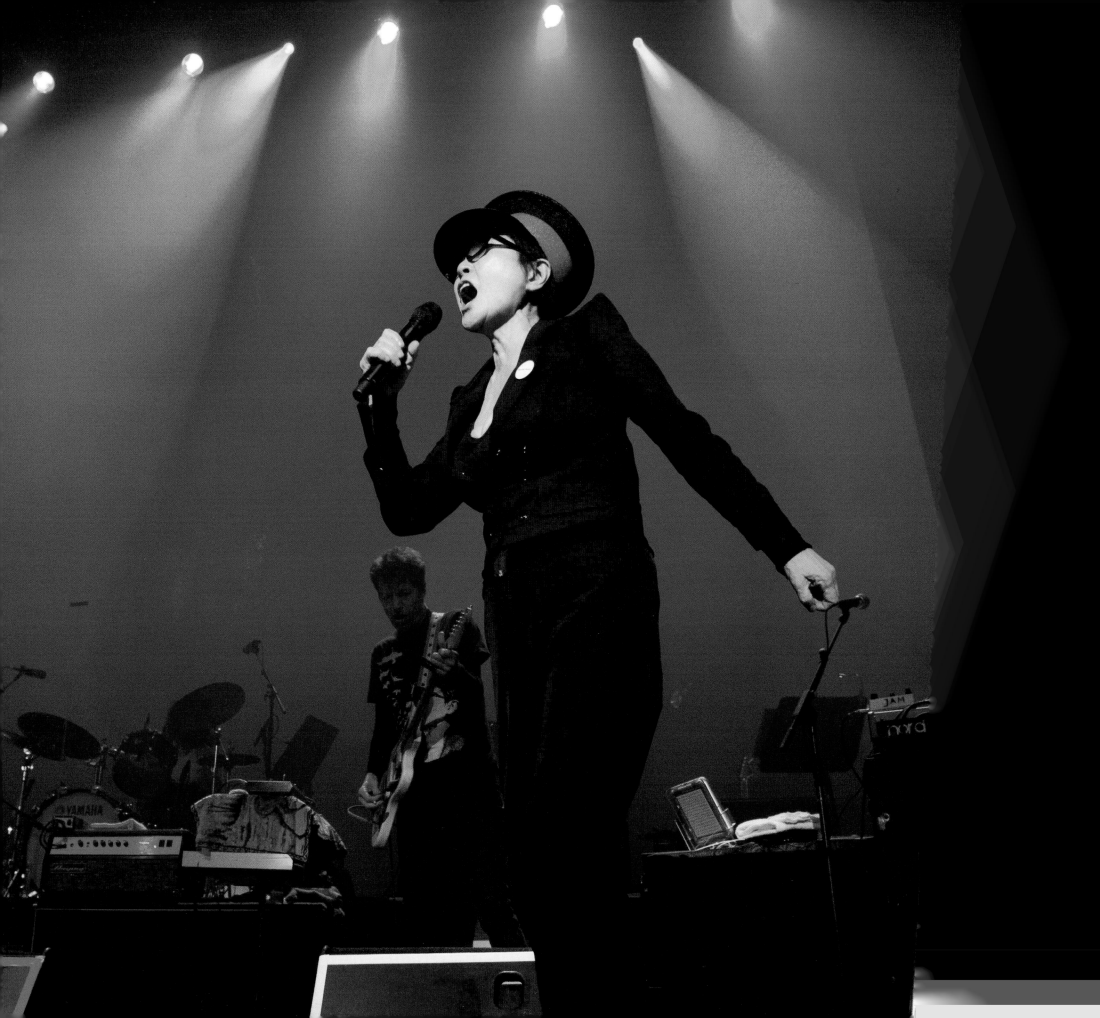

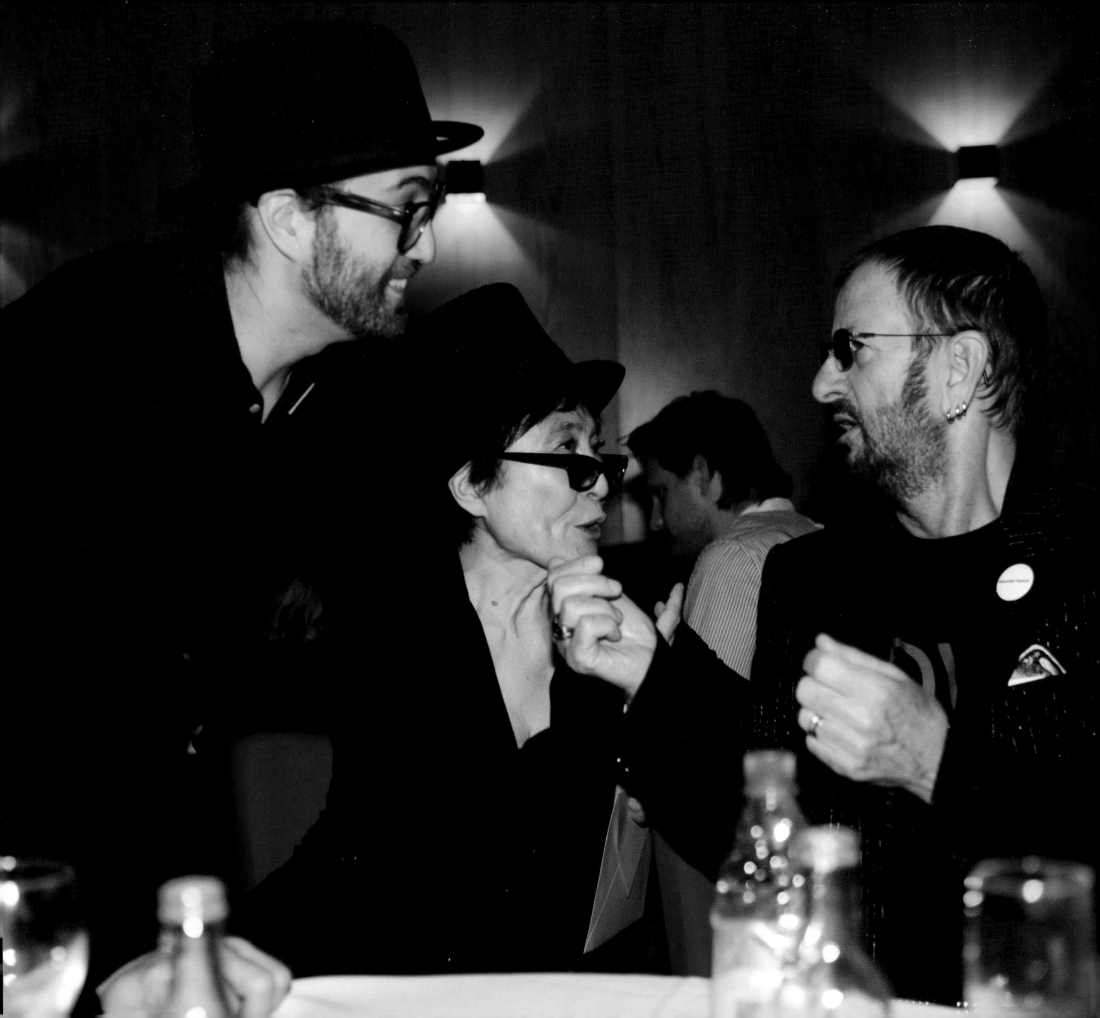

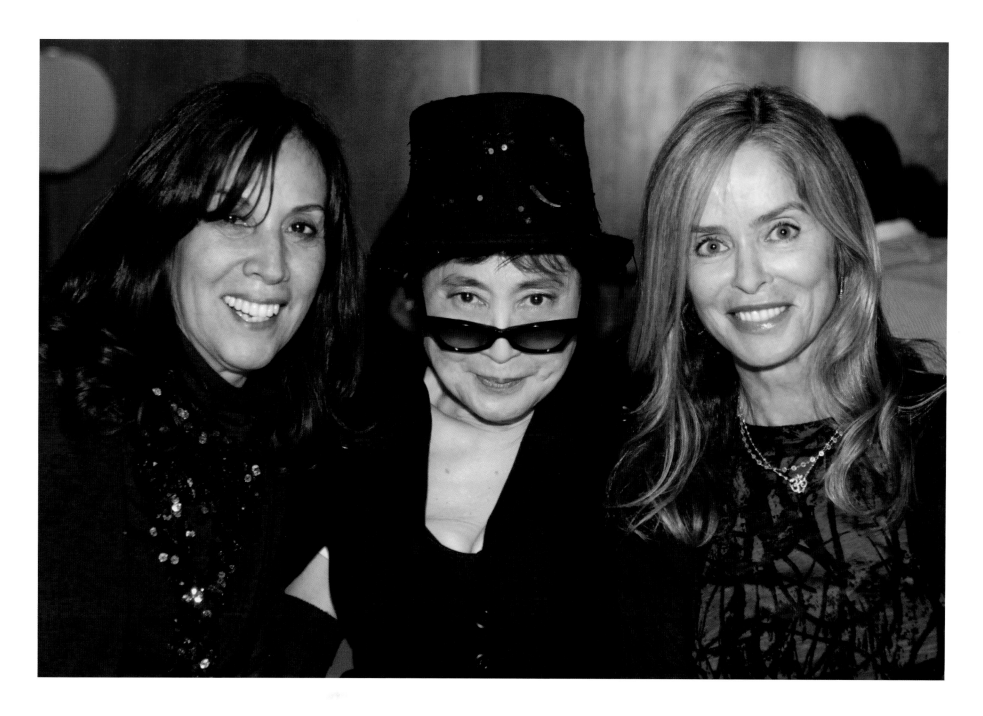

"Every day is very, very
important for me, as I go,
precious, precious,
time is precious."

LEFT (L–R) Sean Lennon, Yoko Ono, and Ringo Starr
during Sean's thirty-fifth birthday party in Reykjavík, Iceland,
October 9, 2010.

ABOVE (L–R) Olivia Harrison, Yoko Ono, and Barbara Bach
during Sean's thirty-fifth birthday party in Reykjavík, Iceland,
October 9, 2010.

FOLLOWING SPREAD Yoko Ono during "John Lennon Super
Live" at the Budokan in Japan, December 8, 2010.

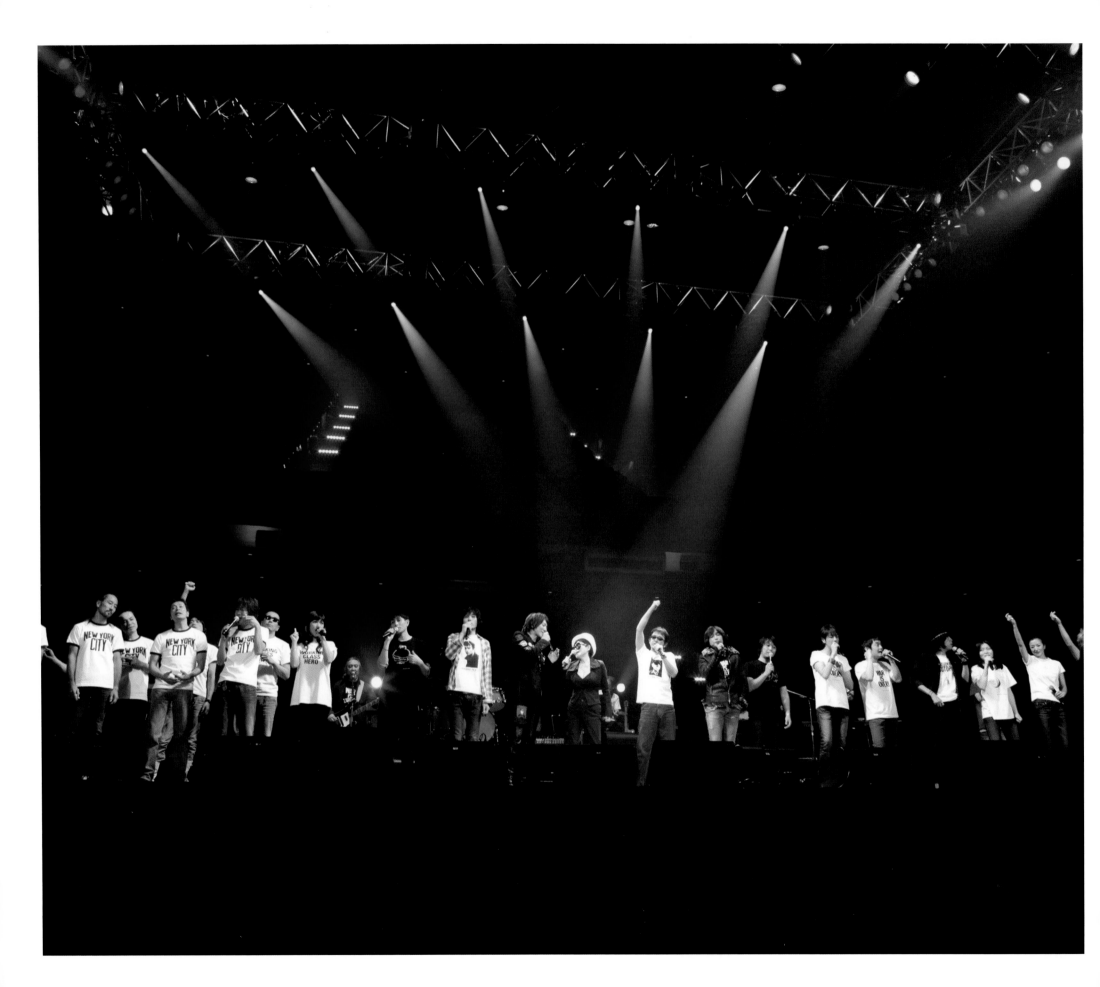

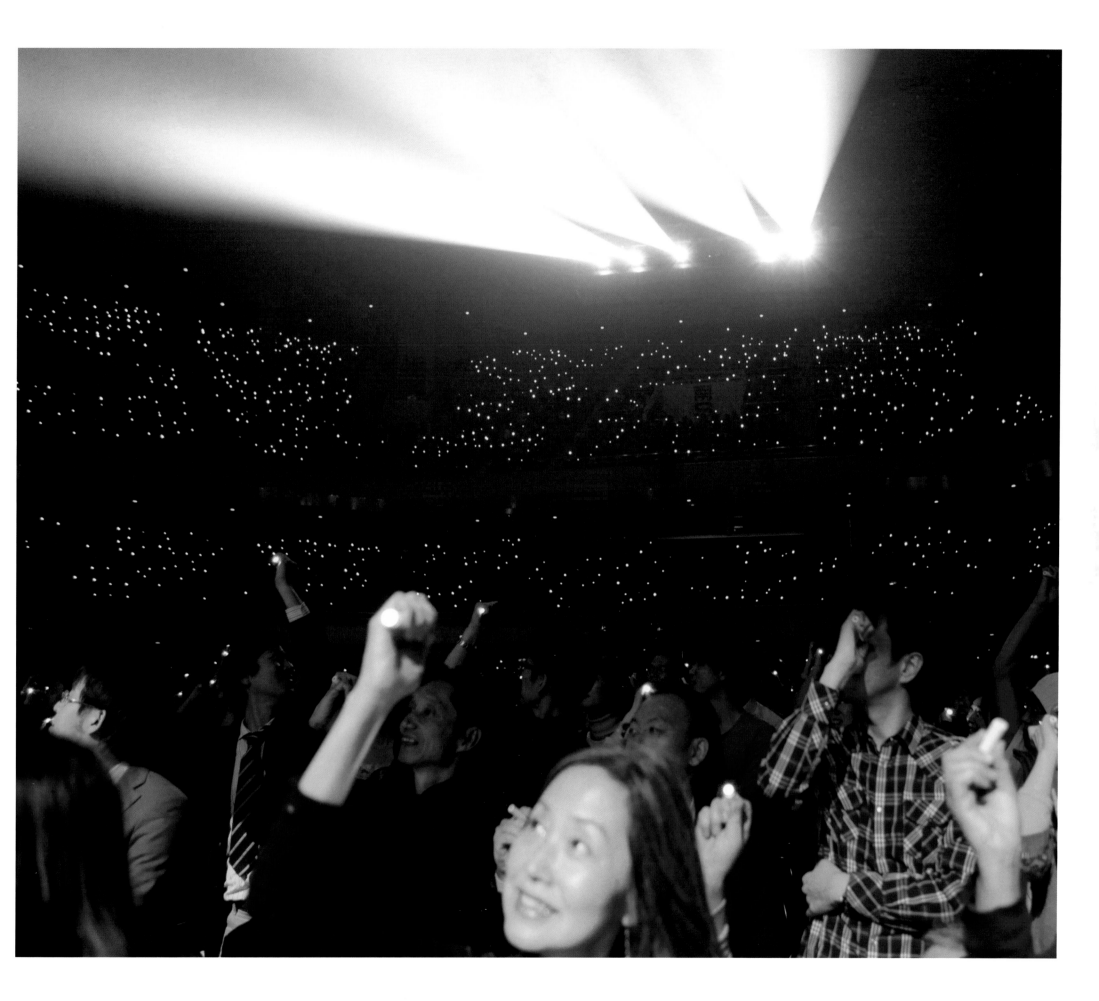

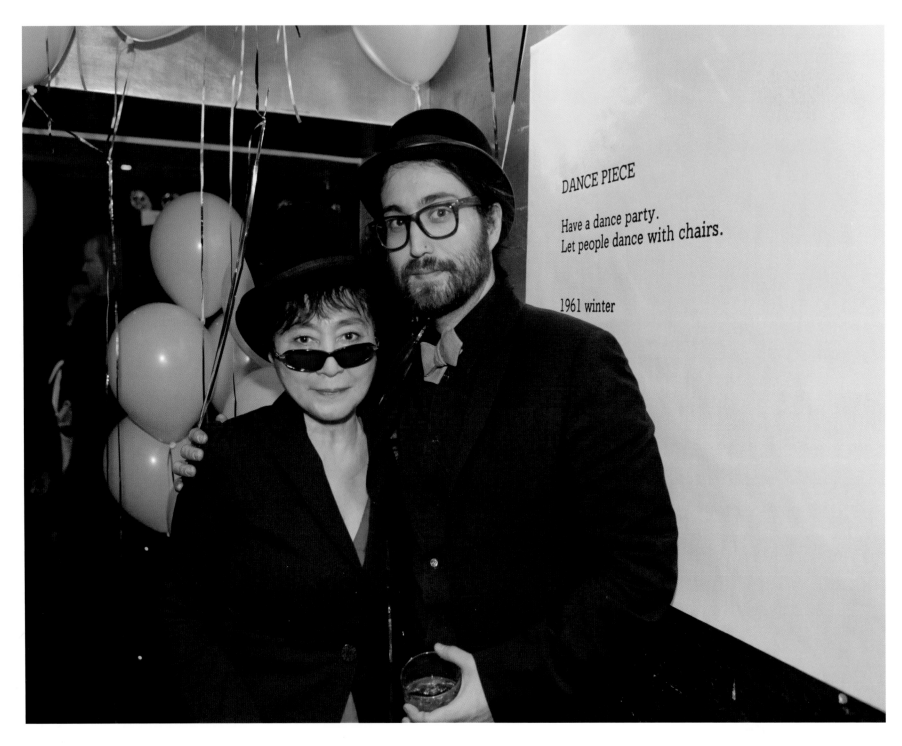

DANCE PIECE

Have a dance party.
Let people dance with chairs.

1961 winter

"Time is a man-made concept. And basically, I don't usually get concerned about age or the year measure."

Yoko Ono and Sean Lennon during Yoko's seventy-eighth birthday party at Dominion, New York City, February 18, 2011.

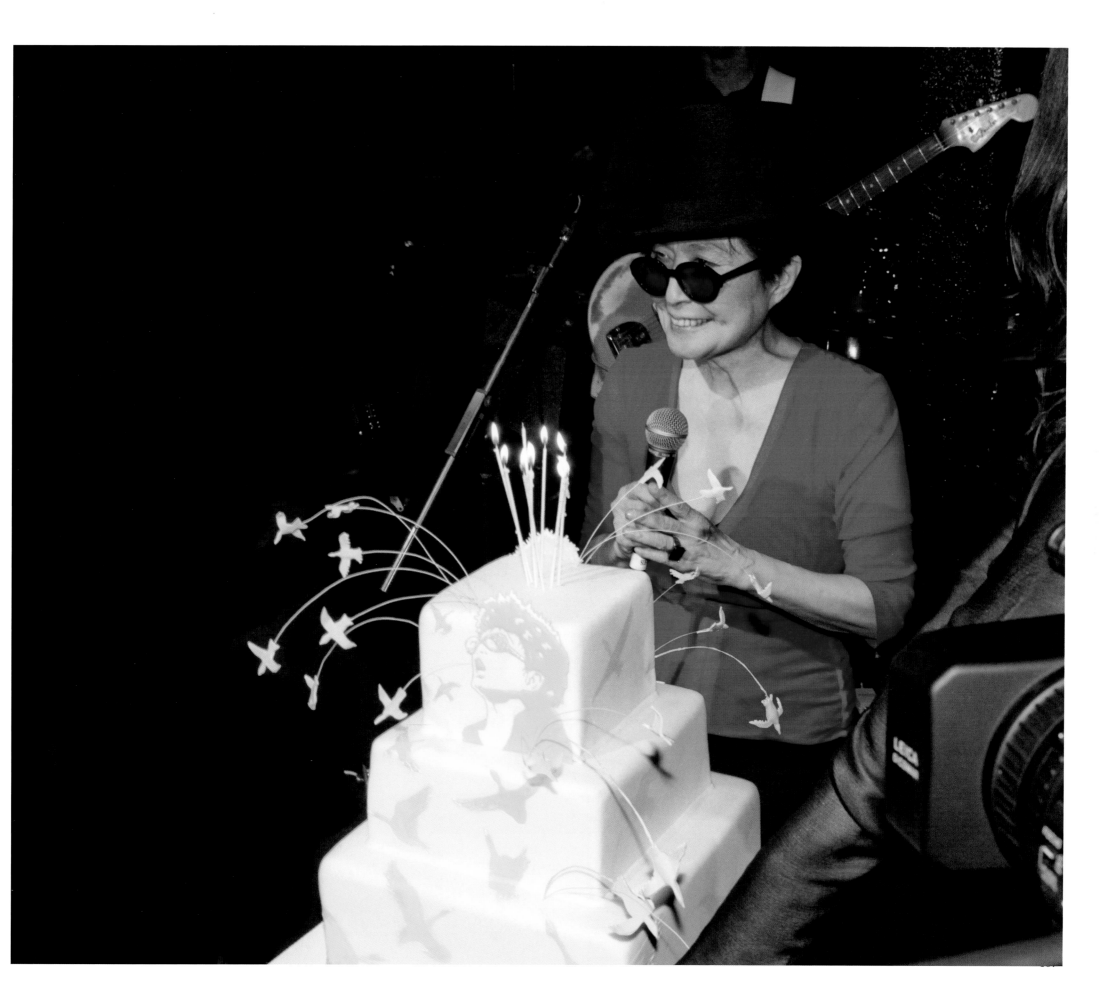

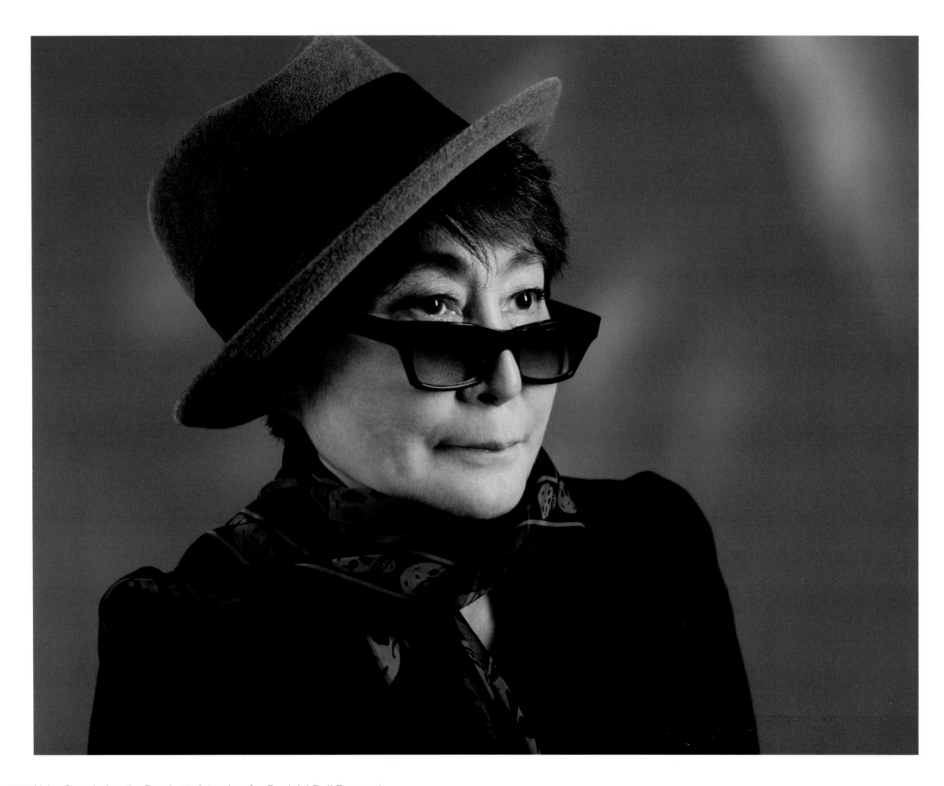

ABOVE Yoko Ono during the Don Letts interview for *Rock 'n' Roll Exposed: The Photography of Bob Gruen*, New York City, January 5, 2011.

RIGHT Yoko Ono for the "Imagine There's No Hunger" campaign in Times Square, New York City, November 1, 2011.

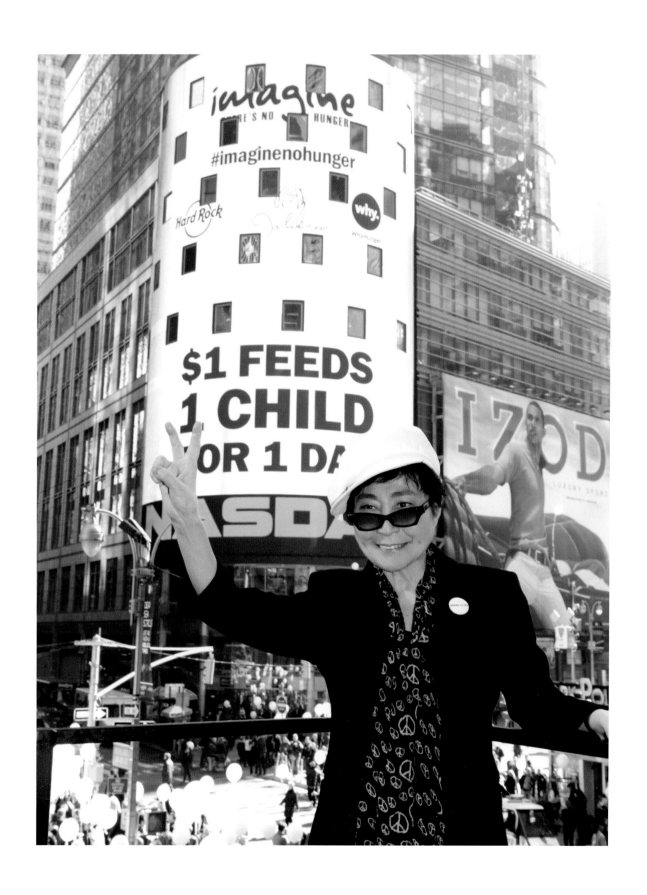

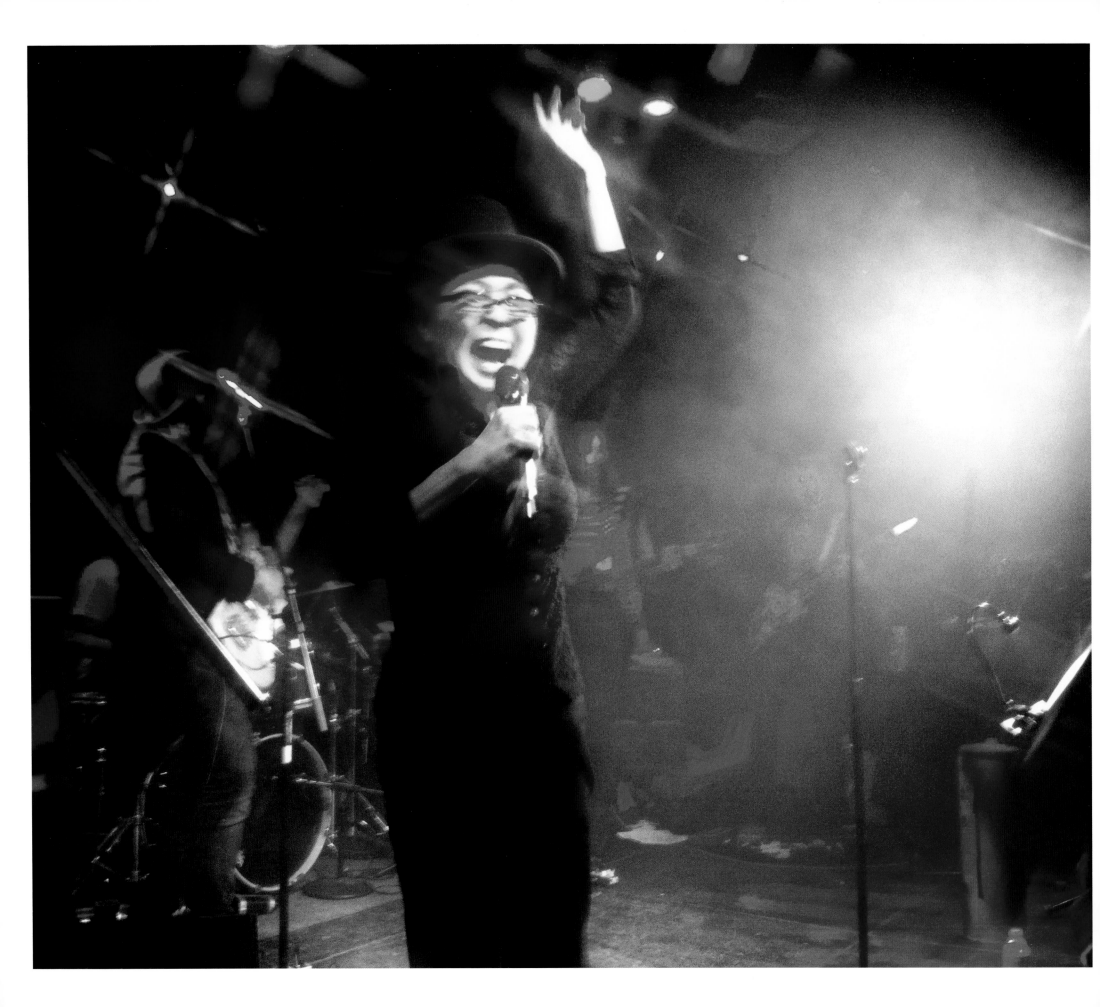

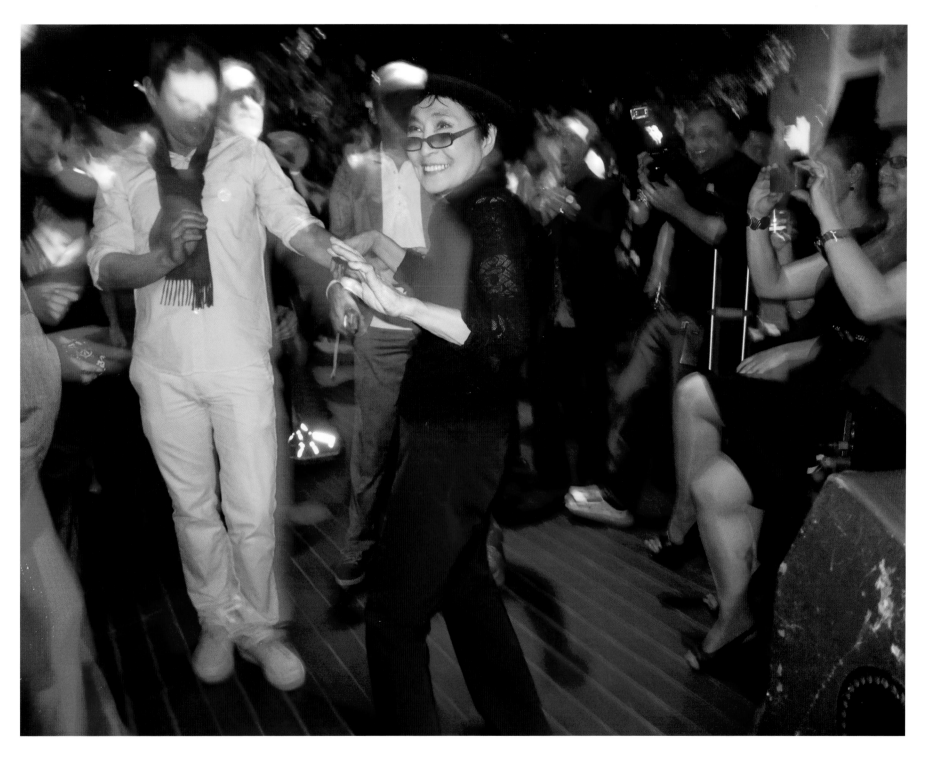

Yoko Ono during her seventy-ninth birthday party at Le Poisson Rouge, New York City, February 18, 2012.

"I love dancing. I think that this whole idea fascinates me the most about the pop-rock field: they write dance music so that you can move your body with it. Or they write in a regular beat so you can follow it, like a heartbeat. It's fantastic, it's great."

On making her first in-store appearance:

"Well anyway, CD signing, that was kind of extremely frightening and I didn't want to do it. . . . But then when I actually did it because I thought, 'I'd better do it, must do it,' and it wasn't so bad. It was just a very nice way of meeting people, who followed my work all this time, and so it was just to say thank you to each one of them. And I'm glad I did it."

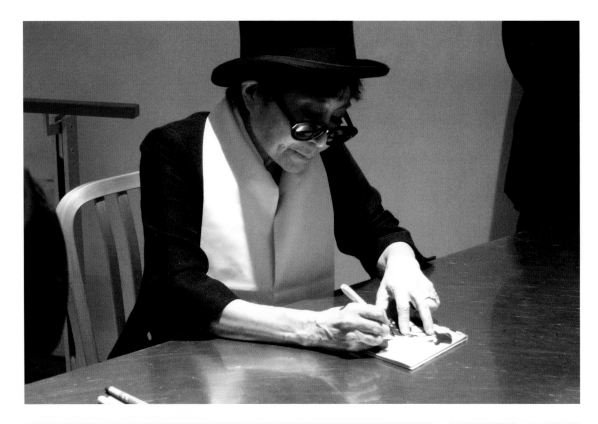

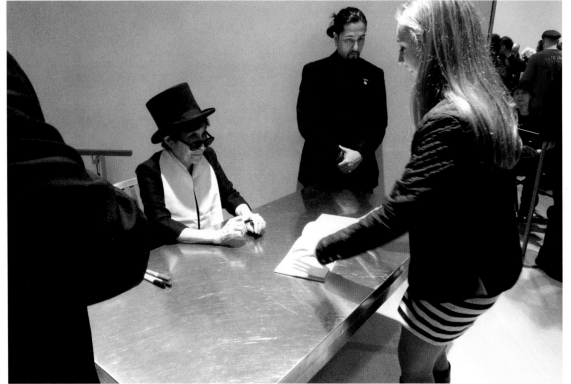

172

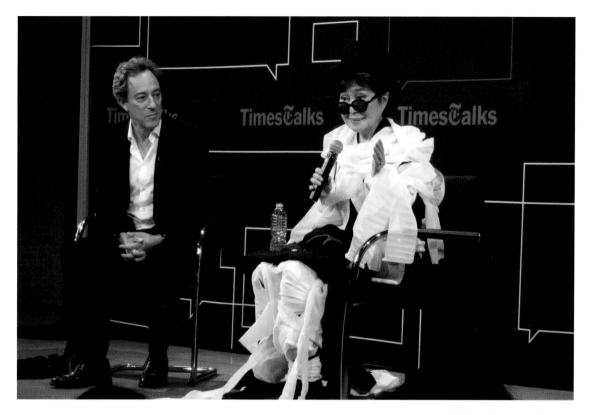

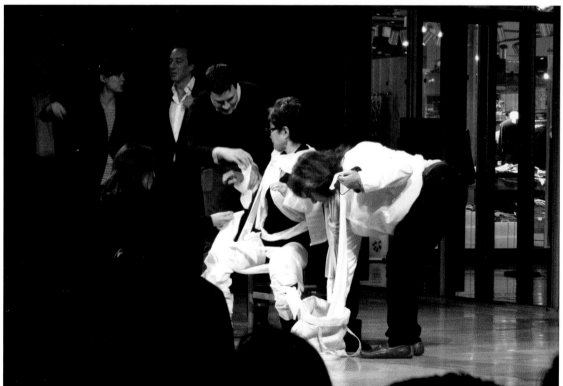

Yoko Ono onstage during, and signing for fans after, her
New York Times talk, New York City, October 15, 2012.

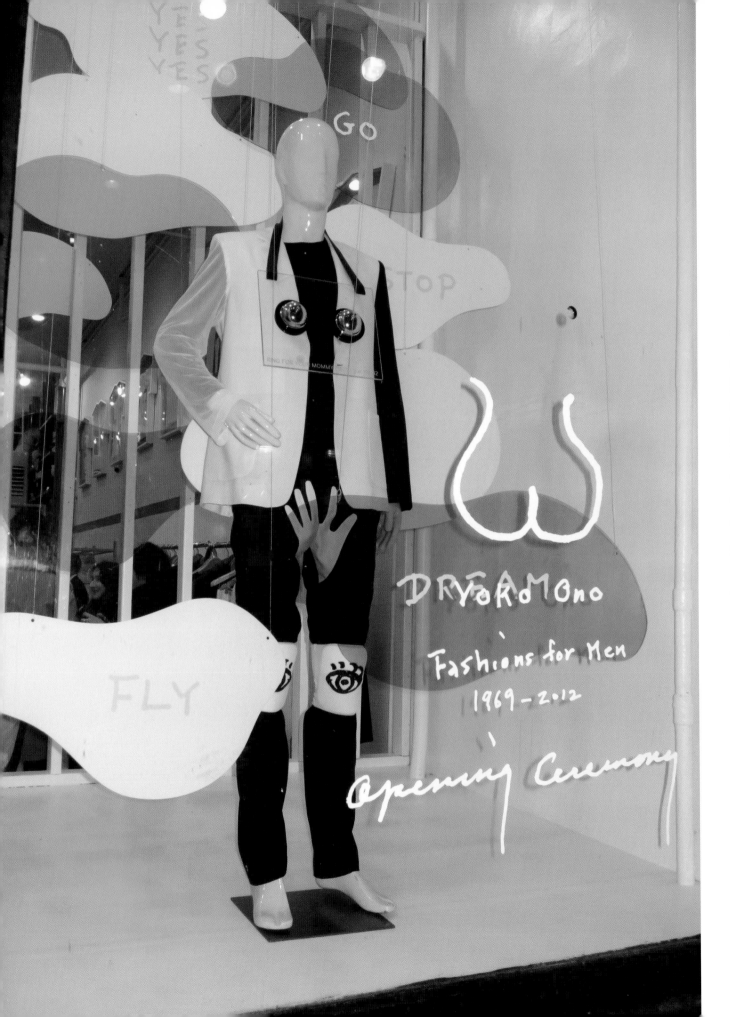

"I think maybe I'm a slow developer. And sometimes it's not easy [when] what you're doing is difficult for people to understand in the beginning. And then you have to wait. You know, I wasn't waiting, I thought, 'Well that was over.' I forgot all that stuff. But then suddenly it started to resurface and it was really great. I love it."

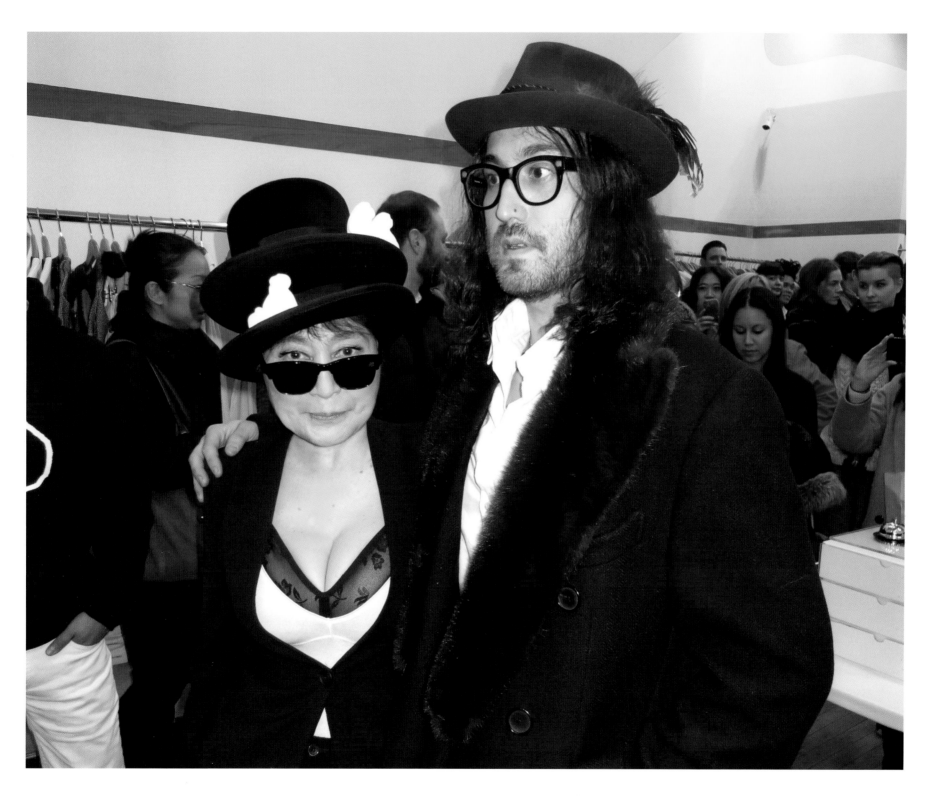

Yoko Ono and Sean Lennon during the opening for "Fashions for Men: 1969–2012" at Opening Ceremony, New York City, November 27, 2012.

"When you go from childhood, it was a long way from Tokyo to New York. It wasn't like a hop over. A lot of things happened like wars between the United States and Japan as well. It was a long way, and many, many different lives I had, nine lives maybe."